LEE HAMMOND'S
All New
big book of
DRAWING

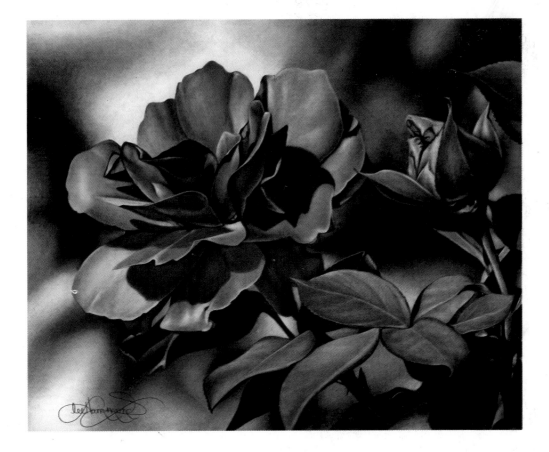

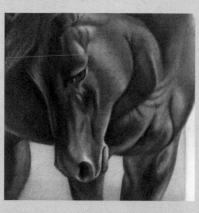
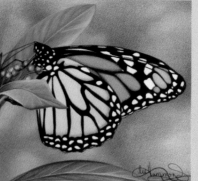
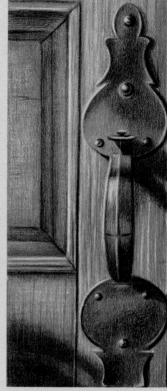
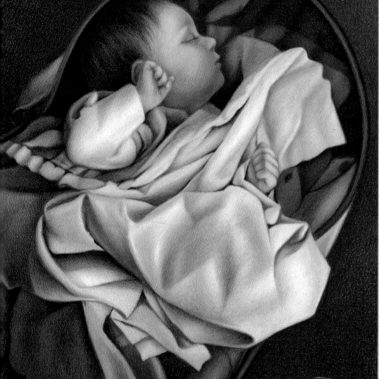

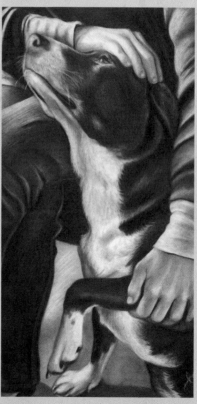
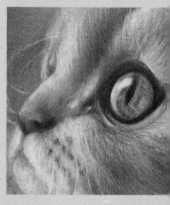

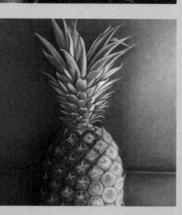

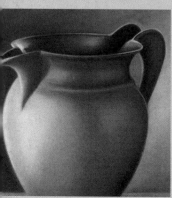
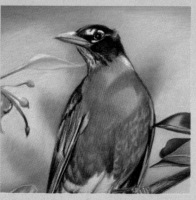
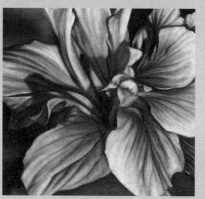
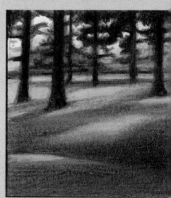

LEE HAMMOND'S
All New
big book of
DRAWING

Beginner's Guide to Realistic Drawing Techniques

NORTH LIGHT BOOKS
CINCINNATI, OHIO
www.artistsnetwork.com

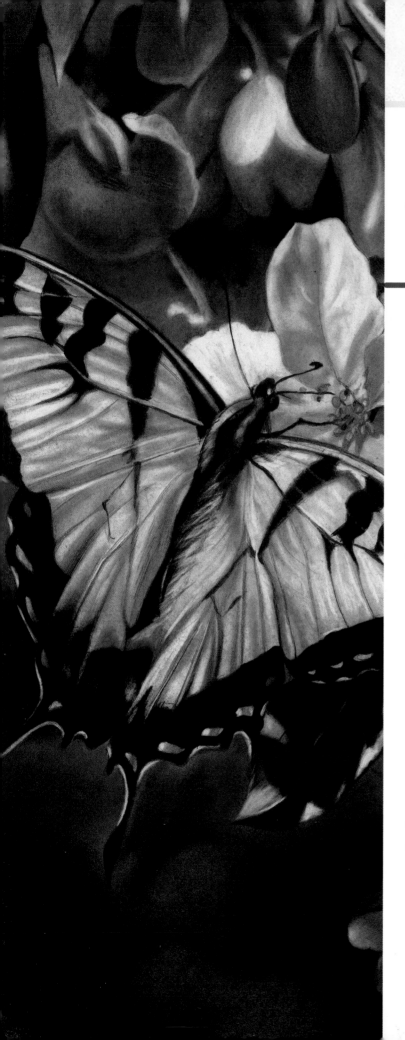

CONTENTS

WHAT YOU NEED

circle template or compass pencil sharpener

colored pencils ruler

craft knife stick eraser

drawing paper stump or tortillion

kneaded eraser

mechanical graphite pencil

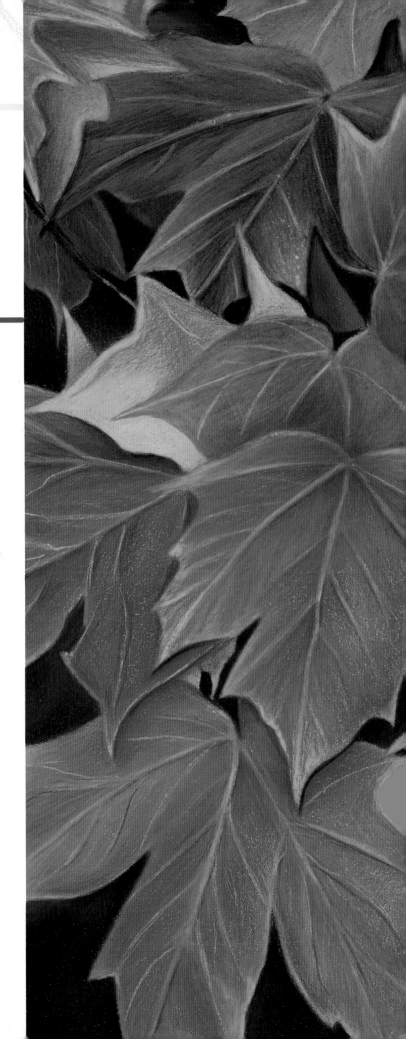

PART TWO
COLORED PENCIL 102

Introduction

Welcome to the *All New Big Book of Drawing*! I couldn't be more excited about this book for it takes all of my expertise about drawing and combines it into one fun, project-filled book. After almost forty years of teaching, I have developed some great tips to share with you—some of which I haven't revealed before.

If you have ever dreamed about becoming an artist but have not had much practice drawing, this is the book for you. It will slowly guide you to producing your most successful drawings yet. Practice on your part will be extremely important, but the lessons and projects in this book will give you everything you need to succeed. Just follow the material in the order that it is presented, and you'll get fabulous results.

The first half of this book is all about drawing with graphite. This is the foundation for all of the other mediums, so everything you learn about graphite will transfer to future techniques you may want to try. Step-by-step projects will help complete your drawing knowledge and make you proficient in drawing a wide variety of subject matter. Even if you have my other graphite books, the all-new projects will still provide plenty of practice for improving your skills.

The second half of the book explores drawing with colored pencil. It takes the basic theories of capturing shape, form and likeness that are covered in the graphite section and applies color theory to them. The simple step-by-step projects will guide you towards drawing realistically with colored pencil in no time.

This book could easily be called a bible of drawing. Use it as your go-to book for any drawing questions you may have. I hope you will love it as much as I loved creating it for you!

YOU CAN DO IT!

Many students have told me that they initially feared taking one of my classes because they didn't know how to draw. But imagine if you were afraid to take a new language class because you didn't speak that language already. Isn't that the very reason you'd want to take the class in the first place? If you want to learn to draw, you don't have to know anything in advance. You just have to want to try. I can show you how.

Drawing is really quite basic, and its theories are very repetitious. Once you learn a few of the basic techniques, you can go on to draw just about anything. It all boils down to three simple procedures:

- Accurate shapes
- Understanding light and shadows
- Drawing tones that match reality

My mantra in my classes is: Get it darker! Many fear the depth of tone required for a realistic drawing, so they end up with a weak, monotone study that lacks depth. Shadows can be quite dark, so learning to love drawing dark is necessary for realism.

My other mantra is: Slow down! Don't rush the project. Often the difference between my own work and my students' is not in the skill level, but in the time I am willing to invest in each piece—especially with colored pencil. Be prepared and willing to work at it for a while. The more time you invest, the better the result will be.

Come along for a fun and creative adventure with me. Just take the projects one at a time, don't jump ahead, and I guarantee you will be very pleased with the outcome.

You CAN do it!

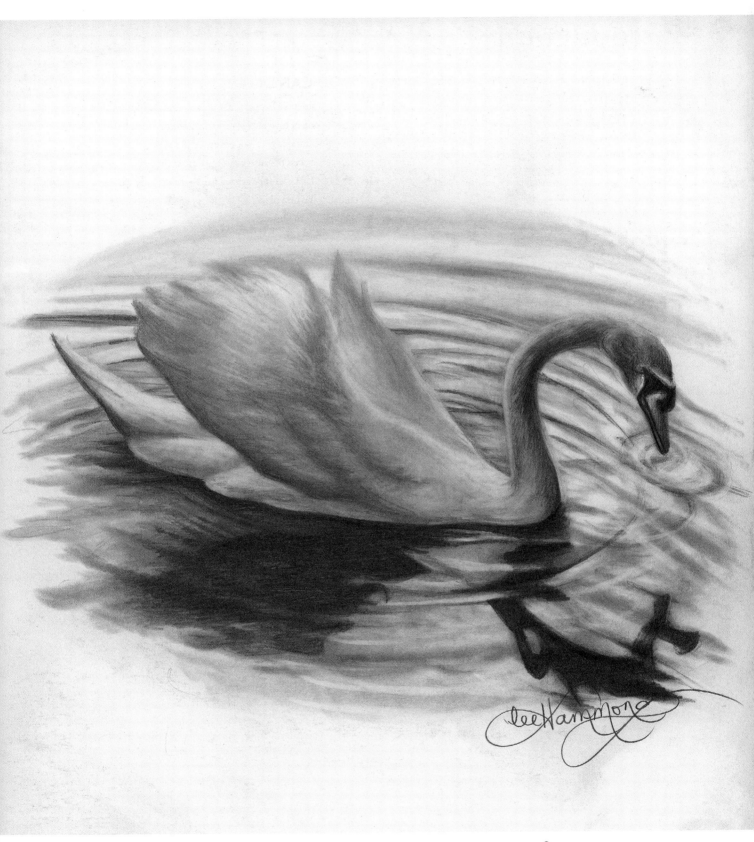

Swan
Graphite on smooth bristol
14" × 11" (36cm × 28cm)

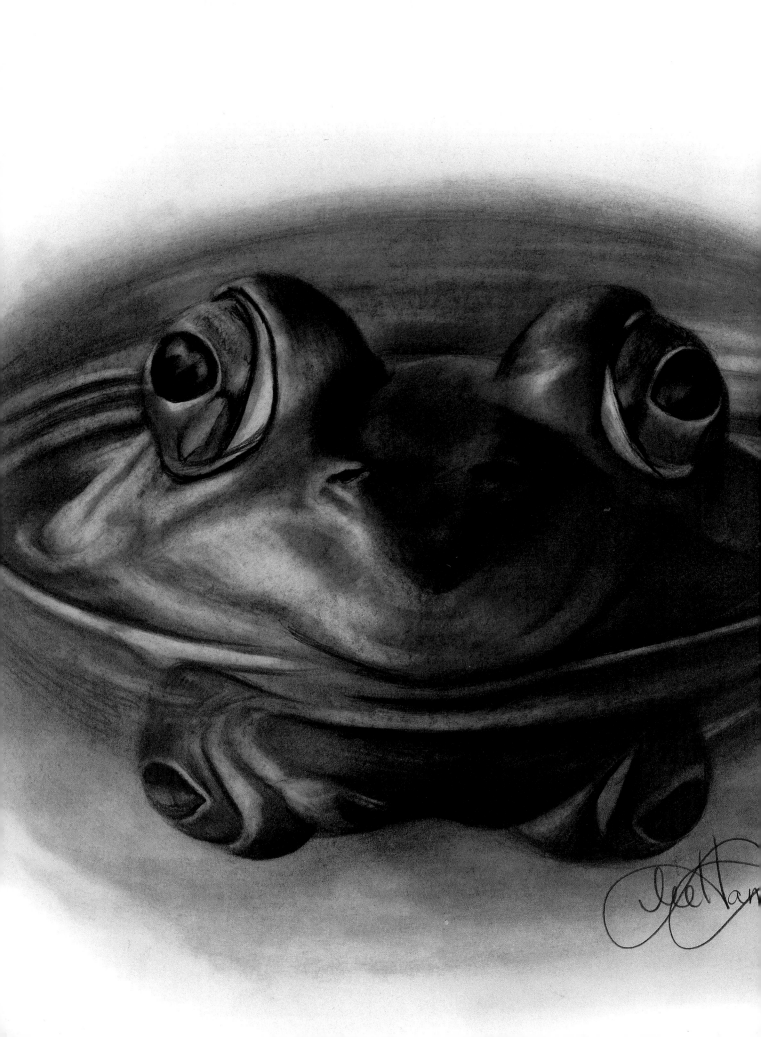

GRAPHITE

There is nothing that cannot be drawn with graphite. No longer should it be considered a preliminary medium for another form of art. Graphite is an art form in itself—it can produce quality pieces suitable for framing, showing and selling.

Once you have learned the blending techniques for realism and come to understand the effects of light and dark on the forms, all subject matter will be within your reach. Practice is the key to developing your skill. The more you practice with various types of subject matter, the better you will become.

Frog
Graphite on smooth bristol
14" × 11" (36cm × 28cm)

CHAPTER ONE
GRAPHITE BASICS

Graphite has always been my go-to medium when it comes to art. It was my first love when it came to learning basic drawing techniques. Because I am self taught, it was the easiest medium to master. It's also the most portable and clean medium, so it was convenient when I was raising my children.

In the 80s, I developed the Lee Hammond Blended Pencil Technique and started teaching it to small groups. Like me, the students found graphite to be the easiest medium to control. By the 90s I was hooked—and writing books about it. This technique has changed the way people draw.

This section of the book will make you proficient in graphite drawing. Even if you have previous experience, the projects will give you additional skill and understanding. I hope the illustrations will inspire you and prove that graphite is not just a tool to be used for preliminary sketching, but is a fine-art medium in its own right.

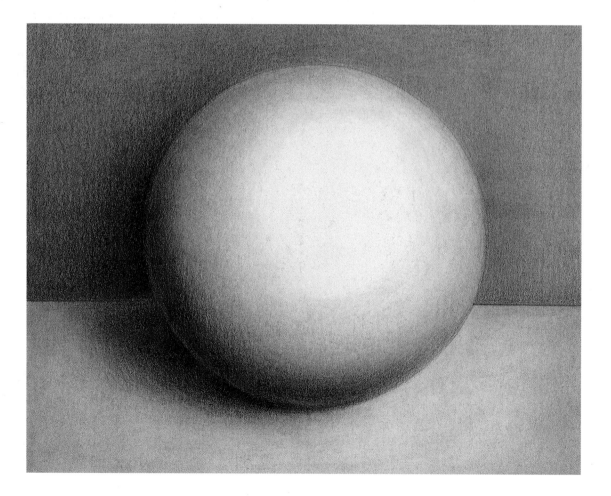

Graphite Tools

You cannot create quality artwork with inadequate art materials. My blended pencil technique requires the right tools to create the look. Don't scrimp in this department or your artwork will suffer.

I've seen many of my students blame themselves for being untalented when it was their supplies keeping them from doing a good job. The following tools will help you be a better artist.

- **Pencils**

 Mechanical pencils are great for fine lines and details, and you never have to sharpen them. While a mechanical pencil is my pencil of choice, the lead is the most important part. 2B is a soft lead that offers a smooth blend. You can also use 4B or 6B with similar results.

- **Smooth Bristol Board or Paper (Two-Ply or Heavier)**

 This paper is very smooth (plate finish) and can withstand the rubbing associated with a technique I'll be showing you later in the book.

- **Blending Tortillions and Stumps**

 Both are used for blending the graphite. Tortillions are spiral-wound pieces of paper that are good for small areas. Stumps are paper pressed and formed into the shape of a pencil. They are pointed on both ends and work well for blending large areas.

- **Kneaded Erasers**

 These erasers resemble modeling clay and are essential to a blended pencil drawing. They gently lift highlights without ruining the surface of the paper.

- **Stick Erasers**

 These erasers resemble mechanical pencils with a click mechanism for advancing them. The erasers in these are made of vinyl and they erase pencil marks cleanly. The small point of the vinyl eraser can remove precise lines and details within your drawing. They come in a variety of sizes from large tips to micro.

- **Workable Spray Fixative**

 This is a spray used to seal your work and to prevent it from smudging when you are finished. *Workable* means you can spray down an area and continue to draw on top of it. However, I don't recommend it for the techniques in this book. It will change the smoothness of the paper and interrupt your blending.

- **Drawing Board**

 It's important to tilt your work toward you as you draw. This prevents the distortion that occurs when working flat. Secure your paper and reference photo with a clip.

- **Ruler**

 Rulers help you measure and graph your drawings.

- **Acetate Report Covers**

 Use these covers for making graphed overlays to place on top of your photo references. They'll help you accurately grid your drawings.

- **Reference Photos**

 These are valuable sources of practice material. Collect magazine pictures and categorize them into files for quick reference. A word of warning: Don't copy the exact image; just use the images for practice. Many photographers hold the copyright for their work, and any duplication without their express permission is illegal. You can avoid this issue altogether when you use your own reference photos.

Blending

I teach a special method of drawing with graphite that I call the Hammond Blended Pencil Technique. I first introduced this technique back in the 80s when graphite drawing had a looser, more impressionistic approach, and smooth blending was rarely seen. Over the years, this smooth and realistic approach has been embraced by thousands of people and become one of the most popular styles of drawing. To create this look, blend your graphite until it appears smooth. It is not as easy as it looks, but with practice you can master this technique.

The following examples show what your blending should look like and what it should not. The smoothness of your blend will depend on how smoothly you apply the pencil. It's important to place your pencil lines down slowly and evenly at the very beginning. If your pencil lines are put down in a fast, scribble-like application, no amount of blending will make them look smooth.

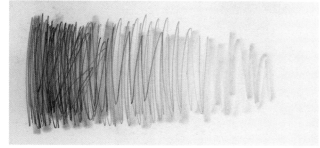

Don't Scribble
No amount of blending will ever be able to make this scribbled application look smooth.

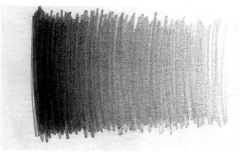

Smooth Lines from Dark to Light
This is what your pencil lines should look like before you begin blending. The individual lines are barely visible. Work from dark to light, going up and down and back and forth at the same time to help the lines fill in as you go.

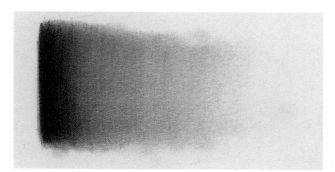

Use a Light Touch for Blending
Apply the tortillion in the same up-and-down, back-and-forth application as you applied the pencil. Do not press down hard as you blend—this will just rough up the paper and make it look choppy. The lighter your touch, the smoother your blend will be.

LEE'S LESSONS
When blending, always hold your stump or tortillion at a slight angle to get the best results for a smooth finish.

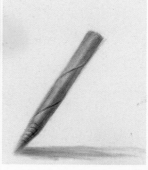

The Five Elements of Shading

In order to draw realistically, you must first understand how lighting affects form. There are five elements of shading that are essential to depicting an object's form realistically. Without a solid foundation of these elements, everything you draw will look flat. Your subject will look three dimensional only when the effects of light and shadow are properly placed. Each of the five elements of shading can be seen on the sphere below:

1. Cast shadow. This is the shadow the object you are drawing casts onto a surrounding surface. It is often the darkest part of your drawing because this is where the light is completely blocked. It should be drawn in as close to black as possible. As it comes out from the object, it will start to appear lighter. It is Number 1 on the value scale.

2. Shadow edge. This is also referred to as a turning shadow. It is not the edge of the object, but rather the shadow on the object that shows it's a rounded surface. This is a dark gray tone that corresponds with Number 2 on the value scale. You will find this shadow where an object has protruded and the surface recedes to the other side.

3. Halftone. This is the true color of your object, unaffected by the light. It has no shadow and is Number 3 on the value scale.

4. Reflected light. Look at the sphere below. You'll see a subtle rim of light along the edge of the shadow side. This is the light bouncing up from the surface and coming from behind. It is the element most often left out of a drawing. Yet without it separating the shadow edge and cast shadow, your object will look flat. Be sure to study your reference for the reflected light—it is always seen on the edges, rims or lip of an object. While it is lighter than the shadows, it is still seen on the darker side of the object. It should never be left too white, or it will not look realistic. It is a light gray and corresponds with Number 4 on the value scale.

5. Full light. This is the part of your subject that receives the most light. It's Number 5 on the value scale, where the tones fade gently into the white of the paper.

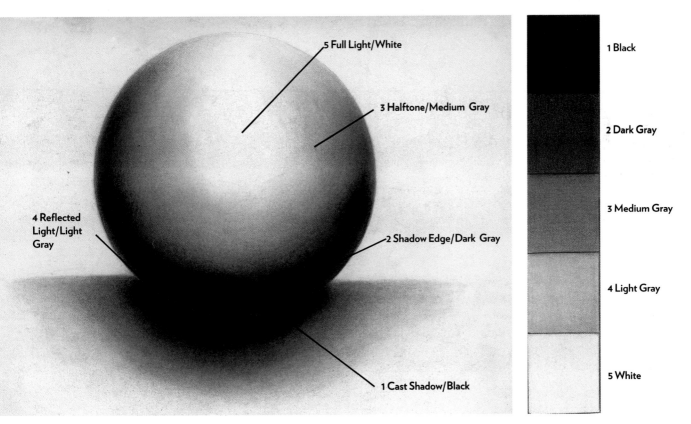

Compare Elements of Shading to Tones on the Value Scale
The five tones create the five elements of shading. Each element matches a tone on the value scale.

Matching Values

It is important to match the values of your subject matter. I always tell my students to analyze and replicate the tones. However, there are times it may be difficult to judge the values in your reference photo and determine whether or not you are close. To compare your tones, use this little trick: Take two small pieces of white paper and punch a hole in each. Place one over an area of your reference photo. Place the other over the same area of your drawing. Look at both of the holes and see if the tones match. By isolating the tones within these holes, you can then compare them to white and see how dark they really are.

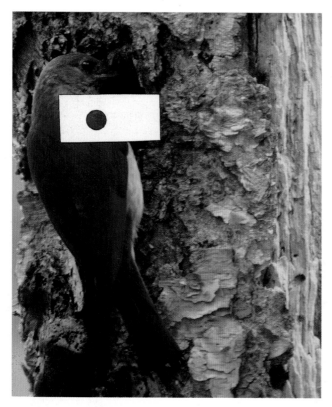

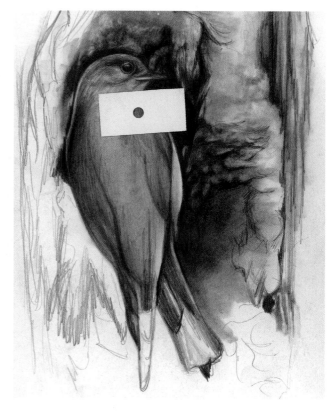

Comparing Tones
Use the hole-pouch technique to compare tones. In the example above, you can see how much darker the drawing of the bird needs to be. Study the bird more closely—you will see all five elements of shading.

LEE'S LESSONS

Here are some helpful tips for blending, shading and achieving even tones:

- **Contrast.** Don't be afraid to get dark in the shadows. Contrast is very important for creating the look of realism.
- **Application of Tone.** Always apply your pencil lines according to the contours of your subject. Blend using long vertical strokes, lightening your touch as you get into the light (like a value scale). You cannot control the fade into the light with cross blending.
- **Edges.** Anytime you have to use a line to describe the shape of something, you must get rid of the look of outlining. The darkness of a drawn line belongs to one surface or another. Fade the dark out into the surface it belongs to and create the look of an edge, not an outline.
- **Uneven Tones.** Correct uneven tones with a kneaded eraser. Form the eraser into a point and gently "draw" the irregularity out. Use a very light touch. This is called "drawing in reverse." You can also crisp up edges this way.

Backgrounds & Edges

Graphite is a foundation medium. The gray tones it produces provide you a means for fully exploring and understanding the importance of value and the five elements of shading.

One way you can use value to achieve a better sense of depth in your drawings is to add tone to the background. Notice below how the dark backgrounds affect the look of the shapes. If these shapes were set against white backgrounds, their edges would look much different.

When it comes to drawing shapes, there are two distinct types of edges: hard and soft. Hard edges are found where two surfaces come together or overlap. They are quite defined as their tones create the look of an edge by stopping abruptly. Soft edges can be found in areas when an object bends gently. They have a gradual change in tone.

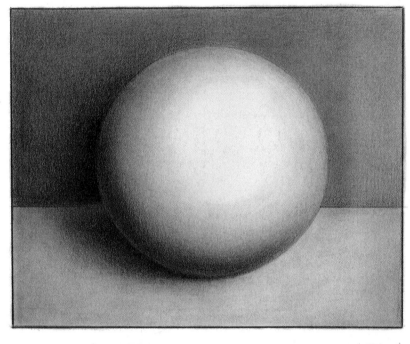

Background Makes a Difference

When the sphere is placed in front of a toned background, its edges look different compared to the previous sphere with the white background. When drawing, always ask yourself if you are blending light over dark (as seen with the toned-background sphere) or dark over light (as seen with the white-background sphere).

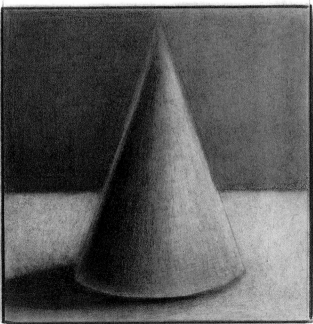

Hard and Soft Edges

This cone has two distinct types of edges: hard and soft. The soft edge can be found in the curve of the shadow on the rounded surface of the cone. Hard edges are created where the cone overlaps the background and touches the table.

Draw a Sphere

A good drawing is always preceded by a lot of practice work. It takes experience to get the feel of your tools and materials. While this sphere exercise may not be as exciting as other subject matter, it is crucial for developing your skills and will give you practice drawing curved objects. The better you can draw rounded and other basic shapes, the more professional your work will appear.

Follow the steps to draw a sphere, and repeat this exercise over and over. Practice drawing it on both white paper and a background.

MATERIALS

drawing paper

kneaded eraser

mechanical graphite pencil

stump or tortillion

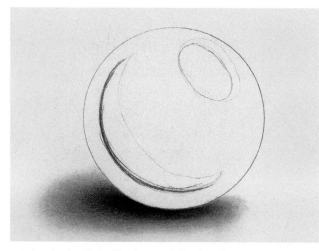

1 Apply the Cast Shadow and Shadow Edge
Always start with the darkest area of your drawing. Usually this is not on the object at all, but found in the cast shadow. Applying it first, helps create the edge of the sphere. Once the cast shadow is complete, start the shadow edge, or turning shadow.

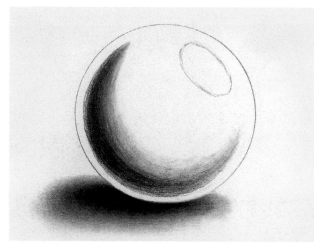

2 Begin Blending
Use a stump or tortillion to blend up from the shadow edge into the halftone area. Follow the contour of the curve. Blend with the contour; never cross blend into the light. Lighten your touch as the tones fade to light. For now, leave the reflected light alone.

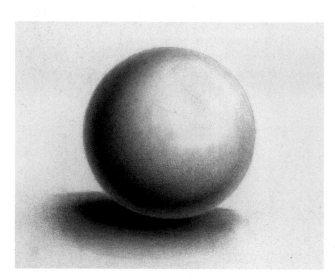

3 Continue Blending and Finish the Edges
Continue blending until the tones fade into the full light area. You should not see where one tone ends and another begins. Blend down into the reflected light to make it a light gray. Be sure to eliminate all looks of outlining around the sphere. Remember—you want to create edges, not outlines.

Draw Cylinders

It is just as important that you are able to draw cylinder shapes as well as spheres. While the cylinder is also rounded, its long tubular shape is seen in many objects.

Follow the steps to create cylinders. Before you begin, identify where the light is coming from and where the shadows should be placed. Note how different the application is when a background is included.

MATERIALS

drawing paper

kneaded eraser

mechanical graphite pencil

ruler

stump or tortillion

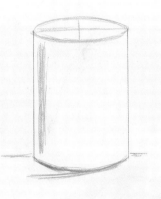

1 Draw the Shape
Create a line drawing of a cylinder. Use a ruler to make the straight perpendicular sides. Draw an ellipse (a circle in perspective) to make the top of the cylinder. Use the ¹⁄₄ rule for this: The shape of the ellipse should create a mirror image if folded in half vertically or horizontally.

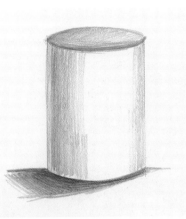

2 Establish the Shadows
Apply vertical strokes with your pencil to establish the shadows. The darkest shadow is below the cylinder in the cast shadow.

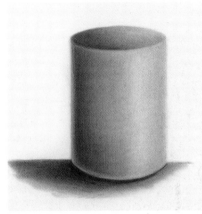

3 Blend the Tones
Use a stump or tortillion to blend the tones smooth. Use the same vertical strokes you did with your pencil.

1 Draw the Border Box and Shape, Place the Shadows
Draw a border box to start the background. It will help create your edges. Then draw a cylinder shape and place your shadows.

2 Tone the Background and Deepen the Shadows
Apply a gray tone to the background to create the light edges of the shape. Deepen the shadows on the cylinder.

3 Build the Tones and Blend
Continue building the tones and blending until smooth. Remember to "draw in reverse" with your kneaded eraser if you get any dark spots in your blending.

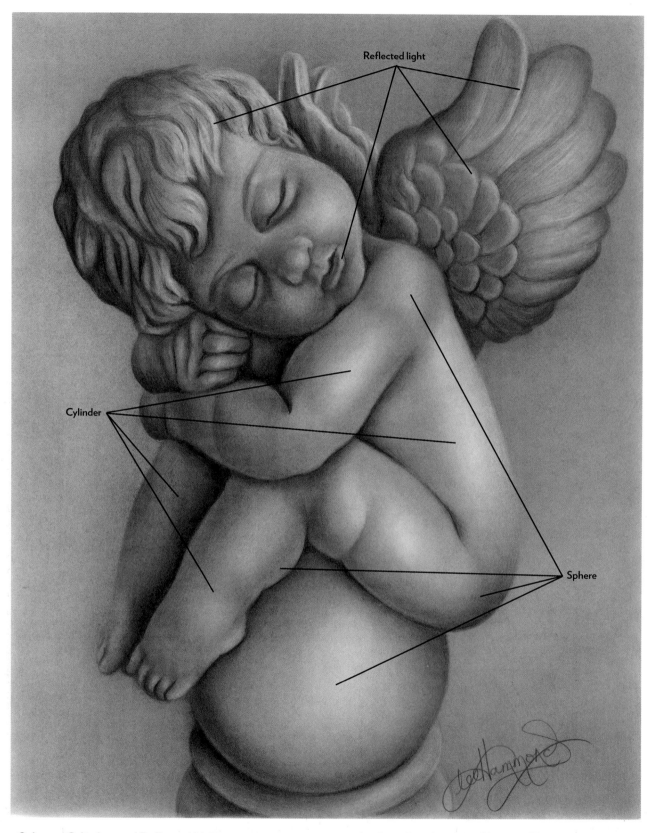

Reflected light

Cylinder

Sphere

Spheres, Cylinders and Reflected Light

This drawing is a perfect example of the sphere and cylinder, and why the five elements of shading are so important to realistic drawing. You can see all five elements of shading as well as those basic shapes clearly depicted here. Not only is the cherub sitting on a sphere, that same rounded shape repeats in the face, head and raised surfaces along the edges of the wings. The cylinder is also obvious—look at the arms, legs, fingers and toes.

The previous practice exercises are necessary if you want to be able to draw a subject like this. It is a reminder of how important it is to not skip the practice work.

Line Drawing: The Grid Method

The foundation for any good piece is an accurate line drawing. And it is best to have your line drawing perfected before you begin rendering because once blending and shading have been applied, it is much harder to make corrections.

There are many different methods for creating an accurate line drawing, but the grid method is the most popular method for acquiring shapes. It consists of evenly sized boxes placed over your reference photograph. You can make a copy or draw the grid right on top of the photo. You can also make a reusable grid by drawing or printing onto a clear acetate sheet. (Report covers work well for this and can be found at your local office supply store.)

Tape the grid onto your photo so it doesn't move. Then lightly draw the same number of boxes onto your drawing paper. Looking at one square at a time, draw the individual parts of the image into the boxes like a puzzle.

You can enlarge or reduce your drawing with a grid if needed. To make your drawing bigger than the photo, enlarge the size of the boxes you draw onto your paper. To reduce it, make them smaller than the grid on the photo. As long as the boxes are perfect squares, everything will be relative.

Once the image is drawn, your grid can be gently erased with the kneaded eraser. What is left behind is an accurate line drawing.

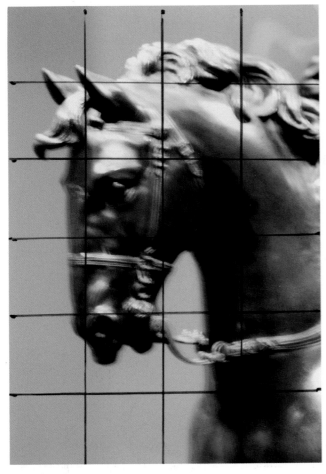

Reference Photo
Using an acetate grid over the reference photo will help you divide the image into segments like puzzle pieces.

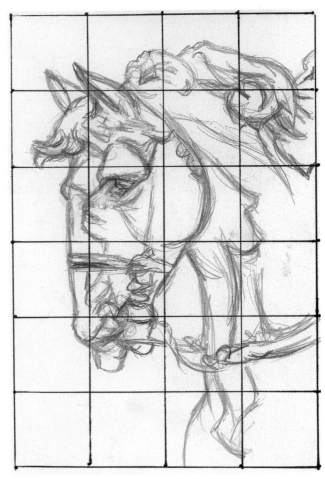

Accurate Line Drawing
Draw what you see in each square until you have captured the basic shapes of your subject. This is your accurate line drawing.

Segment Drawing

Another useful method for capturing shapes accurately is segment drawing. All you need to do for this is make a small viewfinder with some black paper or card stock. The window should be 2–4 inches (5cm–10cm). When placed over your reference photo, only a small portion of the image is revealed. By making the subject less recognizable in this manner, you will be able to see the shapes and patterns of light and dark more accurately.

A segment drawing is a good way to practice your drawing skills without investing in an entire project. By concentrating on just small studies, your drawing skills will grow and improve rapidly.

Viewfinders Aid Accuracy

A viewfinder placed over a photo will reveal a small portion of the subject. Drawing these small sections is a good way to develop your skills.

In this example, two L-shaped pieces of card stock were used to create the viewfinder window. There is also a grid of four equal squares drawn onto the photo to help with accuracy.

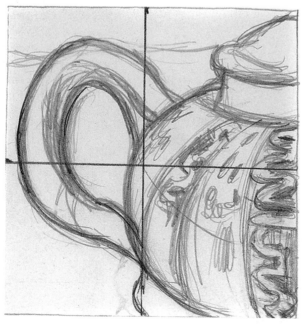

Drawing in Pieces

The viewfinder was used as a template to lightly draw boxes dividing the paper into four equal segments. The subject was then drawn in segments, focusing on the individual shapes in each box.

LEE'S LESSONS

Whether you use segment drawing, the grid method or are able to create an accurate line drawing freehand, you will discover that all subject matter is really just a puzzle of shapes and patterns of light and dark.

KEEP A SEGMENT DRAWING NOTEBOOK

It's a good idea to create a notebook devoted to just segment drawing. This will allow you to practice certain things that are problem areas for you without having to spend the time doing a large drawing. In addition, studying various subjects in a more abstract fashion will allow you to really hone in on small details and practice different approaches.

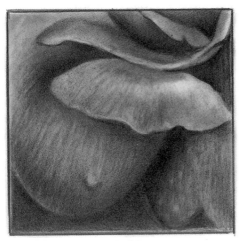

Segment Drawing of a Rose

Segment Drawing of a Seashell

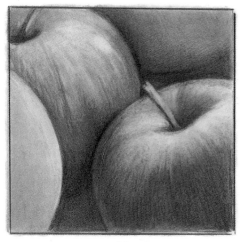

Segment Drawing of Apples

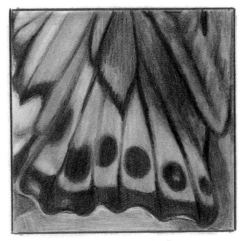

Segment Drawing of a Butterfly

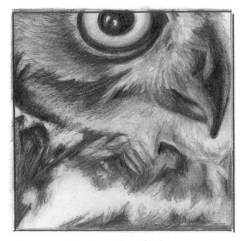

Segment Drawing of an Owl

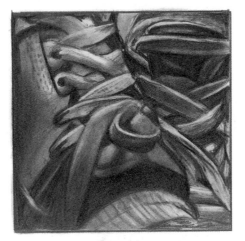

Segment Drawing of Tennis Shoes

LEE'S LESSONS

You may find that you like your segment drawings so much that you want to keep them. You can even redo them on a large scale to make beautiful, creative and frameable "realistic abstracts."

Draw Eggs

The egg is another basic shape commonly found in both nature and objects. Lighting and the five elements of shading apply to eggs the same way they do to spheres and cylinders. It's a good idea to try drawing a single egg first for practice. However, things really change when you draw them in groups because the overlapping edges complicate things. Follow the steps to draw multiple eggs together by using the grid method to help with accuracy of the shapes.

MATERIALS

drawing paper

kneaded eraser

mechanical graphite pencil

ruler

stump or tortillion

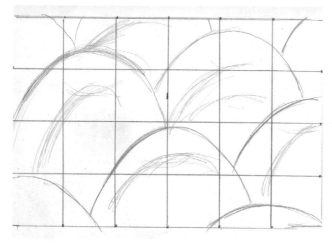

1 Create a Line Drawing
Use the grid method and a mechanical pencil to create a line drawing of a group of eggs.

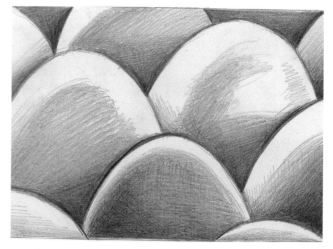

2 Add Tones
When you are sure of the accuracy, carefully remove the grid lines with a kneaded eraser. Analyze the edges where things overlap, and add the darkest tones with your pencil. The darkest places represent recessed areas where two or more surfaces overlap. (I call these areas "the Vs.") Fade your tones like a value scale as they progress towards the light.

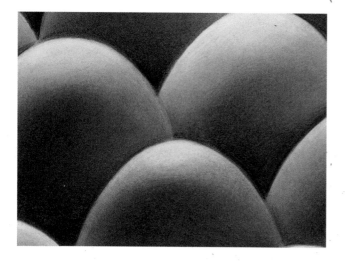

3 Blend
Blend the tones with your tortillion or stump. Use curved strokes like you did with the sphere exercise to create roundness, contours and form. Lift highlighted areas with a kneaded eraser.

It's important to note here that reflected light is rarely bright white. Except for the full light areas like the tops of the eggs, reflected light is subtle and gray in tone. Look at the edges of the eggs and notice how the reflected light gets darker as it travels down along the edges.

Draw Garlic

This garlic exercise will provide further practice for drawing a rounded object depicting the five elements of shading. This time, however, the surface is not perfectly smooth, so you'll need to add a little texture to create some dimension and make it look realistic. When drawing things with texture, it's important to create the form first. All texture is surface oriented, so it should be developed last.

MATERIALS

drawing paper

kneaded eraser

mechanical graphite pencil

ruler

stump or tortillion

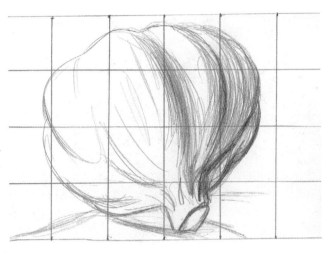

1 Create a Line Drawing
Use the grid method and a mechanical pencil to create a line drawing of garlic. Curve your pencil lines to develop the irregular contours and start the illusion of texture.

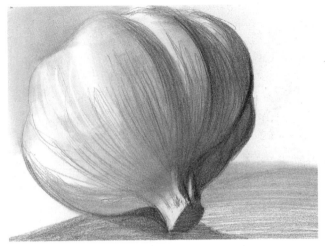

2 Apply Blending and Shading, Add Cast Shadows
When you are sure of the accuracy, carefully remove the grid lines with a kneaded eraser. Use blending to create the tones and the look of form. Place some shading into the background to help create the light edge on the top left of the garlic. Add the cast shadows below.

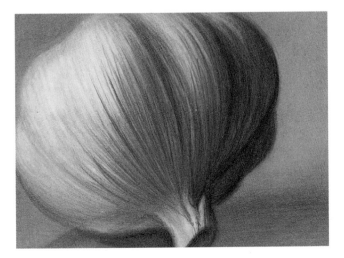

3 Continue Blending, Building Shadows and Adding Texture
Continue to blend the background to make it a gray tone. It should be lighter on the right. Deepen the cast shadow and blend everything smooth. Add texture to the garlic with curved, quick pencil lines. Create a razor edge on your kneaded eraser and "draw" the light back into the textured areas to make them look more realistic. (This is also known as lifting light or drawing in reverse.)

Perspective

When drawing buildings or other structures, it is important to learn the rules of perspective. Without these rules, the illusion of depth and distance will be lost. Perspective is a complicated mathematical process, and entire books have been dedicated to it. For architectural renderings and interior design, the elements of perspective must be exact. For general drawing, just the basics will suffice.

When we look at something, often the angular lines appear as optical illusions. Something may appear slanted upwards, when in reality it is going down. Or it may appear tilted, when it is actually straight. Knowing some perspective basics can help you see and draw things more realistically.

Now let's go over some basics of one-point and two-point perspective to help you draw structures more accurately. In one-point perspective all of the lines lead to one point on the horizontal horizon line. Two-point perspective occurs when the lines extend out to two different points on the horizon line.

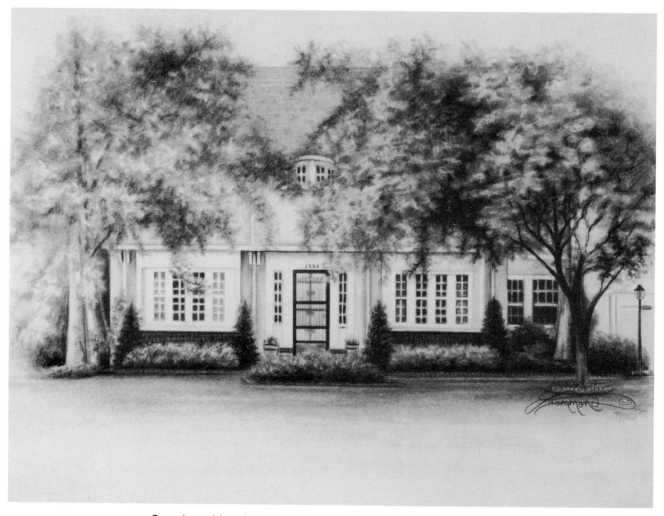

Straight-on View, No Perspective

Not all views will be seen at an angle. In this drawing of my childhood home, the house is viewed from a straight-on vantage point, so the look of distance and perspective is not present. This makes the horizontal lines straight across, and the vertical lines straight up and down. This angle is much easier to draw.

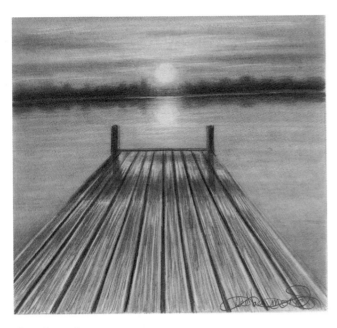

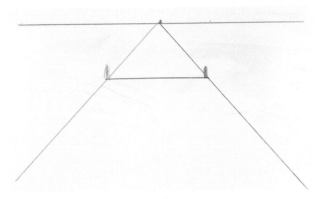

One-Point Perspective

Because of the perspective in this drawing, the front of the dock looks huge compared to the end, which looks much smaller. This is because the dock projects out into the distance. We know that if we viewed the dock from above, it would be the same size from beginning to end. But viewed like this, the shape becomes distorted and appears smaller the farther away it gets.

Horizon Line

The lake shore in the background is the horizon line. If you were to draw a line from each side of the dock, clear to the horizon line, they would meet at the same point in the middle. All of the boards of the dock follow the same angle to the horizon line.

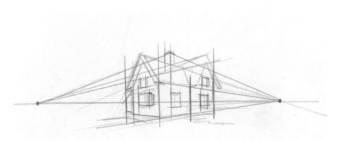

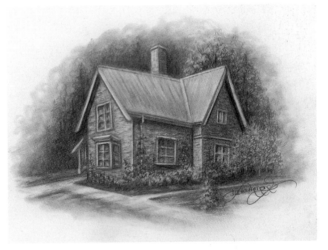

Two-Point Perspective

When viewing a structure from this angle, two different sides are visible. Look at how the lines of the roof angle differently in this drawing. One side goes off one way, and the other side goes a different way. The angles from each side of the house lead to different points on the horizon line.

When drawing structures like this, it is important that the vertical lines remain perfectly vertical and perpendicular to the ground. While things may appear slanted, especially in a reference photo, you should straighten everything up and make the edges perpendicular to your paper edge. This will give it a much more realistic appearance.

Keep Details in Perspective, Too

When you apply shading to render the drawing, the small details must be in perspective as well. All details within the structure, such as the windows, chimney and bricks, must also follow the perspective lines. Even when the shading is applied to create the illusion of bricks or shingles, they must follow the lines of perspective as well.

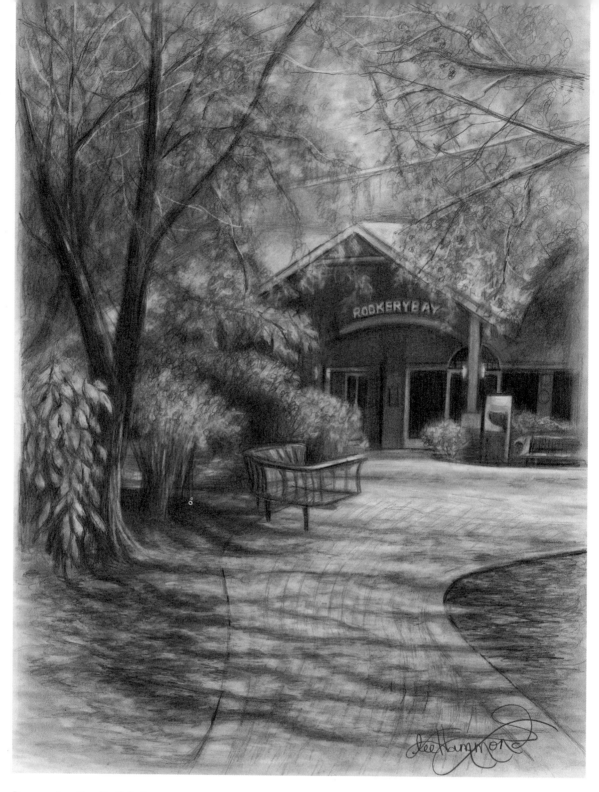

Perspective Can Be Subtle

In this drawing, not much of the building is actually showing. The trees and foliage block the view. But even if a structure is not completely visible, what does show must be in proper perspective.

The walkway is seen as one-point perspective where it appears larger at the beginning and slightly narrows as it recedes. The illusion of bricks follows the perspective and curves along with the shape.

The building is at an angle rather than a straight-on view. If you drew lines extending outward from the roof edge and all of the windows, they would meet way out on an imaginary horizon line off to the left.

Often we misjudge angles visually. When you draw, make a copy of your reference photo and use a ruler to draw lines extending outward from all of the edges. That way you can properly see the angles and where things would converge on a horizon line.

Draw in Two-Point Perspective

The roofline of this little wishing well is seen at an angle, making it a simple project to practice drawing in two-point perspective.

MATERIALS

drawing paper

kneaded eraser

mechanical graphite pencil

ruler

stump or tortillion

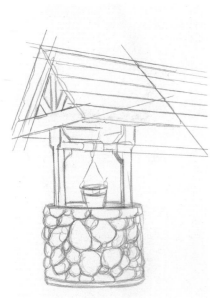

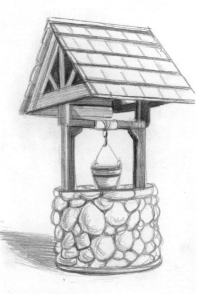

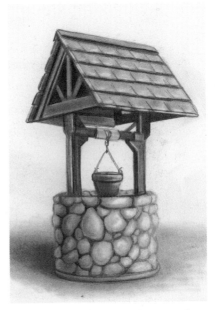

1 Draw the Angle Lines

Draw lines to represent the angles. This will help you create two-point perspective. I recommend making a copy of your reference photo and using a ruler to draw the lines directly on it in order to properly see the angles. You can erase them later with a kneaded eraser.

2 Apply the Darks

Once the angle lines have been removed, the perspective is revealed. To start the rendering, apply the darkest tones into the shadow areas first with your pencil. Make sure the stones follow the cylindrical shape of the well.

3 Blend and Apply Shadows and Highlights

Blend the drawing for realism. Always study your reference photo well to see where the light is coming from and where the highlights and shadows should be placed. Look for the patterns of light and dark.

Each stone is sphere-like. Apply shadow edges to make them look rounded and dimensional. Lift out highlights with a kneaded eraser to make their surfaces look shiny.

The shingles of the roof have distinct edges with reflected light along them. Lift the highlights with a kneaded eraser to make them look realistic as opposed to just empty and flat.

CHAPTER TWO
STILL LIFE

Understanding the basic shapes is very important when drawing any object. The effects of light and shadow on those shapes is what creates the form. If you learn how to apply the correct principles to drawing glass, shiny surfaces, metal and other textures, it will enhance the look of your still lifes.

Many will avoid complicated subjects like this, but complicated doesn't necessarily mean it's hard. It may be more time consuming, but the procedures are repetitive. Knowing that all things are drawn using the same principles makes it much easier. Even complex subjects can be mastered if you learn to see and draw everything as patterns of light and dark.

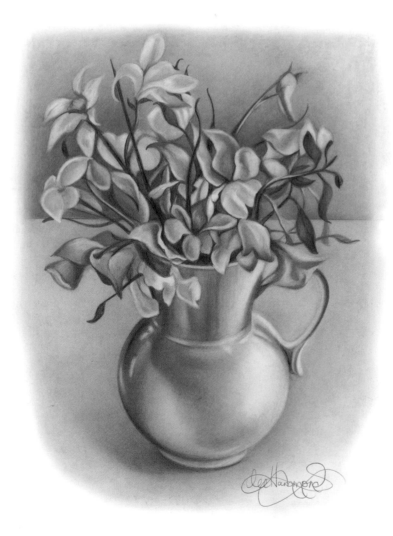

Pitcher with Water
Graphite on smooth bristol
10" × 8" (25cm × 20cm)

Shiny Surfaces

You have already learned how the five elements of shading help make subjects look three dimensional and how contrast is important to creating realistic forms. All of these same principles apply when drawing shiny surfaces, but the highlights are often more exaggerated. Shiny surfaces also require very smooth blending with no irregularities in the tones.

Study the drawing of the vase below, along with its close-up segments, to gain a better understanding of the role lighting and tone play in capturing shiny surfaces realistically.

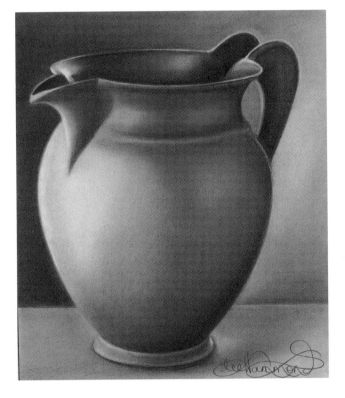

Contrasting Light and Shade Aid Realism

This vase is a good example of a shiny surface and the way the five elements of shading create form and dimension. What makes it look so believable is the even blending. The surface looks extremely smooth because there is no choppiness or division between the tones—they fade into one another seamlessly.

The lighting is also quite effective. The dark background on the left makes that side of the vase look illuminated. The lighter background on the right gives the shadow side more contrast. Reflected light helps the edges look real. Notice how it varies in its intensity. Some reflected light is bright, while in other areas it remains a subtle gray tone.

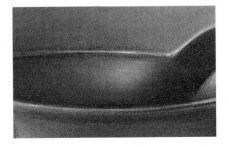

Reflected Light
Reflected light is always seen along the edges and rims of an object. This shows how it will vary in its intensity, from bright white in the highlight area to dull gray in the shadows.

Contrast
A dark edge is shown against a light background. These contrasts create the look of form and dimension.

Smooth Blending
Smooth blending is crucial for depicting a shiny surface. No irregularities or choppiness should show.

Draw a Shiny Vase

Follow the steps to draw a vase with a smooth, shiny surface.

MATERIALS

drawing paper

kneaded eraser

mechanical graphite pencil

stump or tortillion

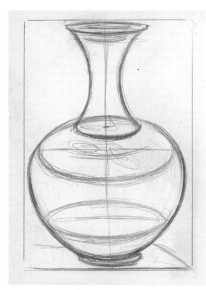

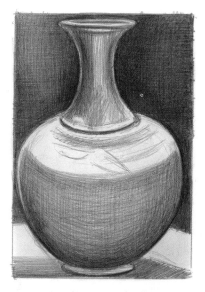

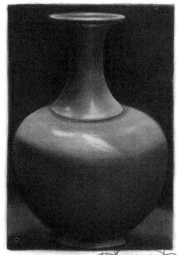

1 Draw the Form
Visualize the object in its entirety and then draw the form of the vase. Try to "see through" it by imagining you are seeing both the front and back of the vase. Draw ellipses around its width to capture the circumference. These curved lines will help convey the depth of the object.

2 Establish Lights and Darks
This is the "blocking in" stage. Establish areas of light and dark by carefully placing tones to help create the edges of the vase. The shadow edge where the vase curves is subtle but is still important to capture. Here, the light is strongest on the upper edges, so use tone in the background to help them stand out.

3 Blend and Add Highlights
Remember that shiny surfaces must look smooth and unblemished. Once you have established the areas of light and dark, blend the tones smooth to get a realistic look. (Keep the sphere exercise in mind as you work— those same critical principles apply here, too.)

As a final touch, add bright highlights on the vase to make it look very shiny. You can lift them out with a kneaded eraser.

Glass

There is often a lot of confusion when it comes to drawing glass and other transparent objects. How do you draw something that's clear? The answer lies in the way you look at the object. Even objects that you can see through have patterns of light and dark. It is the proper placement of these overlapping light and dark patterns that gives the illusion of transparency.

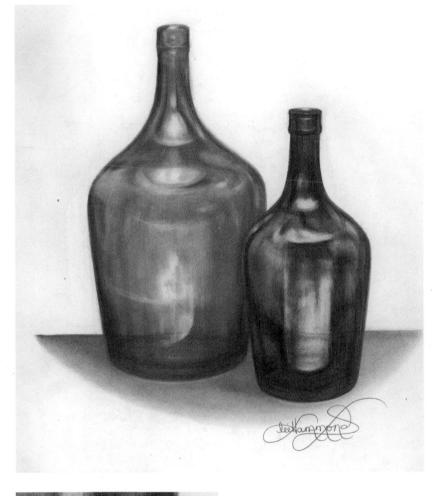

Highlights and Blending

These glass bottles are dark in color, but they are still transparent by nature. Highlights were lifted out to give the illusion the bottles are see-through. Both vertical and curved lifting and blending were used to create the contours of both sides. The highlights and shadows overlap each other. Some are curved horizontally to create the circumference of the bottles. Others are vertical to show light dancing off the outside surfaces.

Look closely and you will see that the edge of the table is visible through the bottles—this also enhances the transparent effect.

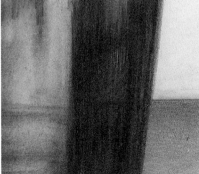

It's All in the Details
You can see the tabletop through the bottle here. This makes the look of transparency more obvious. Without that detail, the bottle could appear opaque.

Curved Highlights
Curved highlights help create the illusion of roundness and form.

Overlapping Highlights
Lifting highlights is always done last since they are on the surface. All form must be created with blending first. Overlapping horizontal highlights with vertical ones creates the illusion of depth and transparency.

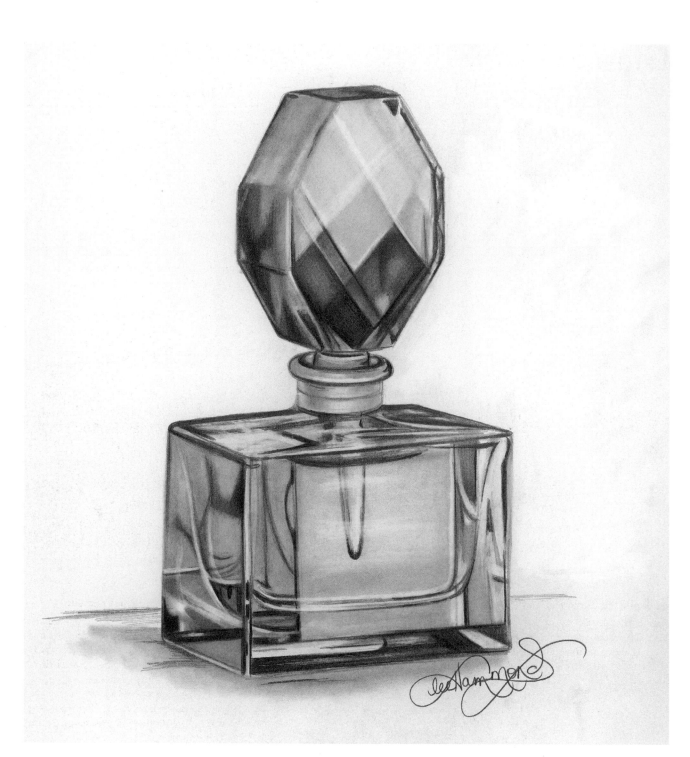

Distinct Light and Dark Patterns

Cut crystal creates patterns of light and dark that are very distinct. Study all of the geometric shapes seen in this perfume decanter. Notice the way the chiseled top reflects light along all of the straight edges. These raised edges are an example of how light is always found along the edges and rims of objects.

To make this look more transparent, the highlights were lifted out last, crossing over the shapes from the back. Clean geometric edges such as these should be drawn out with a mechanical click eraser, which will erase a more distinct area than a kneaded eraser would.

Draw a Marble

Marbles offer a good combination of roundness, form and transparency. The patterns of light and dark create the illusion of being able to see through them. The small bubbles in the glass help give it a look of realism.

Follow the steps to draw a marble.

MATERIALS

circle template or compass

drawing paper

kneaded eraser

mechanical graphite pencil

stump or tortillion

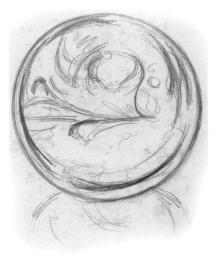

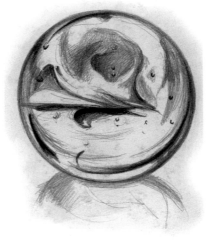

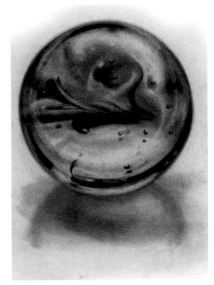

1 Draw the Circle Shape and Patterns

Start with a perfect circle. You can use a template, a compass, or draw around a glass. Add the patterns and bubble shapes seen within the marble using this example as a guide.

2 Darken the Patterns, Add Tone for Reflection

Begin darkening some of the patterns. (Remember, you always want to apply the darkest darks first.) Place some tone underneath the marble for the reflection. A transparent object does not cast a solid cast shadow, so make the tones irregular.

3 Blend the Surface and Lift Out Highlights

Blend the surface of the marble to give it a shiny appearance. Look at the contours and blend going along the curves. Think of the little bubbles as mini spheres—they have a cast shadow and a highlight. All of the highlights should be lifted out last. This will make it look like they are on the outer surface of the marble.

Metal

Drawing metal is similar to drawing glass because metal is also made up of patterns of light and dark. However, metal has one very distinctive characteristic—its reflective, mirrorlike surface will always create exaggerated contrasts of extremely light and extremely dark areas. The reflected light and shadow edges appear very extreme, while the halftone is hardly seen at all.

Study the drawing of the pitcher below. You will see the extremes with very few areas of gray in between. Notice the way the edges of the pitcher change according to the tones of the background.

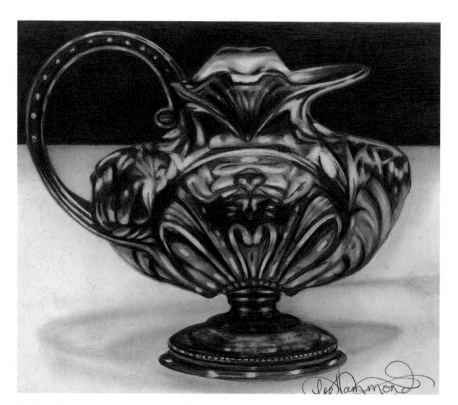

Interlocking Light and Dark Shapes Lend Contrast

Metallic objects have extreme contrast due to their reflective nature. If you isolate an area, you can see all of the small geometric shapes that go together to create the illusion of the pitcher's surface. This is a very good example of how everything can be seen as a puzzle of interlocking light and dark shapes.

Geometric Patterns
Everything can be seen as geometric patterns much like that of a puzzle.

Light Edges Against a Dark Background
This dark background helps illuminate the object's light edges.

Dark Edges Against a Light Background
Likewise, placing dark edges against a light background can help create the shape and define form.

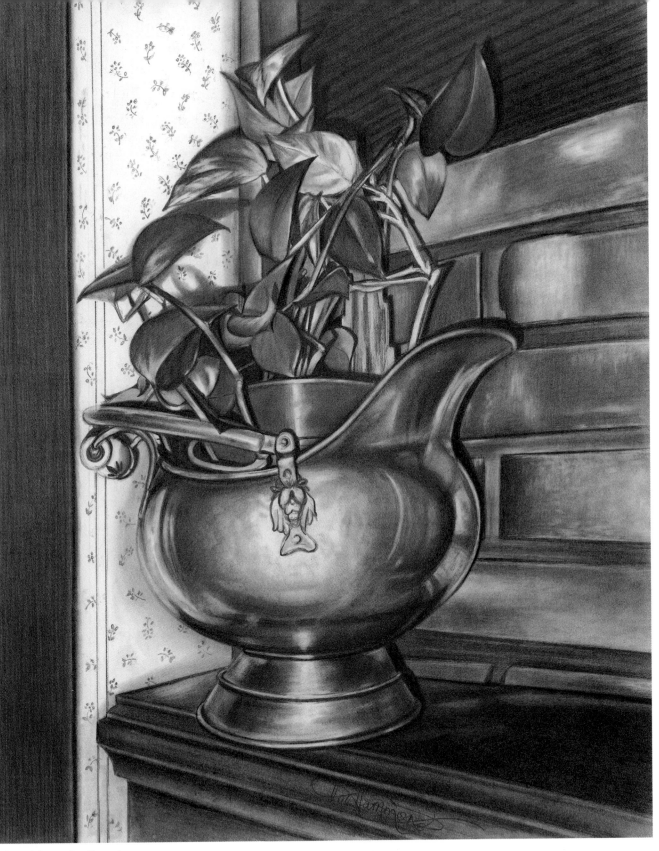

Simplifying the Complex

All things can be looked at as patterns of light and dark. The most complex subject matter can still be simplified using this method. Even the leaves in this drawing are made up of light and dark patterns.

Also note how the mirrorlike surface of the brass reflects everything around it. You can see the shapes of the bricks within the shine although they appear distorted due to the curved contours.

Draw Silverware

This exercise will give you practice drawing darkly when needed and using extreme contrast to help create shapes and the illusion of shine.

Follow the steps to draw silverware.

MATERIALS

drawing paper

kneaded eraser

mechanical graphite pencil

ruler

stump or tortillion

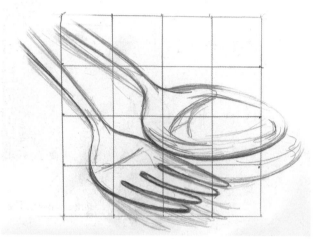

1 Create a Line Drawing
Use the grid method and a mechanical pencil to create a line drawing of a fork and spoon.

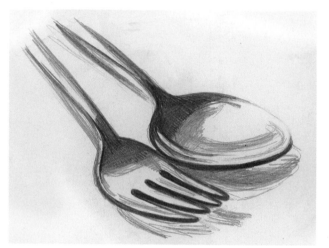

2 Block in the Light and Dark Patterns
When you are sure of your accuracy, carefully remove the grid lines with a kneaded eraser. Block in the patterns of light and dark with your pencil. Pay attention to the edges. Some are light and some are dark. Do not outline everything.

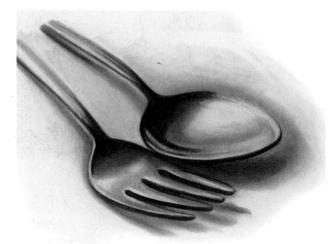

3 Blend, Shade and Add Shadows
Use blending to smooth the tones and create the look of shine. Use some background shading to help create the edges along the top of the spoon. Use shadowing to make them look like they are raised above the table's surface.

Textures

Textures are not as complicated as they look. They are done using the same methods and procedures we've been using so far. Don't overthink it. Remember, most of drawing is just an illusion. The effects of light and shadow can completely alter the way a subject looks—especially when it comes to textured objects.

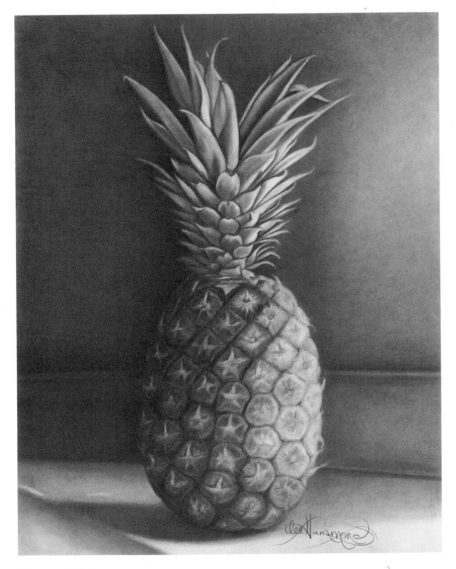

Extreme Lighting
The extreme lighting in this drawing of a pineapple is critical. It makes each area of the fruit appear different from the next. The lighting conditions give it distinct light and dark sides.

Dark Over Light
In this view the raised medallions of the pineapple appear as geometric patterns. The inner section of each medallion here is dark over light in the center. The light appears very bright against the dark background.

Light Over Dark
Here the centers appear light over dark. The dark edge of the lower portion shows up against the light in the background. As it moves up into the darker background it almost fades into the dark. This is what is called a "lost edge."

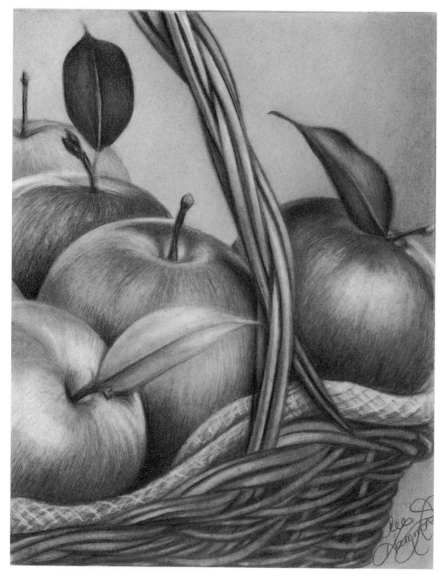

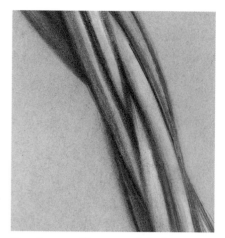

Overlapping Shapes and the Five Elements of Shading

The handle of this wicker basket is an example of overlapping shapes and the importance of the five elements of shading on a cylindrical shape. Notice how dark the tones are in the Vs. This makes them look extremely recessed.

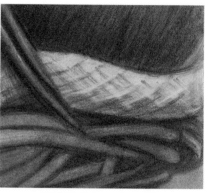

Extreme Texture and Smooth Detail

Some drawings will be a combination of extreme textures and smooth details. You can see how important it is to practice drawing them all. This drawing combines a multitude of drawing challenges, which made it a fun piece to draw. Try placing a grid over this and practicing its many elements.

Blending and Lifting

This fabric is created by blending first, then lifting the light out on top. Using a kneaded eraser as a drawing tool helps create the illusion of woven fabric.

LEE'S LESSONS

Hopefully by now you can see how repetitive the drawing process really is. Regardless of the subject matter, it is always approached the same way. Drawing realistically always consists of three things:

1. Capturing the shapes
2. Analyzing and replicating the light and shadows
3. Blending the tones and lifting the highlights

The number of times you have to repeat these steps may vary, but the process itself remains the same.

DEMONSTRATION
Draw Wood

Textures and shadows are what make a drawing interesting to look at. It is the accurate rendering of everyday details that begs us to look at realistic artwork.

This door handle shown below is an ordinary object, but it makes for an interesting drawing. It is not as difficult to render as it may appear. Like everything else, wood is an illusion we create. It is made up of pencil lines, blending and the lifting of light.

Follow the steps to learn how easy drawing wood grain actually is.

MATERIALS

drawing paper

kneaded eraser

mechanical graphite pencil

stump or tortillion

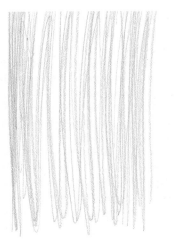

1 Lay Down Vertical Strokes
Wood grain is mostly made up of pencil lines. Get the illusion started with some vertical pencil strokes.

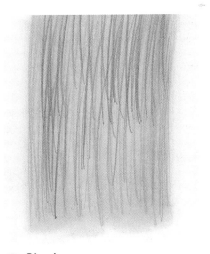

2 Blend
Blend the entire area to a gray tone. This removes the white of the paper. If you do not blend, it will appear as if you were looking through it to the white of the paper. It would look unfinished.

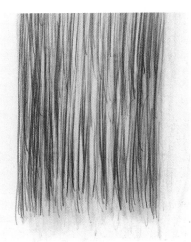

3 Deepen and Lift
Deepen the darkness of the vertical lines to make them stand out more. Lift white vertical lines out with a kneaded eraser. Lifting the lights last will help make it look like the light is outside of the surface, not showing through it.

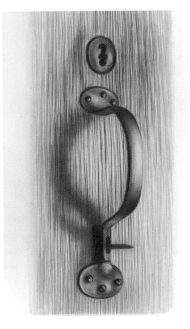

Soft Diffused Shadows Help Create the Look of Wood

Look at the area of the door handle's cast shadow. It is blended out, making the edges of the shadow appear soft and diffused. Shadows should not look hard edged or too solid. The highlights cannot be too white here either. They are a gray tone because they are in a shadow area.

Draw a Sea Shell

It's fun to create unusual shapes and textures. The unique shapes and raised surface textures of sea shells make them perfect drawing practice pieces.

Follow the steps to draw a sea shell.

MATERIALS

drawing paper

kneaded eraser

mechanical graphite pencil

ruler

stump or tortillion

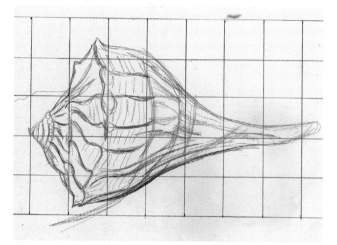

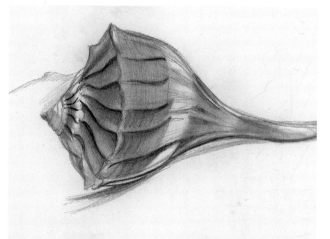

1 Create a Line Drawing

Use the grid method and a mechanical pencil to create a line drawing of a shell. The patterns of the shell are very important, so be as accurate as possible.

2 Add Patterns and Begin Blending

When you are sure of your accuracy, carefully remove the grid lines with a kneaded eraser. Start to create the patterns with your pencil. Begin with the dark areas first. Blend the shaded areas before you start too much detail. This helps create the contours and form.

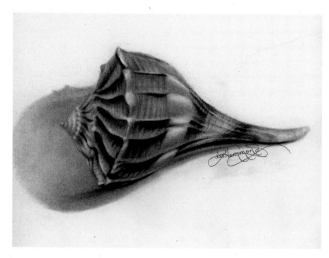

3 Add Texture and Details

Once the drawing is blended, apply the texture and pattern details with a pencil. The direction of your pencil lines is very important when creating the illusion of texture. Once the dark areas are done, use a kneaded eraser to create all of the raised edges. This will give the shell a realistic look.

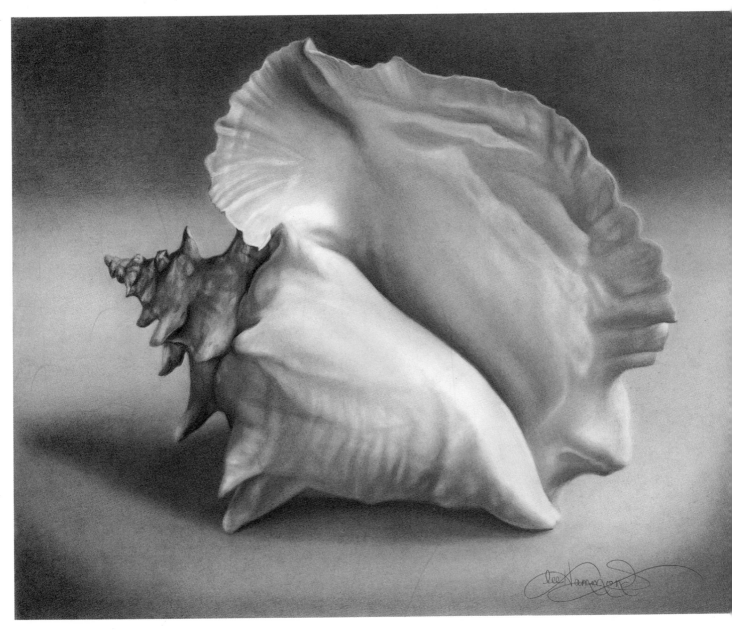

Texture Can Be Subtle

Here is an example of how realistic a graphite drawing can appear. The smooth blending, realistic edges and proper use of light and dark make the drawing appear three dimensional.

Texture can be very subtle. If you compare this drawing to the demonstration example, you can see it is not nearly as extreme in its appearance. The smooth, even finish, however, still has texture that is important. In this case, a kneaded eraser was very important for lifting the highlights and slightly raised areas.

You can also see how important a smooth blend is for creating shaded backgrounds.

LEE'S LESSONS

Texture is surface oriented. It is very important to create the shape and the form of your object *before* you start the texture. Any texture or detail that is on the outside layer of your object must be added last.

CHAPTER THREE
NATURE

Drawing nature is a challenge, but you can produce beautiful images with graphite. Many artists reserve nature studies for color only, using paint or pastel to capture them instead of regular pencil. In the second half of this book I will show you how to capture nature with colored pencil. However, a graphite study in black and white can be every bit as beautiful.

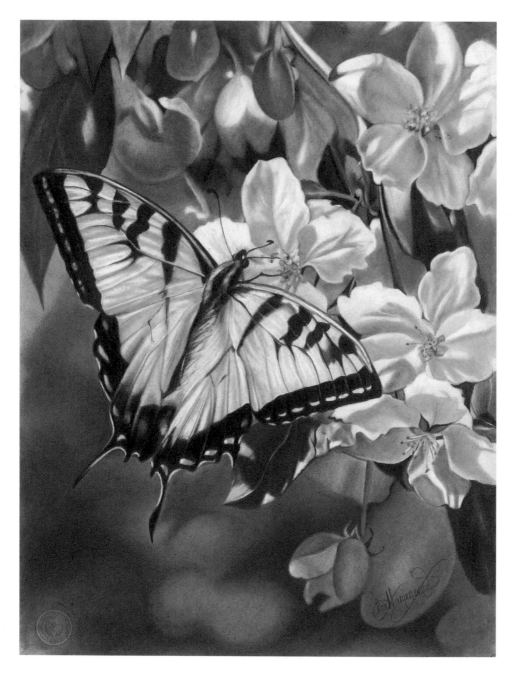

Monarch with Flowers
Graphite on smooth bristol
10" × 8" (25cm × 20cm)

Backgrounds

When drawing nature, it's best to work from back to front. In nature everything overlaps, so it is easiest to complete the background first. Human nature wants us to dive in and draw the recognizable objects right away, but nothing looks worse than drawing the things in the foreground first and then trying to create a background around them. (For more detailed instruction, you can refer to both my book and my DVD titled *Draw Animals in Nature*.)

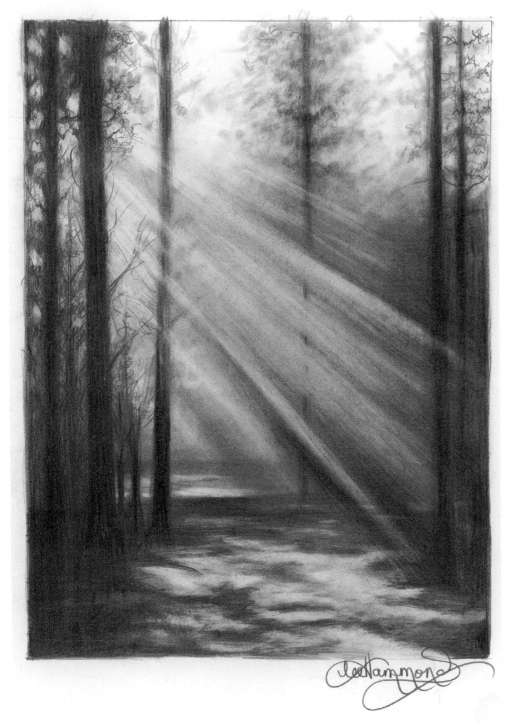

Soft Background, Sharp Foreground

The subject matter in front looks in focus, and the back looks blurry with less detail. Look at the trees in the distance compared to the ones that are closer. Because they are farther away, they appear softer and lighter in tone. Many of them were drawn with the tortillion instead of the pencil to make them look out of focus. A kneaded eraser was used to create the illusion of the sun rays. The highlights seen on the ground were also lifted out with a kneaded eraser. After everything else was complete, I streaked across the drawing with the eraser.

Skies & Water

Drawing skies and water with graphite can be a fun challenge. You can easily create believable looking clouds using the bending and lifting techniques shown in the previous exercises. Likewise, the sparkle of water can be created by lifting out with a kneaded eraser using horizontal strokes. This proves that any subject can be captured with graphite using the same drawing principles.

A Good Value Scale Is Crucial

It is important to know how to create a gradual blend like this to create nature drawings that include skies. A good value scale is crucial. The sky is made up of smooth tones. A choppy blend will ruin the illusion. Practice drawing value scales often to master control over your tools and application.

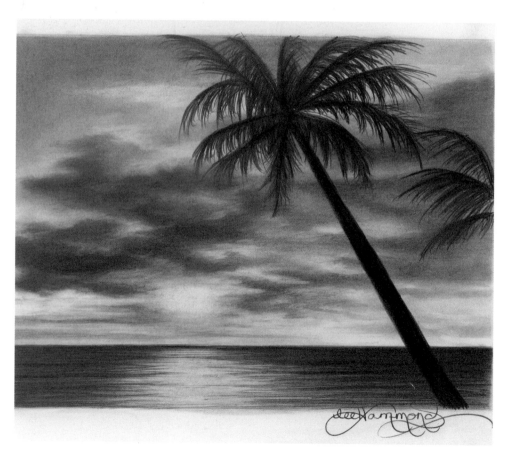

Blending and Lifting Are Key for Creating Clouds and Reflections

All subject matter is drawn using the same repetitive techniques. Blending and lifting are the key techniques for creating beautiful clouds and water reflections.

The palm tree appears as a silhouette against a light sky. Since the sun is behind the tree, no highlights would be seen on the side facing us.

Draw a Tree on the Beach

Basic shapes can be seen in everything we draw. The cylinder can be seen in many objects, even in nature. Without knowing how to accurately depict the five elements of shading on a cylinder, you will not be able to make a realistic looking tree.

Follow the steps to draw a tree in a beach scene.

MATERIALS

drawing paper

kneaded eraser

mechanical graphite pencil

stump or tortillion

1 Create a Line Drawing
Create a line drawing of a tree. Use multiple cylinder shapes to make up the branches. You can freehand this; it doesn't have to be exact.

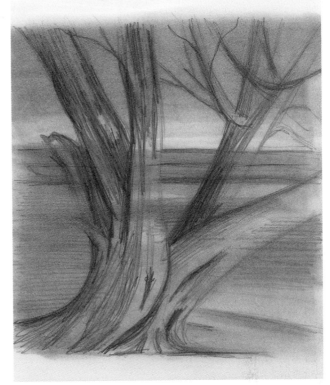

2 Blend the Background and Add Darks
Start blending in the background before you begin detailing the tree. Since the tree overlaps everything else, blend the background tones first. You can see that the blending goes right through the tree.

Start adding the dark areas of the tree with loose pencil strokes. This establishes the patterns of highlights and shadows and begins the look of texture.

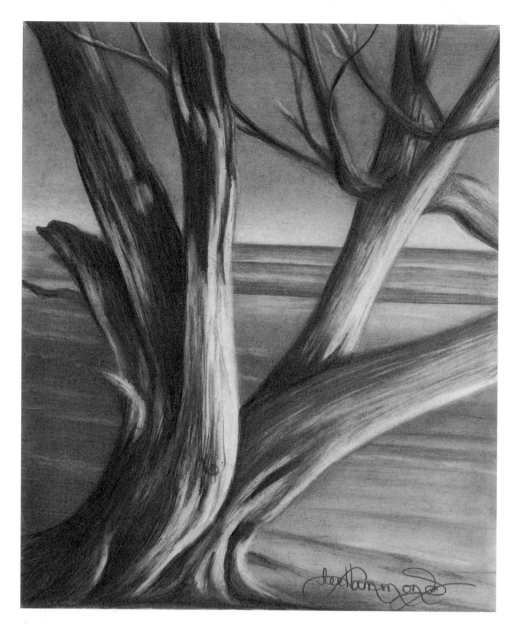

3 Build the Shadows

Build up the dark shadow areas of the tree. Blend the first layer to a gray tone. Then continue with loose pencil strokes to deepen the tones and build up the look of texture. The illusion of tree bark is now created.

With a kneaded eraser, lift out the bright highlight areas. You can also use a stick eraser to draw in bright white and clean edges.

At this stage you can still modify the background. If you do, be sure to blend into the tree again and then redo the tree. You do not ever want your background to look like it comes up and stops when it reaches the subject. You do not want a light halo showing either. This would make the background appear as if it is next to the tree. By blending through the tree, the background appears to be behind it.

Basic Shapes and Patterns Create the Illusion of Texture

These examples show how important the cylinder is for creating trees. The only real difference between these two drawings is how the texture alters the way the lights and darks appear on the surface. Patterns of light and dark were added with quick pencil strokes and quick lifting to create the illusion of textured bark.

Flowers & Foliage

It is not necessary for something to be in full color for it to be artistically impressive. Graphite is a wonderful medium for learning the value scales associated with different types of subject matter. Beautiful flowers and leaves can be drawn in graphite. While many automatically use color for flowers, a black-and-white study can be very impressive. The drawing procedure is always the same, even when drawing flowers. It consists of:

1. Creating an accurate line drawing

2. Adding the dark patterns

3. Blending

4. Lifting highlights and deepening dark areas

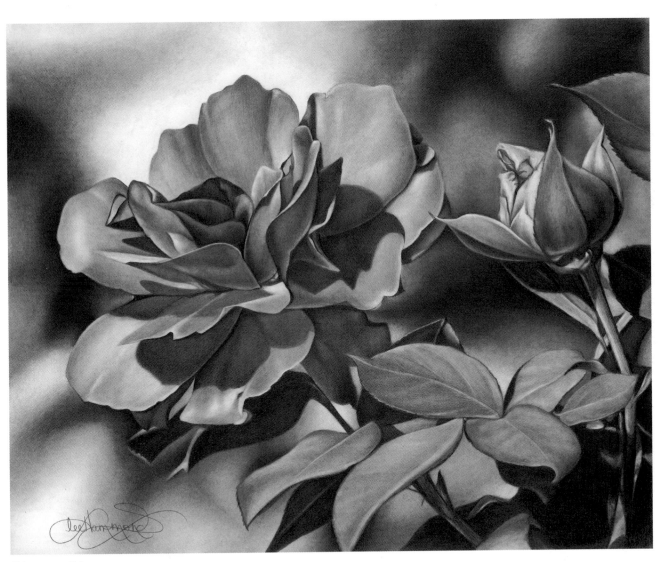

Observing Edges

This is a great example of how important edges are when drawing subjects with overlapping shapes. Notice how each edge of every leaf and flower petal has been carefully rendered. Without addressing these very important edges, the realism would be lost.

Look at all of the edges and you can see how they switch from dark over light in some areas to light over dark in others. It takes close observation of your reference and a slow approach to make it look real.

SHADOW EFFECTS

The Old Masters used to say that they didn't draw a subject—they drew the effects of light and shadows on a subject. That is how I now view everything I do. The more shadows a subject has, the more compelled I am to draw it.

However, you must be careful to not overdo shadows. Refrain from the temptation of just filling them in solidly. Instead, look *into* a shadow. The surface of the object must still be seen. Remember that a shadow is nothing more than lack of light on a subject. It is not a separate object. If you fill it in with a solid tone, it will look like something separate sitting on top of the subject. Always look through the shadow to the small details within it.

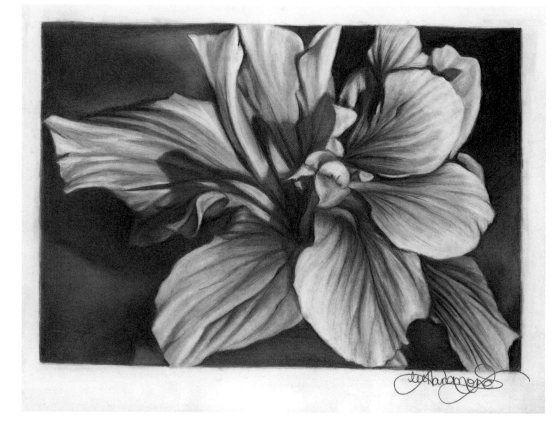

Shadows Lend Contrast
Study the effects of light and shadows on everything you draw. The edges of this hibiscus have been carefully rendered, and the shadows give it a lot of contrast.

Create Surface Texture with Pencil Lines
The subtle texture surface of an object must be included to make it look real. These were created using pencil lines and lifting with the kneaded eraser. The texture and the uneven surface of the flower petals are evident.

Look Into the Shadow
Always look *into* a shadow for the surface details within it.

Draw a Leaf

Leaves are not flat. In fact, they are full of light and shadows. Their subtle curves and contours are fun to draw.

Follow the steps to draw a leaf.

MATERIALS

drawing paper

kneaded eraser

mechanical graphite pencil

ruler

stick eraser

stump or tortillion

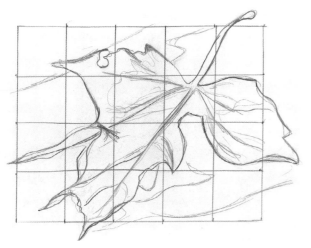

1 Create a Line Drawing
Use the grid method and a mechanical pencil to create a line drawing of a leaf.

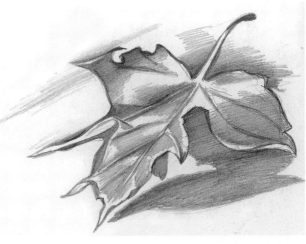

2 Apply the Dark Patterns
When you are sure of your accuracy, carefully remove the grid lines with a kneaded eraser. Apply the dark patterns with a pencil. These are on the leaf and in the shadow areas underneath. Make sure to leave the small white veins of the leaf exposed. This is very important to the character of the drawing.

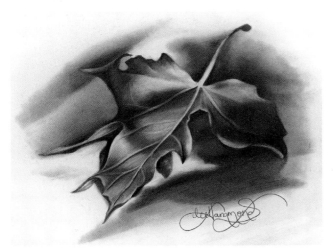

3 Blend and Lift
Blend the tones smooth with a tortillion or stump. Reapply the dark areas and blend them some more. Repeat this process until they match the darkness of the example shown here.

Draw light back into the veins with a stick eraser. Make them stand out by creating a cast shadow underneath. This will make them appear as if they are protruding.

Lift highlights off the surface of the leaf with a kneaded eraser.

Blend the cast shadows and background to finish the drawing.

DEMONSTRATION
Draw a Rose

This project will give you good practice drawing edges. Study the finished example closely as you work so you can see the shift in tones as it fades from dark to light. As you work, look for light-over-dark areas and dark-over-light areas.

Every flower is unique. This one differs from the previous examples. It has subtle texture that the flowers in the other drawings did not have. Its surface has a crepe-like appearance with visible yet subtle veining.

Follow the steps to create a rose.

MATERIALS

drawing paper

kneaded eraser

mechanical graphite pencil

ruler

stump or tortillion

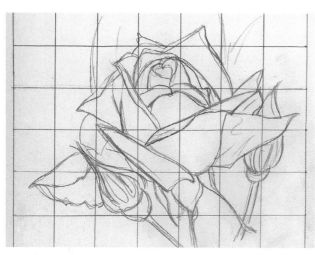

1 Create a Line Drawing
Use the grid method and a mechanical pencil to create a line drawing of a rose.

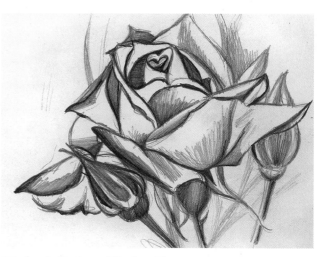

2 Apply Darks and Surface Texture
When you are sure of your accuracy, carefully remove the grid lines with a kneaded eraser. Apply the dark areas with a pencil. Use your pencil line direction to help create the crepe-like surface texture of the rose.

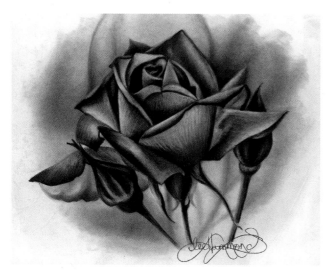

3 Blend
Blend the tones smooth with a stump or tortillion. Reapply the darker areas, allowing the pencil lines to add to the texture of the rose petals. Then use a dirty stump to blend the tones in the background. This gives it an out-of-focus look and gives the drawing the illusion of depth.

Draw a Butterfly with Flowers

Not all drawings need to have detailed backgrounds to make them look pretty. This is a fun drawing of a tiger swallowtail butterfly that looks good against plain white. While not as complicated as the previous piece, this is a good practice drawing for creating butterflies.

Follow the steps to draw a butterfly with flowers.

MATERIALS

drawing paper

kneaded eraser

mechanical graphite pencil

ruler

stump or tortillion

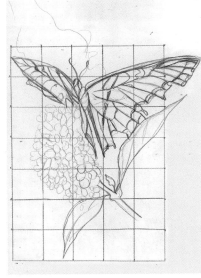

1 Create a Line Drawing
Use the grid method and a mechanical pencil to create a line drawing of a butterfly. The patterns of a butterfly's wings are very important, so be as accurate as possible.

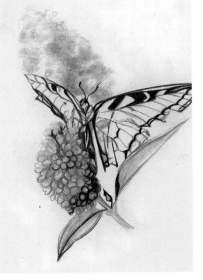

2 Apply Tones
When you are sure of your accuracy, carefully remove the grid lines with a kneaded eraser. Begin applying tones with your pencil to capture the patterns of the butterfly's wings. Apply the darkest areas first.

The lilacs are done two ways: The ones in the back are out of focus. To create them, use circular pencil strokes and circular blending. This gives the drawing depth.

The lilac in the front is more in focus. Use dark tones to make it look recessed in the darker areas. Blend the lighter areas so they do not appear bright white.

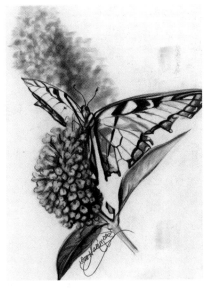

3 Deepen the Tones and Draw the Leaf
Deepen the tones throughout the drawing to make it look crisper. Use a kneaded eraser to lift highlights out of the lilacs, both in back and in front.

Create the leaves with blended tones and by lifting highlights. Be sure to include the veins.

CHAPTER FOUR
ANIMALS

Animal drawing is one of my favorite subjects to teach. My animal-drawing classes are very popular, and the subject attracts many artists. I think the subject matter appeals to so many because it presents an opportunity to really capture the personality and soul of the animal you are drawing.

The pressure to produce an exact likeness is not as important when drawing animals as it might be when drawing people—where all of the features must be perfect to capture their likeness. With animals, there is a little more leeway to relax and let your artistic license take over.

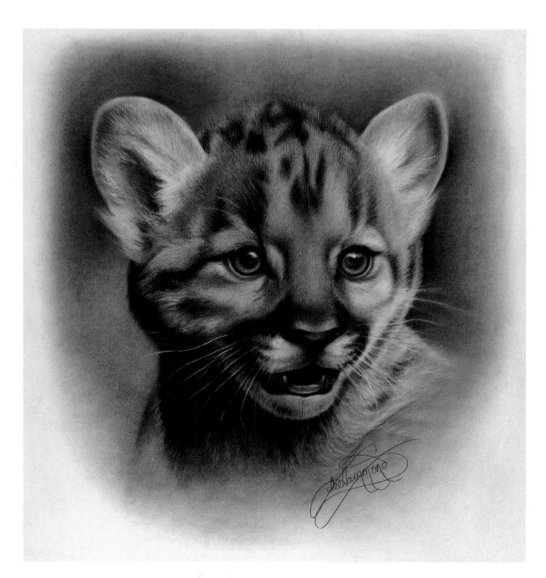

Panther Kitten
Graphite on smooth bristol
10" × 8" (25cm × 20cm)

Fur

Realistic animal drawing means learning to draw all different types of animal fur. In the animal kingdom you will see short, long, curly, striped and spotted hair. Often there will be more than one type of fur on a single subject. Drawing fur may appear difficult at first, but like any other subject matter, fur can be drawn using the same simple procedures we used before.

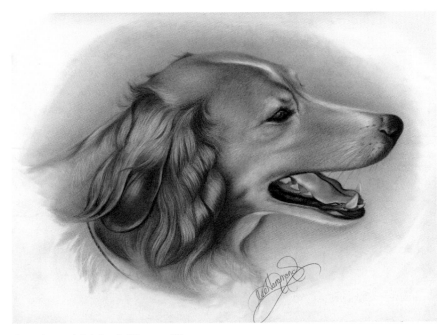

One Animal, Multiple Types of Fur
You will often see more than one type of fur on a single animal.

Short Hair
This area shows very short hair. After the area was blended, very small pencil lines were layered on top to give it texture. Remember, the length of the fur is depicted by the length of the pencil stroke. These need to be extremely short, quick strokes, or the fur will appear too long. A kneaded eraser was also used for highlighting. Just like with the pencil, quick, short strokes make the fur appear textured. This process of adding dark and lifting light is repeated over and over to make it look real.

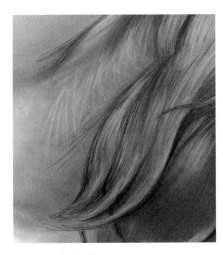

Long Straight Hair
The length of the pencil lines in this area tells us the hair is long and straight. A kneaded eraser was used to lift out the highlights after the drawing was blended.

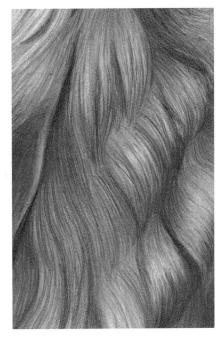

Long Wavy Hair
This area shows long wavy hair. This time the long pencil strokes curve, giving the fur a wavy look. You can see how each curl has an area of highlight where it protrudes.

Draw Fur

When drawing fur of any kind, it is the pencil strokes that determine how long the hair will appear. And it is the amount of pressure you apply to the pencil that dictates the color of the fur. When the fur has a pattern to it, draw the patterns in like puzzle-piece shapes first.

Follow the steps to draw short and long fur.

MATERIALS

drawing paper

kneaded eraser

mechanical graphite pencil

stump or tortillion

SHORT FUR

1 Apply the Fur Patterns
Apply the patterns of the fur first.

2 Fill in the Darks and Blend
Fill in the dark patterns with a pencil. This fur is short, so use short, quick strokes to fill them in. Blend the tones out into the white areas with a stump or tortillion to remove the white of the paper.

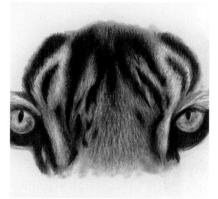

3 Continue Building Texture and Lift out Highlights
Continue building the texture of the fur with quick, short pencil strokes. Use a point on your kneaded eraser to lift out the lighter hairs with quick strokes to make it look furry. The light areas and dark areas must overlap and work into each other. Making the dark areas too solid and hard edged would make it look cartoonlike.

LONG FUR

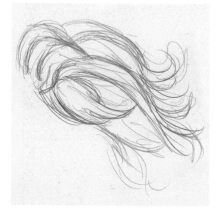

1 Lay Down Pencil Strokes
Long fur and hair is described by the pencil strokes. Make long and curved pencil strokes to create the look of waves.

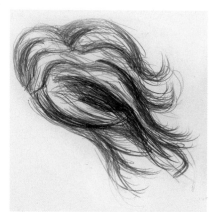

2 Apply Light and Dark Patterns
Always build the dark areas first. These are the underlayers of the fur. Use long, curved pencil strokes to create the patterns of light and dark.

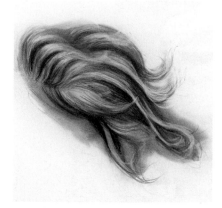

3 Blend and Lift Highlights
Blend everything out with a stump or tortillion. Lift the highlight areas using a kneaded eraser. Add more pencil strokes to help the tones appear integrated and give texture.

Features

You must learn the facial features of different animals before you attempt to draw the whole thing. Each animal species has different characteristics to look for. No two will ever be alike. Study your reference photos for the unique traits that each particular animal possesses.

Creating segment drawings will give you practice drawing different types of animal features. I recommend taking each of these drawings and reproducing them for practice work.

Black Isn't Black
This drawing is a good example of drawing dark. I always say, "Black isn't black, and white isn't white." Even though this gorilla has black fur, the highlights make it various shades of dark gray, not solid black.

White Isn't White
This is an example of "white isn't white." The white fur of this kitten is affected by the shadows, so it is created with various shades of gray.

Experiment with Unusual Subject Matter
Always use a segment drawing for experimenting with unusual subject matter. The more you do, the more proficient you will become with your drawing skills.

Practice Texture on a Small Scale
Segment drawings are good for practicing things you've never drawn before. The textures of this goat's horn are easy to practice on a small scale like this.

DEMONSTRATION

Draw Animal Eyes

The eyes are the most important aspect of drawing any living animal. Through the eyes, we connect with the soul of the subject and feel the personality behind them.

Follow the steps to draw a couple different types of animal eyes. You will see unique differences between them, but notice that the drawing procedure is exactly the same for both.

MATERIALS

drawing paper

kneaded eraser

mechanical graphite pencil

ruler

stump or tortillion

HORSE

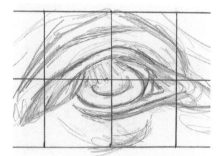

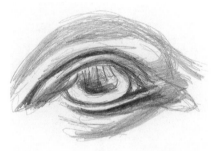

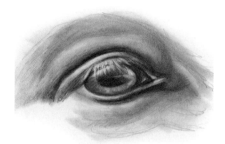

1 Create a Line Drawing
Use the grid method and a mechanical pencil to create a line drawing of a horse's eye. Notice how the pupil is not round, but it is a horizontal ellipse.

2 Apply Dark Tones
When you are sure of your accuracy, carefully remove the grid lines with a kneaded eraser. Add the darkest tones with a pencil.

3 Blend, Deepen the Darks and Lift out the Lights
Blend the drawing with a stump or tortillion to remove the white of the paper. Deepen the dark areas with your pencil. Then lift light areas out with a kneaded eraser.

TURTLE

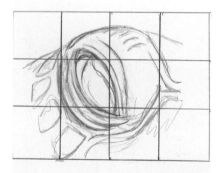

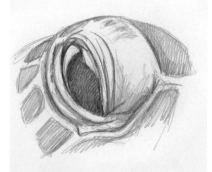

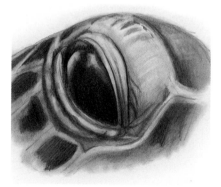

1 Create a Line Drawing
Use the grid method and a mechanical pencil to create a line drawing of a sea turtle's eye.

2 Apply Light and Dark Patterns
When you are sure of your accuracy, carefully remove the grid lines with a kneaded eraser. Apply the patterns of light and dark with a pencil. The pupil of the eye is always the darkest part of the drawing.

3 Blend, Deepen the Darks and Lift out the Lights
Blend the drawing with a stump or tortillion to remove the white of the paper. Deepen the dark areas with a pencil and then lift light areas out with a kneaded eraser.

Draw Animal Noses & Mouths

While drawing an animal's nose and mouth may not be something you would choose for a project, it is still important to practice drawing them if you want to be able to draw all animal species.

These two exercises will give you some practice drawing unusual mouth-nose combinations. While no two are alike, the process for drawing them is always the same. (Note: When drawing nostrils of any kind, you will always see some reflected light around the rim.)

Follow the steps to draw different types of animal noses and mouths.

MATERIALS

drawing paper

kneaded eraser

mechanical graphite pencil

ruler

stick eraser (optional)

stump or tortillion

CAT

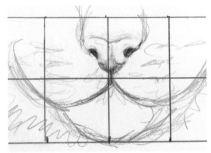

1 Create a Line Drawing
Use the grid method and a mechanical pencil to create a line drawing of a cat's nose and mouth.

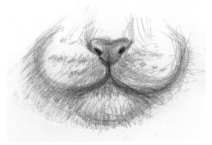

2 Apply the Darks
When you are sure of your accuracy, carefully remove the grid lines with a kneaded eraser. Apply the darkest areas with a pencil. Create a furry look with short, quick pencil strokes. Always go with the direction that the fur is growing.

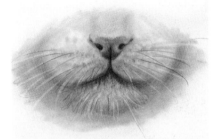

3 Blend and Lift
Blend to remove the white of the paper. Add more quick pencil strokes for the fur and whiskers. Use a pointed kneaded eraser to lift the white hairs and whiskers. (You can also use a stick eraser, using quick strokes.) If the area you lift out looks too wide, narrow it by coming in on each side lightly with a pencil.

PIG

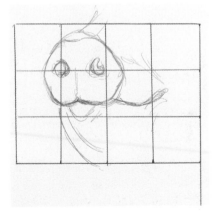

1 Create a Line Drawing
Use the grid method and a mechanical pencil to create a line drawing of a pig nose and mouth.

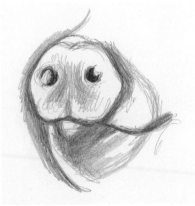

2 Apply the Darks
When you are sure of your accuracy, carefully remove the grid lines with a kneaded eraser. Apply the darkest areas with a pencil. This is a not a furry animal in the face. Use your blending skills to create the form.

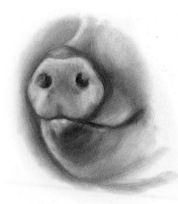

3 Blend and Lift
Blend to remove the white of the paper. Use a kneaded eraser to lift the highlight areas.

Draw a Kitten

Now that you've gotten some practice drawing animal features, let's try a whole portrait.

The kitten's tilted head makes this piece appear more emotional than just a straight-on shot would. Poses like this can make your artwork have more impact on the viewer.

Follow the steps to draw a cute little kitten.

MATERIALS

drawing paper

kneaded eraser

mechanical graphite pencil

ruler

stump or tortillion

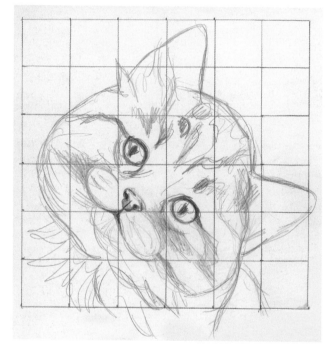

1 Create a Line Drawing

Use the grid method and a mechanical pencil to create a line drawing of a kitten. Be sure to pay close attention to the shapes and how they appear in each box. This is important to creating the right tilt to the head. The grid will help you maintain the angles.

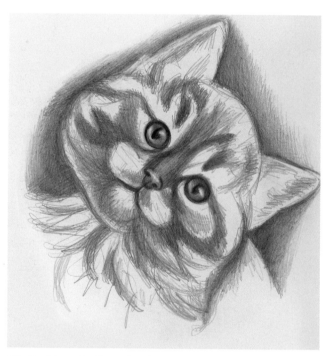

2 Build up the Eyes, Apply the Darks and Blend the Background

When you are sure of your accuracy, carefully remove the grid lines with a kneaded eraser. Build up the eyes. This will help you connect with your subject right away. Notice that the pupils are not circles. They are elongated vertically.

Apply the darkest areas of the fur with a pencil. Lay in the patterns. Create the look of fur with short, quick pencil strokes. Always go with the direction that the fur is growing.

Begin blending the background into an oval shape. This is called a vignette. It gives the drawing a finished look, acting almost like matting in the way it frames the image.

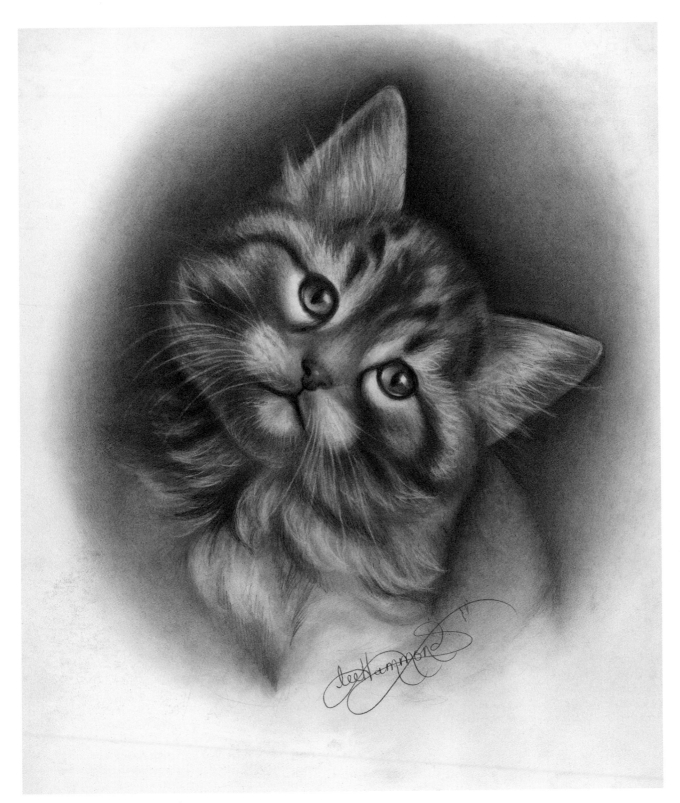

3 Continue Blending and Lifting
Blend the drawing with the stump or tortillion to remove the white of the paper. Deepen the darkest areas with a pencil and then lift light areas out with a kneaded eraser. Go back and forth doing these two processes until the fluff of the fur is created.

Continue to build and deepen the background, making sure to blend it very smooth with the stump.

Draw a Dog

Now use the same procedures you've been practicing to draw a dog. While the subjects are totally different, the drawing procedure is very much the same. The only difference is the length of the fur.

This drawing will be time consuming. The fur is very thick, so it will take multiple layers of adding darks and lifting lights to build it up. (Even the white patch on her chest is made up of many layers.) Before you begin, make sure you have the time and patience necessary to create volume and depth in the fur required for this drawing.

Follow the steps to draw my beloved pet, Penny the Wonderdog.

MATERIALS

drawing paper

kneaded eraser

mechanical graphite pencil

ruler

stick eraser

stump or tortillion

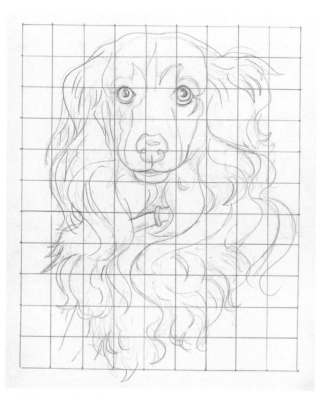

1 Create a Line Drawing
Use the grid method and a mechanical pencil to create a line drawing of a dog. Take your time and study the shapes seen within each square.

2 Build up the Eye and Apply the Darks
When you are sure of your accuracy, carefully remove the grid lines with a kneaded eraser. Start building up the eye to capture the dog's expression and connect with her personality. Unlike the kitten, here the pupils are round.

Apply the darkest areas of the fur with a pencil to show depth and overlap. Create wavy fur with long, curved pencil strokes. Always go with the direction that the fur is growing.

The hair on top of the head is very short. Blend this area first to get rid of the white of the paper. Then apply short, quick strokes on top of it. Leave the muzzle white for now.

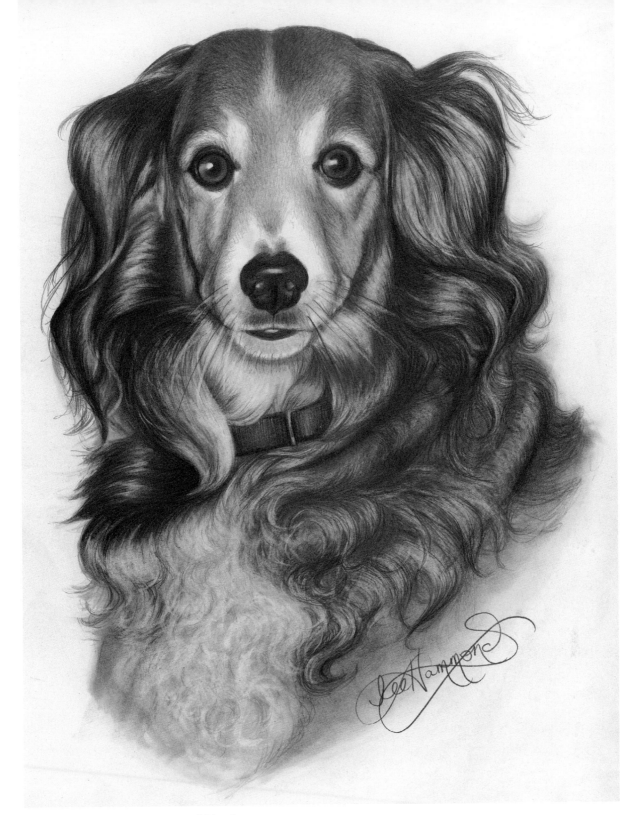

3 Continue Building Layers and Blending

Blend the entire drawing to remove the white of the paper. Then add more pencil strokes for the curls and waves.

Use a pointed kneaded eraser to lift the highlights from each curl and wavy area. This gives the curls dimension.

Use a pencil and kneaded eraser to create the whiskers. Make some light and some dark. If the area you lift looks too wide, narrow it by coming in on each side lightly with a pencil.

Heavily blend the white patch on the chest to make it a mid gray. Use a stick eraser to create the curved lines in this area. (It can be used in the darker areas as well, but because of the contrast, the lines may appear too contrived.) Use a kneaded eraser for more subtle highlights.

Draw a Horse

This horse exercise will give you practice drawing an animal with very sleek fur. Other than the mane, very little fur texture shows here. It is more about blending the tones smooth to show off the contours of the muscles and anatomy. The blending is the most important factor in this piece. The five elements of shading should be constantly referred to. Study the gentle contours and shadows of the horse's anatomy. Horses are very muscular, which creates many rounded and raised surfaces, resembling the sphere.

Follow the steps to draw a horse.

MATERIALS

drawing paper

kneaded eraser

mechanical graphite pencil

ruler

stump or tortillion

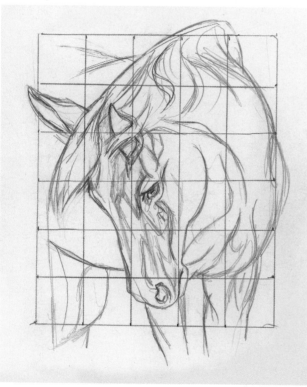

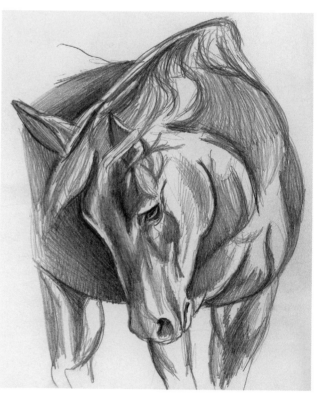

1 Create a Line Drawing
Use the grid method and a mechanical pencil to create a line drawing of a horse. Take your time and study the shapes seen within each square.

2 Apply the Darks and Build up the Contours
When you are sure of your accuracy, carefully remove the grid lines with a kneaded eraser. Apply the darkest areas with a pencil. Follow the same curves and contours you would if you were drawing a sphere. Capture the five elements of shading. This creates the facial structure, the muscles and the overall anatomy.

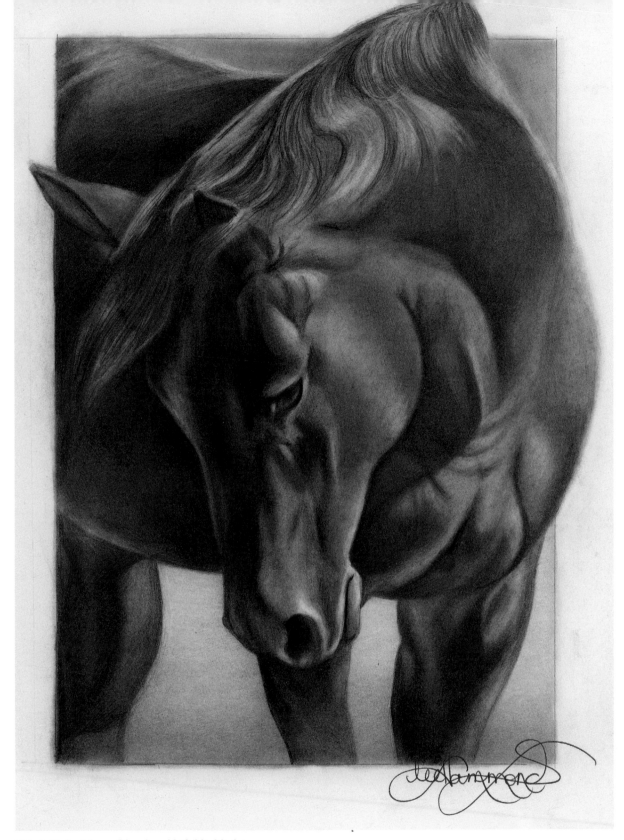

3 Add the Mane, Blend and Lift Highlights

Blend the entire drawing to remove the white of the paper.

Use a kneaded eraser to lift the highlights from the areas that protrude the most. This will give the horse dimension and create the rounded muscular form.

Create the mane using the same fur and hair procedure covered in the previous exercises.

There are endless approaches to adding backgrounds to a drawing. There really is no right or wrong. I suggest you experiment with different looks. To give this drawing an interesting look, I added a border box. It would also look good with a finished background showing nature around the horse.

Birds

Many of my students love birds but are hesitant to draw them, fearing they are too difficult. The thought of drawing each feather seems daunting. When drawing a bird close-up, it is important to make the feathers believable. Birds have definite feather placement. The number of feathers and pattern details vary according to species. If you want to get them to look right, the features must be accurate to nature.

But in all honesty, feathers are not any more difficult to draw than anything else. It all comes down to good observation and using the same drawing procedures as we've used before.

Overlapping Shapes

This African Gray parrot is a great example of drawing feathers. Each feather is like its own project. If you look closely though, you will see that they look very much like the flower petals we addressed earlier. The overlapping shapes create the Vs of darkness and they have reflected light along each edge.

The feathers on the head are not nearly as distinct and separate as the others. Creating feathers resembles the technique used for creating fur.

You can see how repetitious the drawing procedure is.

SEGMENT STUDIES

Study each of the segments and you will see how different the feathers of the owl all appear. Each requires a different approach to make it look real.

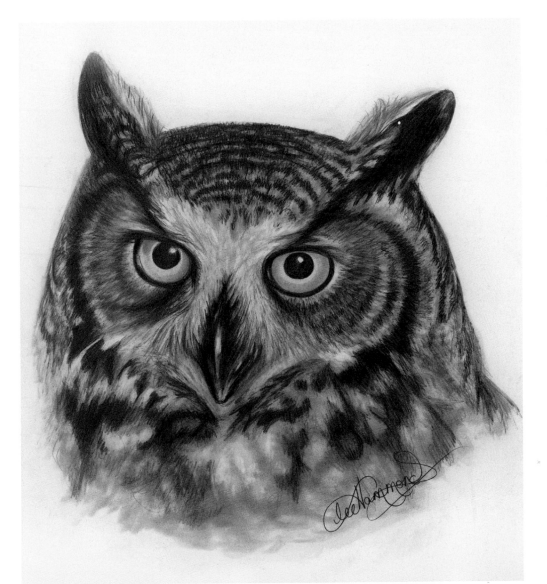

One Subject, Various Feather Types
The study of this owl shows how different feathers can look. Each area of this owl has a different appearance. The varying feather types need to be addressed differently to produce a particular look.

Short Vertical Pencil Strokes
This area is made up of short, quick vertical pencil strokes. They appear to go in rows across the head.

Long Pencil Strokes with Lifting and Blending
This area looks like more like fur than feathers. It is created using longer pencil strokes and a lot of lifting with an eraser after it has been blended.

No Definite Shapes or Edges
This area looks less detailed altogether. It is mostly made up of blending and lifting, with no definite shapes or edges.

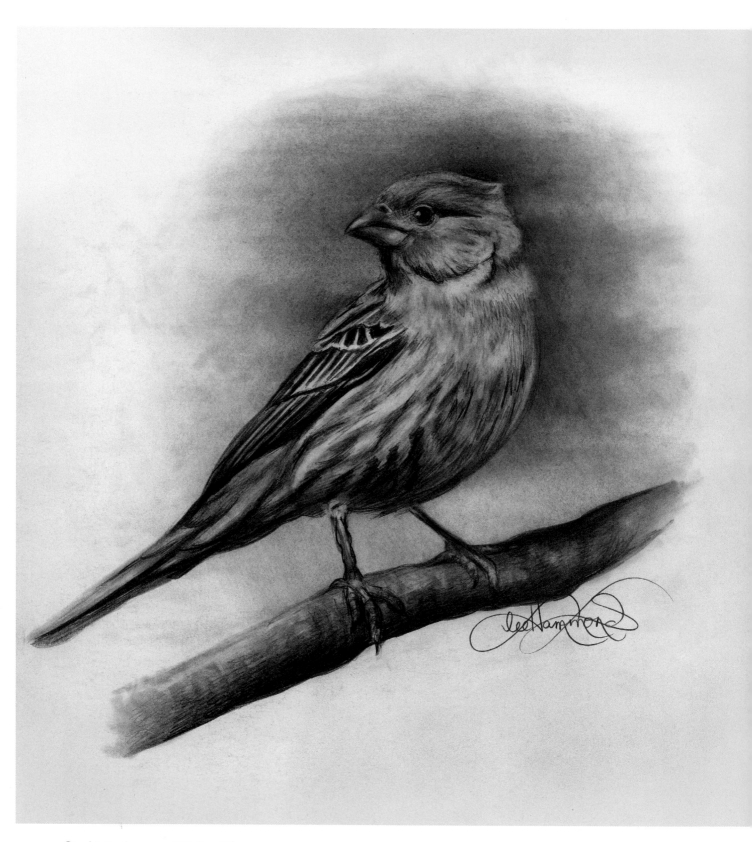

Combining Loose and Defined Shapes

This drawing combines very defined shapes (look at the wings) and looser shapes (look at the chest). It also utilizes the basic cylinder shape in the tree limb. Everything shown here can be drawn using the methods covered in this book.

Draw Feathers

A segment drawing is the perfect way to practice drawing unusual subject matter.

Follow the steps to practice drawing feathers in segments.

MATERIALS

drawing paper

kneaded eraser

mechanical graphite pencil

ruler

stump or tortillion

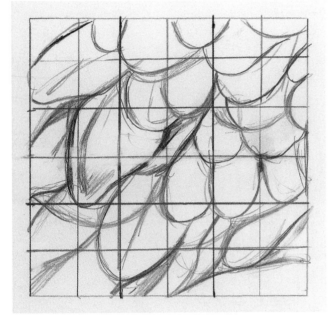

1 Create a Line Drawing
Use the grid method and a mechanical pencil to create a line drawing of a parrot's feathers. It's OK to make the boxes smaller (½ inch [13mm]) because of the complex shapes. This will help you be more accurate.

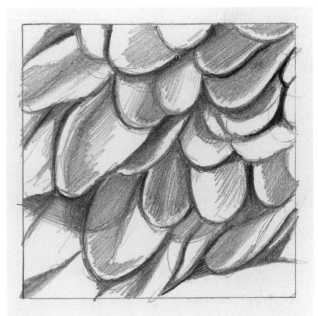

2 Apply the Darks and Shadow Shapes
When you are sure of your accuracy, carefully remove the grid lines with a kneaded eraser. Create the look of overlapping shapes by applying the dark tones with your pencil. Notice the V shapes where things recede the most. Apply the shadow shapes, being sure to leave the edge of reflected light along each feather.

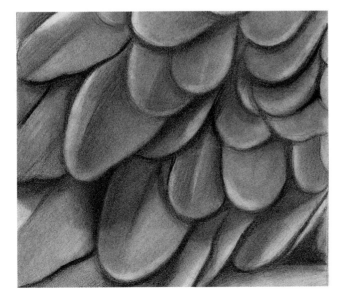

3 Blend, Deepen Shadows and Lift out Highlights
Blend out the tones with a stump or tortillion to remove the white of the paper. Deepen the shadows and blend them smooth. Use a kneaded eraser to lift the highlights and reflected light.

Draw a Crane

There are many different species in the bird kingdom and each is unique. This blue heron has a very distinct shape and it makes a pretty drawing.

Follow the steps to draw this beautiful water crane.

MATERIALS

drawing paper

kneaded eraser

mechanical graphite pencil

ruler

stump or tortillion

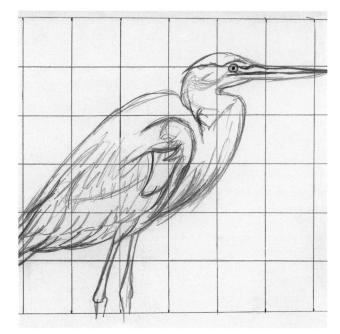

1 Create a Line Drawing
Use the grid method and a mechanical pencil to create a line drawing of a blue heron.

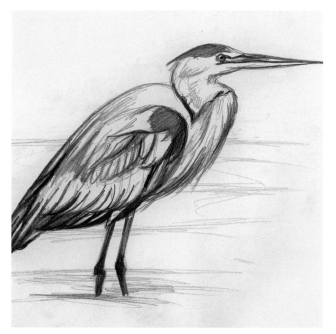

2 Apply the Darks and Establish the Shapes
When you are sure of your accuracy, carefully remove the grid lines with a kneaded eraser. Apply the darkest areas with a pencil. Establish the shapes of the feathers and darken the tones of the top of the head and the legs. The feathers on the chest and along the back are created like you would drawing hair or fur. Use long, quick strokes with the pencil.

Add a few horizontal lines in the background to help create the illusion of distance. You can also use lines to create the look of the water reflections.

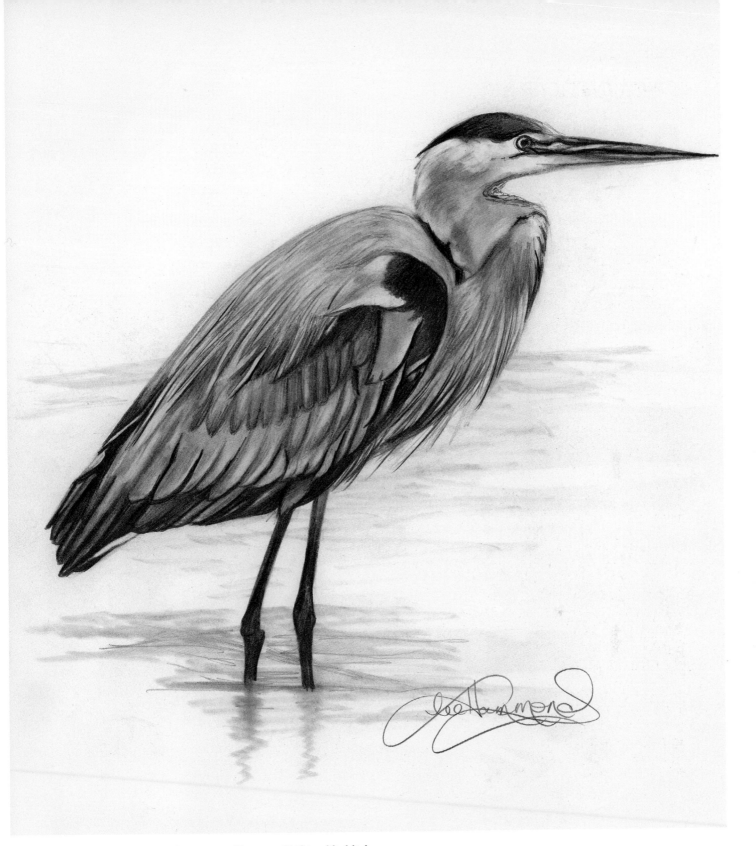

3 Continue Blending, Deepening Tones and Lifting Highlights

Blend out the entire drawing with a stump or tortillion to remove the white of the paper. Reapply the darkest areas with a pencil, making sure to follow the shapes and direction of each feather. Use a kneaded eraser to lift out highlights and reflected light along the edges of the feathers. Use horizontal pencil strokes and blending to create the illusion of water. The legs should create a mirror image below the bird.

CHAPTER FIVE
PEOPLE

As popular as animal drawing is, portrait drawing remains my most popular class. It is a subject I have written many books on. This is an area where you must be exact. There is no room for error when drawing a person's face. The slightest inaccuracy will distort the likeness. You may end up with something that looks similar to the person, but in realistic portrait drawing, similar is not good enough.

You will find more involved instruction in my book *Drawing Lifelike Portraits from Photographs,* as well as my DVD of the same name. However, this chapter will cover the basics of what makes a good portrait. I will show you everything you'll need to draw people realistically—from facial features and extremities to a fully finished portrait.

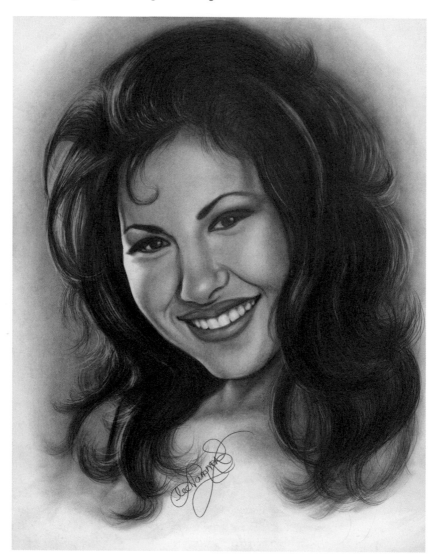

Selina Quintanilla Perez
Graphite on smooth bristol
11" × 14" (28cm × 36cm)

Facial Features

Before you can draw an entire face, you must first learn to draw each of the facial features individually. Only by taking one feature at a time can you learn the anatomy well and understand what to look for and capture in your drawing.

If you analyze the drawing of Selina, you will see why I reference the sphere exercise so much when teaching drawing. Every aspect of the face contains the five elements of shading and the rounded essence seen in a sphere.

Below, the different areas of the face show where the sphere is very obvious within its shape and form. Remember: The five elements of shading will always be seen in everything you draw.

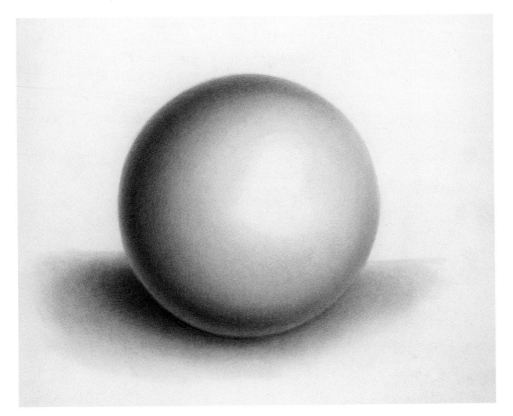

The Sphere Is a Recurring Shape
The sphere is seen repeatedly in the human face. It is visible in all rounded and curved surfaces, especially the cheeks, nose and chin.

The Nose
The nose closely resembles a sphere. It is actually made up of three distinct spheres—each nostril and the ball of the nose.

The Chin
The chin also resembles a sphere. You can see the reflected light along the edge and the cast shadow on the neck.

The Cheek
The sphere is seen in all rounded areas of the cheek. The five elements of shading are clearly visible.

AGING FEATURES

When drawing portraits, the features will change with age. The younger the subject, the fewer small details there are. The older the age, the more small details there are to capture. The two drawings below showcase the difference.

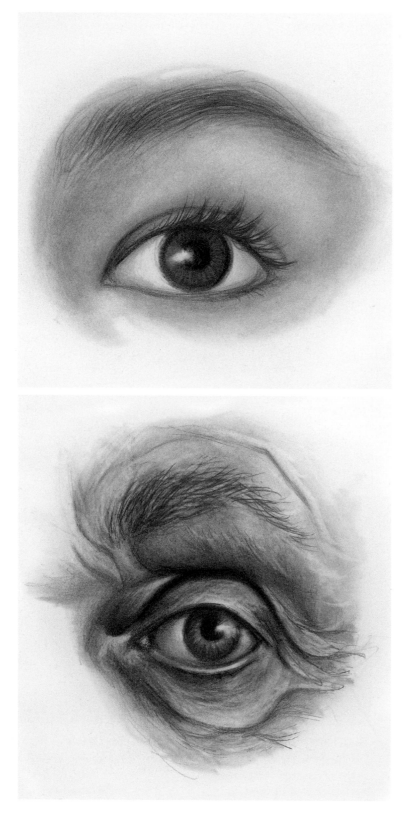

Young Eye

A young eye has very smooth features. The lashes are more apparent, but the details within the iris are harder to see. The eyebrows are softer, so the pencil lines creating them must be more delicate.

Old Eye

A very old eye is full of small details. The eye is more sunken into the face, so the bone structure is more obvious. The wrinkles are very important to capture, but they must be done carefully. Resist using too harsh of a line. The eyebrows are much more coarse, and the hairs are thicker and longer than those of a child.

Draw Noses

The nose is the least complicated feature and most closely resembles the sphere exercise. The five elements of shading are easy to see.

It is important to learn to draw the facial features in different poses. These straight-on and profile views of the nose will give you ample practice.

Follow the steps to draw a nose in both straight-on and profile views.

MATERIALS

drawing paper

kneaded eraser

mechanical graphite pencil

ruler

stump or tortillion

STRAIGHT-ON VIEW

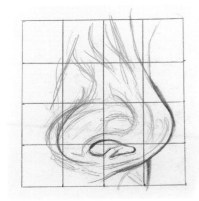

1 Create a Line Drawing
Use the grid method and a mechanical pencil to create a line drawing of a nose in a straight-on view.

2 Develop the Lights and Darks
When you are sure of your accuracy, carefully remove the grid lines with a kneaded eraser. Develop the patterns of light and dark with a pencil. Be sure to refer to the sphere. Add reflected light along the edges of the nose and the rim of the nostril. Add a shadow edge under the tip of the nose to makes it look rounded. Place cast shadows under the bottom edge of the nose.

3 Blend
Blend the tones smooth with a stump or tortillion. Very little of the drawing should be left white. Many artists will leave skin tones too light, but only the highlights should be as white as the paper. Be sure to blend out from the dark areas into the lighter face area, just like you did in the sphere exercise. This makes it appear real.

PROFILE VIEW

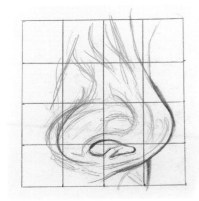

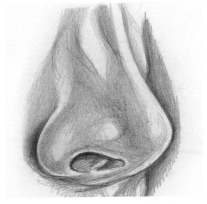

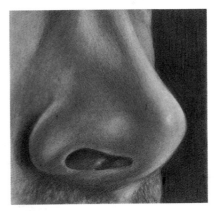

1 Create a Line Drawing
Use the grid method and a mechanical pencil to create a line drawing of a nose from a side view.

2 Develop the Lights and Darks
When you are sure of your accuracy, carefully remove the grid lines with a kneaded eraser. Develop the patterns of light and dark with a pencil. Be sure to refer to the sphere.

3 Blend
Blend the tones smooth with a stump or tortillion. Use the dark tones behind the nose to make the edges stand out. Lighting is crucial. The dark background makes this example look very different from the previous one.

Draw Lips

Drawing a mouth can be a challenge. Many beginning artists outline them too much. But it is only when the lips are defined by makeup that the edges are very distinct.

When studying the mouth, you will notice that the upper lip is usually smaller and will appear darker than the bottom lip. It creates an M shape.

Follow the steps to draw lips.

MATERIALS

drawing paper

kneaded eraser

mechanical graphite pencil

ruler

stump or tortillion

MALE AND FEMALE LIPS

There are differences between male and female lips. Female lips are much more defined and seem fuller and shinier. The edges of male lips are more subtle and are described by the shadows around them more than the edges themselves.

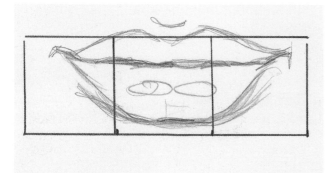

1 Create a Line Drawing
Use the grid method and a mechanical pencil to create a line drawing of female lips.

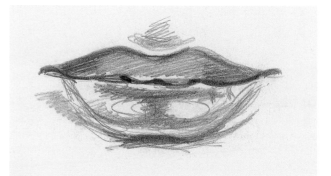

2 Apply the Dark Patterns
When you are sure of your accuracy, carefully remove the grid lines with a kneaded eraser. Apply the dark patterns of the lips with a pencil. Make the upper lip darker than the bottom one. This is because the upper lip angles in, and the bottom lip angles out.

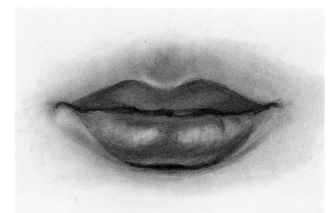

3 Blend Tones and Lift Highlights
Blend the tones smooth with a tortillion. Be sure to create the tones of the skin around the lips to make them look realistic. Use a kneaded eraser to lift the bright highlights of the lower lip to make them look moist and shiny.

LEE'S LESSONS

Learn the anatomy of the mouth by drawing as many mouths as you can in different positions and expressions. I used magazines as a learning tool, drawing all of the features on every page. Repetition is the key to learning.

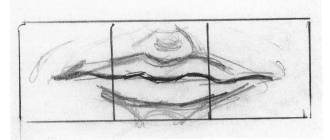

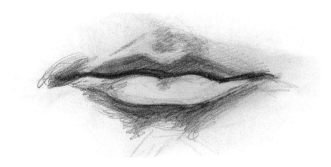

1 Create a Line Drawing
Use the grid method and a mechanical pencil to create a line drawing of male lips.

2 Add Dark Tones
When you are sure of your accuracy, carefully remove the grid lines with a kneaded eraser. Add the darkest tones first with the pencil.

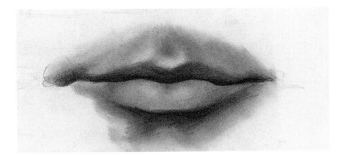

3 Blend and Lift
Blend the drawing with a stump or tortillion to remove the white of the paper. Deepen the dark areas with your pencil and then lift light areas out with a kneaded eraser.

SMILING LIPS

Mouths become much more difficult to draw when the teeth are showing. When drawing teeth, never draw a hard line between each tooth. Because the teeth touch, a hard line would make them look too separate by representing a dark space. They should also have some shading applied. Teeth are dimensional, so leaving them white would make them look flat. As the teeth recede into the mouth, the shadows get darker. The bottom teeth are always a bit darker too since they do not protrude as much.

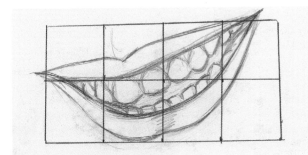

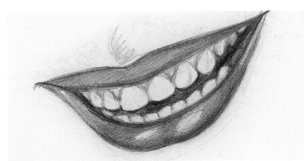

1 Create a Line Drawing
Use the grid method and a mechanical pencil to create a line drawing of a mouth and teeth. Each tooth must be perfect to create a good likeness. Do not draw hard lines between each tooth. For accuracy, draw the shapes of the gum line and the edges of the teeth.

2 Apply Dark Tones
When you are sure of your accuracy, carefully remove the grid lines with a kneaded eraser. Apply the darkest tones with a pencil. It is darkest inside the mouth. The upper lip is darker than the bottom lip and does not have bright highlights.

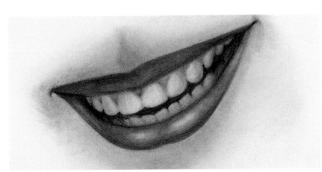

3 Blend, Add Shading and Lift
Blend the tones smooth with a tortillion. Apply some shading to each tooth to make sure they look dimensional. Lift the highlights of the bottom lip to make them look full and shiny. Keep the lines between the teeth subtle. Use a kneaded eraser to soften where they touch.

Draw Facial Hair

When drawing the male mouth, you will often encounter facial hair such as mustaches and beards. While it may seem difficult, it is very much like drawing animal fur. Just as you learned with fur in the previous chapter, all hair is drawn using pencil strokes that reflect the length of the hair. It is built up in multiple layers.

Follow the steps to draw facial hair.

MATERIALS

drawing paper

kneaded eraser

mechanical graphite pencil

ruler

stump or tortillion

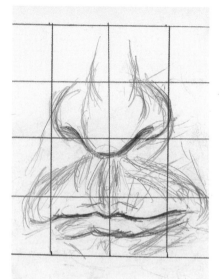

1 Create a Line Drawing
Use the grid method and a mechanical pencil to create a line drawing of a nose, mouth and mustache.

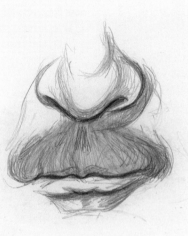

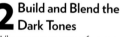

2 Build and Blend the Dark Tones
When you are sure of your accuracy, carefully remove the grid lines with a kneaded eraser. Apply the darkest tones with a pencil. The mustache is created with short pencil lines going the direction of the hair's growth. Blend the entire area to a gray tone with a tortillion and then continue building pencil lines on top.

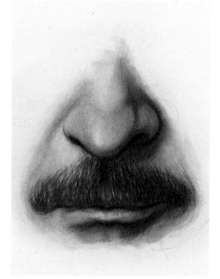

3 Deepen the Tones, Blend and Lift
Continue deepening the tones and blending the drawing for a smooth appearance. Once the darkness of the mustache is achieved, use a kneaded eraser to lift out some light hairs. This will help it look full and dimensional.

LEE'S LESSONS

The area above the upper lip between the nose and mouth is extremely important. This area, the philtrum, is often unaddressed and left plain white by beginning artists. It is very important to the anatomy and must be drawn correctly. It usually has a shadow of the nose cast onto it. The M shape of the upper lip goes up and connects with the nose.

Draw an Eye

There are many components to the eye and all of them are important. Here are a few hints to help you:

- The iris and the pupil are perfect circles when the eye is looking straight at you. If turning away or looking up and down, they become ellipses.
- The pupil is always perfectly centered within the iris.
- The pupil is the darkest part of the eye. Fill it in as dark and smooth as possible. Leave an area for a catch light.
- The catch light should be half in the pupil and half in the iris. If the photo shows it blocking the pupil, move it over.
- The lower lid thickness below the iris is very important. Never just draw a line under the eye. This small detail gives the eye dimension.
- Patterns within the iris will vary depending on the color of the eye and resemble a starburst.
- The white of the eye needs to be blended to resemble a sphere shape. Never just leave this area (the sclera) white.
- The lashes on the upper lid come together to make a dark edge called the lash line.
- The upper eyelid recesses, making the eyeball take on a sphere shape.
- Follow the steps to draw an eye.

MATERIALS

drawing paper

kneaded eraser

mechanical graphite pencil

ruler

stump or tortillion

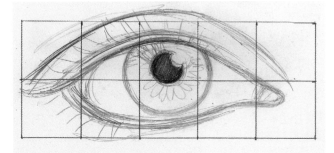

1 Create a Line Drawing
Use the grid method and a mechanical pencil to create a line drawing of an eye.

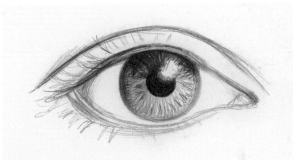

2 Lay in the Patterns and Blend
When you are sure of your accuracy, carefully remove the grid lines with a kneaded eraser. Lay in the patterns of the iris with a pencil. Use pencil lines that resemble a starburst pattern or wagon wheel spokes. Leave an area open for the catch light (half in the pupil and half in the iris). Blend things smooth with a tortillion. Use a kneaded eraser to lift the catch light and increase the patterns in the iris.

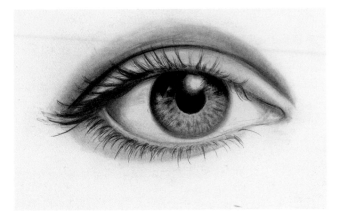

3 Continue Blending and Shading, Add Eyelashes
Blend the skin areas of the drawing to create the form and contours. Shade the white of the eye to make it look rounded like a sphere.

Add the eyelashes with very quick strokes that taper at the ends. They grow in layers and clumps, so do not make them go all along in a row. Notice how the lashes on the bottom grow from the lower edge of the lower lid thickness. You can see how much dimension the lower lid thickness gives to the look of the eye.

Draw a Nose & Eyes Together

Once you learn the anatomy of the eye and how to draw it realistically, it is important to understand how to put two of them together along with other facial features like the nose. Here are some guidelines to remember:

- The space between the eyes is one eye width.
- Both eyes should be directly across from each other.
- If you draw a vertical line down from the corner of the eye, it will line up with the edge of the nose. (This can change according to different races.)
- Both eyes must be looking in the same direction. The pupil and iris must be the same in both.
- Place the catch light in the same place on both eyes (half in the pupil, half in the iris).

 Follow the steps to draw the eyes and nose together.

MATERIALS

drawing paper

kneaded eraser

mechanical graphite pencil

ruler

stump or tortillion

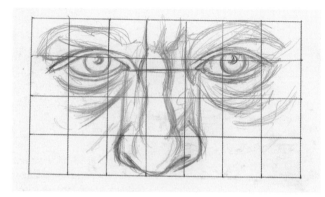

1 Create a Line Drawing
Use the grid method and a mechanical pencil to create a line drawing of a nose and eyes together. Notice how the vertical line drawn down from the corner of the eyes lines up with the edge of the nose. Place the eyes directly across from one another.

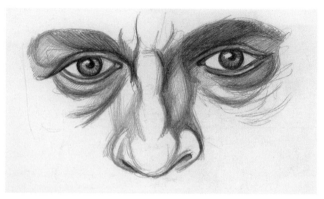

2 Apply Dark Tones, Fill in the Shadow Areas and Eyebrows
When you are sure of your accuracy, carefully remove the grid lines with a kneaded eraser. Apply the darkest tones with a pencil. The pupils of the eyes are the darkest areas. Fill in the tones of the shadow areas and the eyebrows. The eyebrows should be shaded in as a shape first, before the hairs are applied.

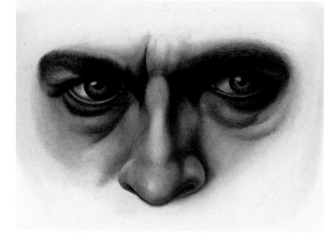

3 Blend and Add Highlights
Blend with a stump or tortillion. Very little of the paper should be left white, even in the white of the eye. Use a kneaded eraser for the small highlights seen in the brows and patterns within the pupils.

Draw Eyes From an Angle

This project will help you see things from a different vantage point. When you draw a person who is at an angle, the rules change. The features look distorted due to the perspective. In this view, the profile of the nose is blocking one of the eyes and only a small portion of the face is showing on that side.

Follow the steps to draw eyes from an angle.

MATERIALS

drawing paper

kneaded eraser

mechanical graphite pencil

ruler

stump or tortillion

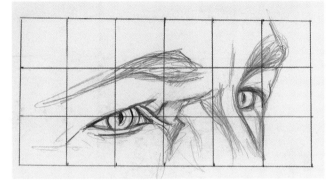

1 Create a Line Drawing
Use the grid method and a mechanical pencil to create a line drawing of eyes in a slightly angled pose. Notice how this angle blocks the view of part of the face. The irises and pupils now are vertical ellipses, since the eye is not looking straight at you. The perfect circle is now changed due to the perspective.

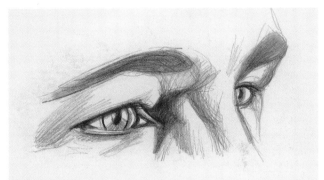

2 Apply Darks, Add Shadows and Blend the Eyebrows
When you are sure of your accuracy, carefully remove the grid lines with a kneaded eraser. Apply the darkest tones with your pencil to create the shadows. The pupils of the eyes are the darkest areas. Blend the shapes of the eyebrows to a gray tone.

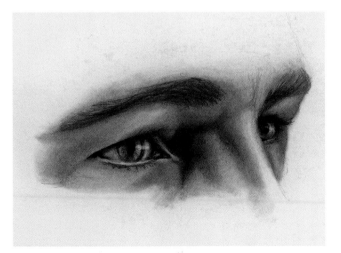

3 Blend and Lift
Blend the skin areas with a stump or tortillion. Use a kneaded eraser for the small highlights seen in the brows. Create the patterns within the pupils and lift the catch lights.

LEE'S LESSONS

If there is more than one person in your portrait, and they are side by side, the irises and pupils must be the same for everyone in the drawing. We all have the same size eyeballs, irises and pupils. It is the anatomy around the eyes that makes them look different on each person.

Draw Eyeglasses

Drawing eyeglasses seems like an impossible task for many. While they do add a complicated element to the drawing, you must see them like everything else—as shapes and patterns of light and dark.

Eyeglasses add a lot of additional patterns to a drawing due to the shadows they create on the face. The reflective nature of glass and metal create strong highlights.

Follow the steps to draw a pair of eyeglasses

MATERIALS

drawing paper

kneaded eraser

mechanical graphite pencil

ruler

stump or tortillion

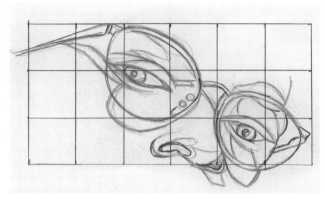

1 Create a Line Drawing
Use the grid method and a mechanical pencil to create a line drawing of all the shapes, highlights and shadows created by eyeglasses.

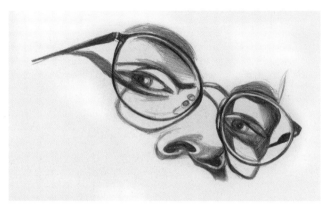

2 Apply the Darks
When you are sure of your accuracy, carefully remove the grid lines with a kneaded eraser. Apply the darkest areas with a pencil. Pay close attention to the shadows being cast onto the face and the cast shadows under the nose.

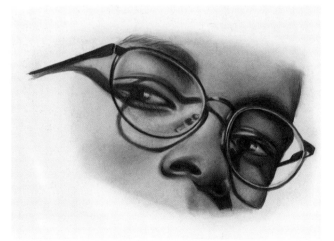

3 Blend and Lift
Blend the drawing with a stump or tortillion. To make this look realistic, lift the highlights seen on the glasses.

Look at how reflected light is seen along the inside edge of the eyeglass rim. This is what makes them look like glass and not just empty frames.

Ears

Ears are one of the most difficult features to draw. They are made up of very strange shapes. We don't particularly pay much attention to ears unless they have earrings or are larger than normal. Either way, they are not shapes that we often think about.

To draw a good portrait, you must learn their anatomy to make them look convincing. It is a good idea to practice drawing ears in a variety of angles and poses, too. Practicing all views is important if you want to be proficient in portrait drawing.

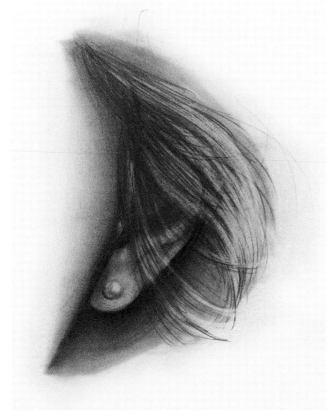

Ear, Front View
This is a typical front view of an ear seen on a portrait. Much of the anatomy is blocked by the hair. Only the protruding part of the earlobe is visible.

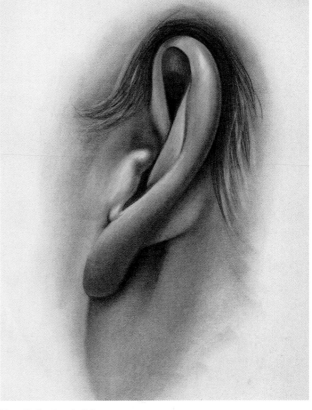

Ear, Side-Angle View
This side-angle view shows the complexities of the ear. It is certainly not a typical pose, but you never know when you may have to draw a person in an unusual pose.

Draw an Ear

This exercise will help you learn the anatomy of ears. They are made up of many intricate shapes that all nestle together. The grid method helps to make them appear more like a puzzle.

Here are some things to keep in mind when drawing ears:

- The outer ear overlaps the inner ear.
- The inner ear has an area that resembles a Y. Look for it in every ear you draw.
- The skin of the ear is different. It is more oily, so highlights can appear very bright.
- There is a protruding area of the inner ear that acts like a cup.
- The earlobe often resembles a sphere.
 Follow the steps to draw an ear.

MATERIALS

drawing paper

kneaded eraser

mechanical graphite pencil

ruler

stump or tortillion

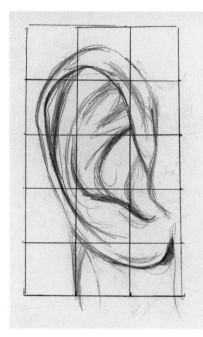

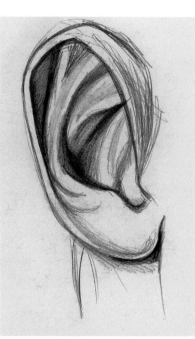

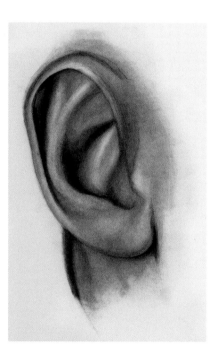

1 Create a Line Drawing
Use the grid method and a mechanical pencil to create a line drawing of an ear. Look at it like a puzzle of interlocking shapes.

2 Apply the Darks
When you are sure of your accuracy, carefully remove the grid lines with a kneaded eraser. Apply the darkest areas with a pencil. Create shadows underneath where the outer ear overlaps the inner ear. Resist the urge to outline too much. Let shading create your edges.

3 Blend and Lift
Blend the drawing with a stump or tortillion. To make it look realistic, lift out highlights with a kneaded eraser. The ear is a bit shinier than other skin, so the highlights should be bright. Remember the five elements of shading and the sphere when focusing on the earlobe.

Hair

A portrait would not be complete without the hair. Unfortunately, drawing hair can take longer than any other part of the drawing. Hair is thick and full, so it must be built up in multiple layers of pencil strokes to create volume. It is impossible to create a thick head of hair with just a few pencil strokes.

These segment drawings show different types of hairstyles and textures. Doing small studies such as these can give you good practice with various techniques.

Here are some tips for drawing hair:

- The pencil strokes always replicate the hair's direction and the length.
- The color of the hair is determined by how dark or how light your pencil lines are.
- A band of light is created in the hair anytime there is a curved area. You will see it in curls and around the circumference of the head.
- Highlights are always seen on rounded or protruding areas.
- Blend the paper to a gray tone before you lift highlights. This makes them look like they are on the outer surface.

Curly Hair

This study shows how curls form tubular shapes similar to a cylinder. Wherever the curls protrude the most, the highlight shows. The pencil lines create the texture of the hair, following the direction the hair is going. The highlights are lifted with the same type of quick stroke. You can tell this is dark hair by the depth of the tones.

Frizzy or Permed Hair

This study shows what frizzy or permed hair looks like. The curls are less distinct here because of the randomness of the hair direction and the overlapping of hair strands. The pencil strokes are more blended out because of the frizzier texture of the hair. This hair appears much lighter than the previous example.

Layered Hair

In layered hair, the same type of V shapes are created as we saw with animal fur, feathers and flower petals. The deep V of darkness gives the illusion of depth.

Band of Light

This is an example of the bands of light—areas where the hair is curved, such as in bangs and around the head. It is the most obvious with long, smooth hair.

Draw Hair

There are many different types of hairstyles and textures. These quick exercises will give you some practice with some of the most common styles. Each type requires a different approach. The texture and color is dependent on the type of pencil stroke used and the pressure applied.

Follow the steps to draw hair.

MATERIALS

drawing paper

kneaded eraser

mechanical graphite pencil

stump or tortillion

STRAIGHT HAIR

1 Lay in the Shape
Start by laying in the overall shape of the hairstyle with a pencil.

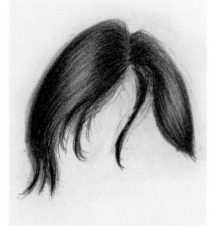

2 Apply the Darks
Apply dark pencil strokes to create the illusion of length. Notice the bands of light. This is where the hair shows curves.

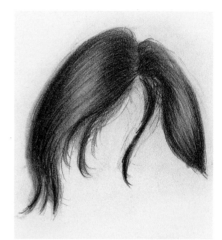

3 Blend, Reapply Darks and Lift
Blend the drawing with a stump or tortillion. Reapply the dark areas using firm quick strokes. Lift the bands of light with a kneaded eraser.

CURLY HAIR

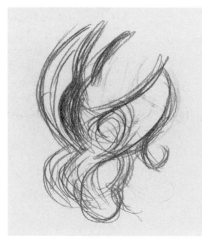

1 Lay in the Shape
Draw the overall shape of the hairstyle. Use long, curved pencil strokes to create the shapes of the curls.

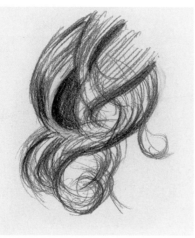

2 Build up the Hair Strands
Use more curved lines to build the hair strands and dark areas of overlap.

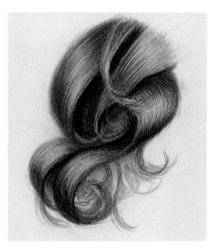

3 Blend and Lift
Blend the drawing to a gray tone. Use a kneaded eraser to lift the bands of light out of each curl.

Portraits

Portrait drawing is an awesome way to evoke a mood. The facial expression of a person tells you a lot about them and is important when telling their story.

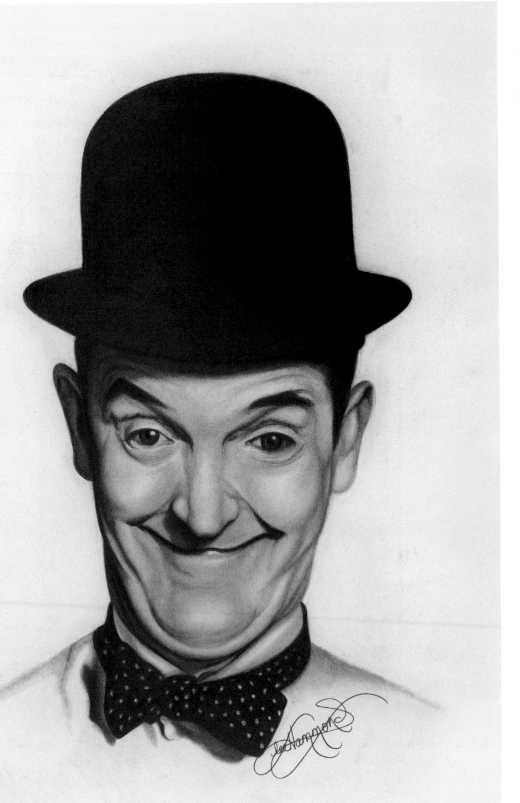

Character Study

In this example, the expression makes you smile just looking at it. This is more than just a portrait. It is a character study meant to connect with you and make you feel happy.

LEE'S LESSONS

When drawing portraits, always use a clean stump or tortillion to blend the skin. It will make fading into the light areas look more delicate and seamless. Using a dark one will add too much graphite to the drawing and make it appear choppy.

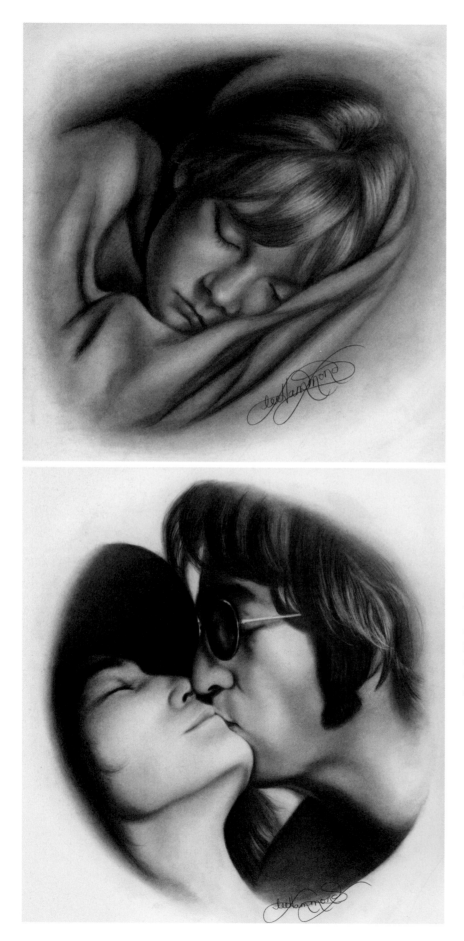

A Portrait Is a Memory

A portrait can be more than just a person looking at you. This portrait of my granddaughter, Cayla, is an example of art capturing not only the person, but capturing a memory. Your photo album can be a wealth of subject matter, and your art can be a great way of documenting the good times of your life.

Capturing Mood

The drawing of John Lennon and Yoko Ono is another example of capturing a mood. Placing people together in a drawing makes for a good gift for anniversaries and weddings. A pose like this is much more artistic than just a photo of a couple together staring at the camera.

Draw a Portrait

Now it's time to put everything together into a portrait. Do not do this project before you have done the proper practice work. Go back and practice all of the facial features first.

Here are some tips for drawing portraits:

- When drawing faces, start with the eyes. This helps create a connection with the viewer and starts to capture the personality of your subject.
- When you finish the eyes, move down and finish the nose, then the mouth. This is called the triangle of features.
- Allow the darkness of the hair to help create the lighter edge of the face. Placing tone behind the face reduces the chance of things looking outlined.
- When drawing hair, apply your pencil strokes going in the same direction as the hair growth.
- Always remember the five elements of shading with everything you draw. Follow the steps to draw a portrait.

MATERIALS

drawing paper

kneaded eraser

mechanical graphite pencil

ruler

stump or tortillion

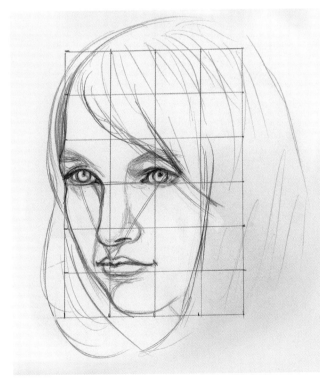

1 Create a Line Drawing
Use the grid method and a mechanical pencil to create a line drawing of a female face. Go one box at a time and be very careful with the shapes.

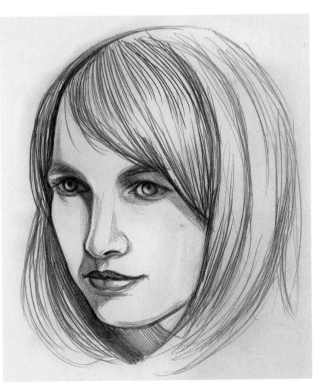

2 Apply the Darks and Start Building up the Hair
When you are sure of your accuracy, carefully remove the grid lines with a kneaded eraser. Apply the darkest tones. Start with the eyes and then move down to the nose and mouth to create the triangle of features. Apply some dark tone next to the face to help create the light edge of the face. Start to build the hair using long pencil strokes.

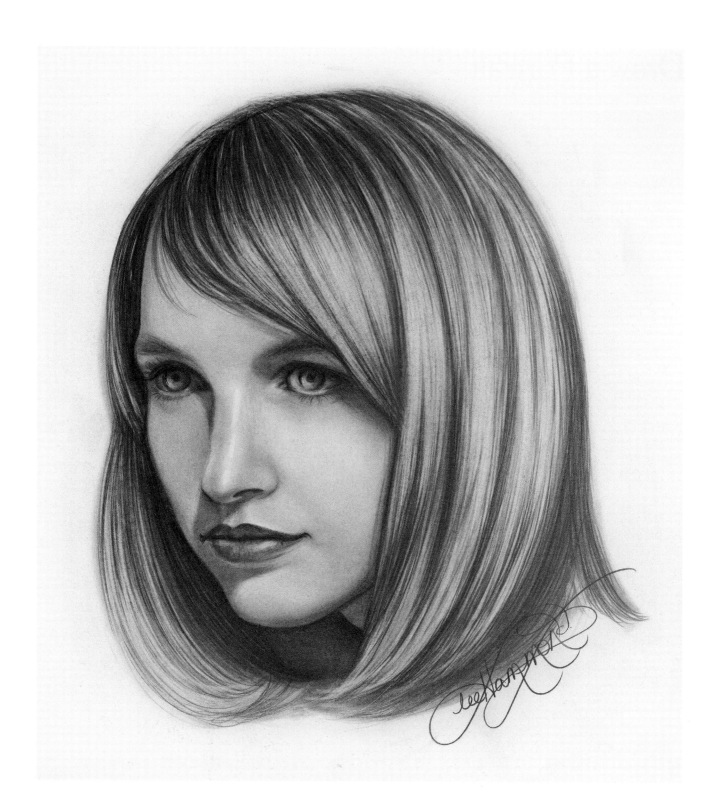

3 Blend and Lift

Take your time finishing. The face must be blended very smooth with a stump or tortillion. Little of the drawing should be left pure white; only the highlights in the eyes and on the nose appear white. As you complete the face, refer to the previous exercises on individual facial features and keep the five elements of shading in mind.

The hair in this portrait takes a lot of time. Use very long pencil strokes to create the length. Blend everything out smooth and then lift bands of light out of the hair with a kneaded eraser.

Hands

Have you ever noticed how many portraits of people do not include the hands? Many of my students avoid them at all costs due to the difficulty in making them look real. Most beginning artists who do attempt drawing hands will make them too rounded, resulting in a puffy, rubbery appearance that misses the most important aspects of the anatomy. Hands are very segmented and angular by nature, so it is important to see them more as geometric shapes.

Practice drawing as many hands as possible. They can add a lot of interest to a drawing and help tell a story.

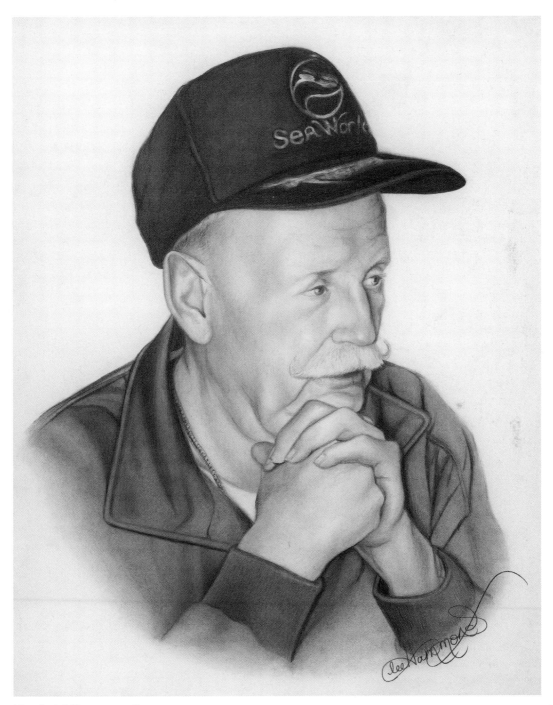

Hands Add Interest to Portraits
I could have easily drawn this portrait of Jack as just a head-and-shoulders study. But the pose using the hands gives the portrait more impact and is much more interesting.

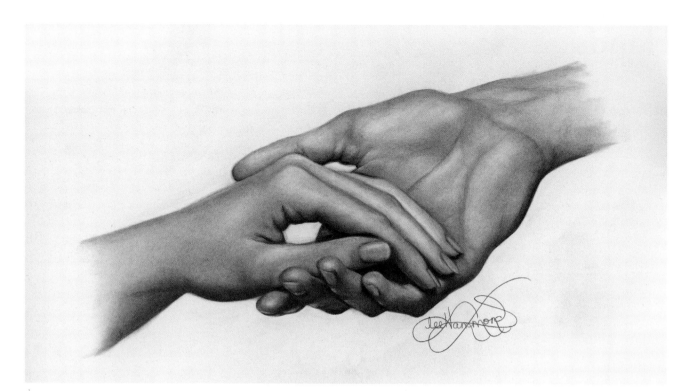

Comparing Male and Female Hands

There are major differences between male and female hands. Male hands are more square than female hands. The female hand usually appears more slender, with the joints of the fingers and wrist less noticeable.

Basic Shapes and Angles of the Hand

When viewed geometrically, hands become more believable in their appearance. This shows an exaggerated example of angles seen in the hand. Foreshortening is visible in the index finger. From this view, the length of the entire finger is not visible. Due to the bone structure and the multiple joints of the fingers, many angles are created. Look for these straight lines when you create a line drawing, and then gently round them a bit when you apply shading.

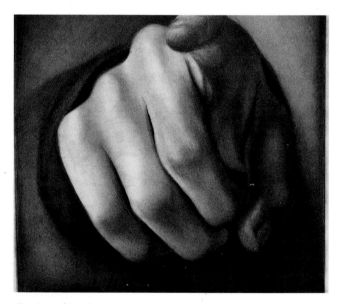

Realistic Rendering

The angles and joints of the hand and fingers are still visible after the drawing is blended and completed. The rendering makes the hand look realistic. While the edges have been smoothed out and rounded a bit, the angles of the joints are still visible.

You will see foreshortening a lot in hands. Depending on the pose, you will see the fingers in different views, which alters and distorts the shapes.

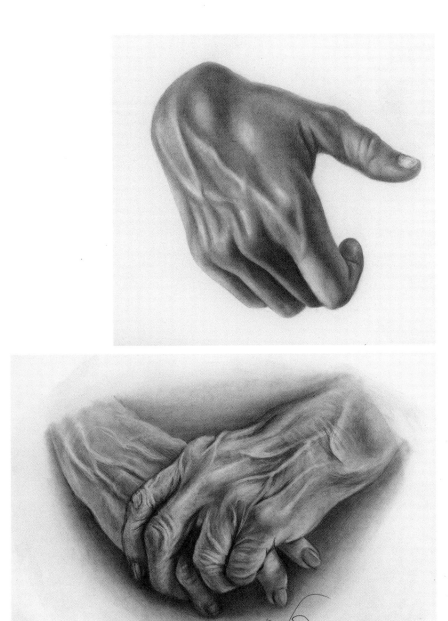

Middle-Aged Hands

Hands change as people grow older, and there are characteristics that must be captured to make them look age appropriate. In this example, the hand is middle aged. The veins are very noticeable. Because the veins are raised, they have both a highlight and a shadow. This must be drawn smoothly without hard lines to make it look like a gentle curve and not a crease. The hands are made up of soft edges.

Old Hands

These hands are very old. The bones are much more obvious, and the joints appear larger than normal. You can see the veins, wrinkles and skin texture, which is crepe-like. A kneaded eraser was used to draw in all of the highlights and skin textures.

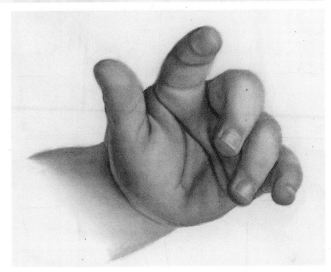

Baby Hands

While a baby's hands are definitely more chubby and rounded than an adult's, it is still important to imagine the angle lines that represent the joints of the fingers. In this example you can see how important the angles are to the pose of the fingers and how they bend. If you draw them too rounded, you lose the perspective.

Draw a Male Hand

Notice how the angle lines in this project have been used to show the angular segments of the fingers and hand.

Follow the steps to draw a male hand.

MATERIALS

drawing paper

kneaded eraser

mechanical graphite pencil

ruler

stump or tortillion

1 Create a Line Drawing
Use the grid method and a mechanical pencil to create a line drawing of a male hand. Use the angle lines to capture the boxiness of the joints.

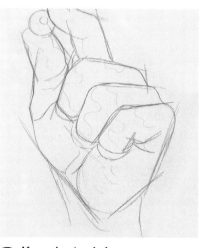

2 Keep the Angle Lines
Erase the grid lines with a kneaded eraser, but be sure to keep the angle lines as a guide. This will prevent the fingers from looking too rounded.

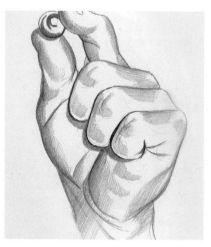

3 Add Dark Tones and Draw the Marble
Add the darkest tones with a pencil. Look for the patterns of light and dark, especially the cast shadows under the fingers. Draw the marble like a sphere. You can tell this is a male hand by its squared-off, more boxy shape.

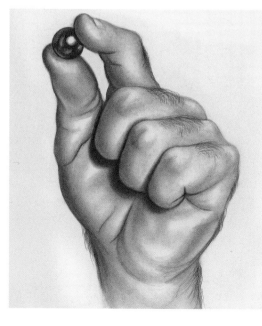

4 Blend, Deepen Tones and Lift Highlights
Blend the drawing to make it look realistic. Deepen the tones as needed and reblend. Use a kneaded eraser to lift the highlighted areas. Use small, quick strokes to create small hairs on the tops of the fingers. These small details lend the drawing realism.

Draw a Female Hand

This exercise shows how to draw a female hand. You can see how much more slender it appears.

Follow the steps to draw a female hand.

MATERIALS

drawing paper

kneaded eraser

mechanical graphite pencil

ruler

stump or tortillion

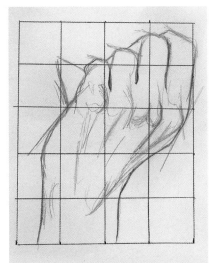

1 Create a Line Drawing
Use the grid method and a mechanical pencil to create a line drawing of a female hand. Keep the angles in mind as you draw.

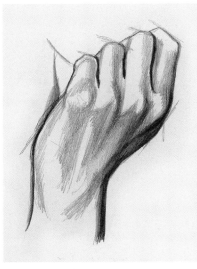

2 Add the Dark Tones
When you are sure of your accuracy, carefully remove the grid lines with a kneaded eraser. Add the darkest tones with a pencil. Look for the patterns of light and dark that are created by the light source. The light is coming from the upper left, so all of the shadows are on the lower right.

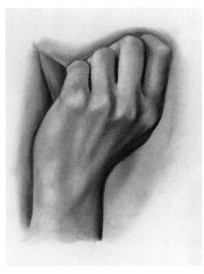

3 Blend, Deepen Tones and Lift Highlights
Blend the drawing to make it look realistic. Deepen the tones as needed and reblend. Use a kneaded eraser to lift the highlighted areas.

Feet

Drawing feet is very similar to drawing hands. The same rules about shape and angles apply.

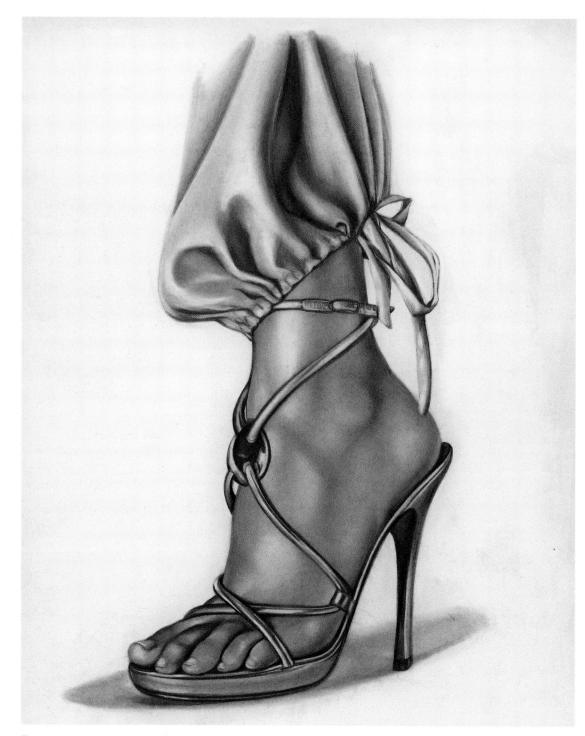

Feet Are Important When Drawing Fashion

This pose shows how important drawing feet would be if you were drawing fashion. You can see how the shiny sandals are much like drawing metal, and the clothing looks realistic. We will cover drawing clothing and fabric in the next chapter.

Draw Baby Feet

This project is a good for practicing feet and for creating a perfect baby shower gift. A drawing like this is very meaningful and can become a family heirloom.

Follow the steps to draw cute baby feet.

MATERIALS

drawing paper

kneaded eraser

mechanical graphite pencil

ruler

stump or tortillion

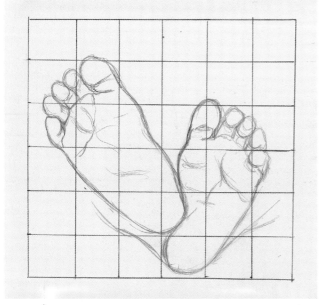

1 Create a Line Drawing
Use the grid method and a mechanical pencil to create a line drawing of cute baby feet.

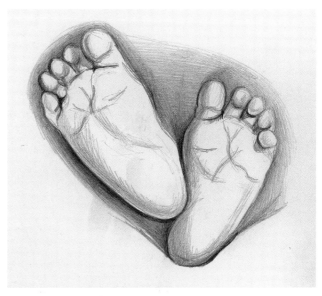

2 Add Dark Tones and Shadows
When you are sure of your accuracy, carefully remove the grid lines with a kneaded eraser. Add the darkest tones with a pencil. Use the background to create the light edges of the feet. Add the shadows, leaving the reflected light visible.

If you look closely, you can see how each of the little toes are actually little sphere exercises.

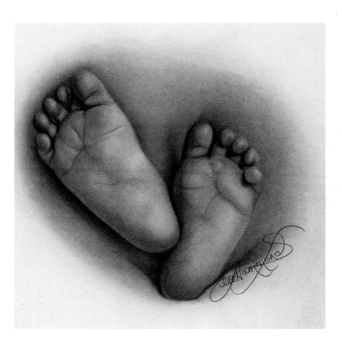

3 Blend and Lift
Blend the drawing smooth with a stump or tortillion. Use a kneaded eraser to lift the small highlights of each toe. The little creases are very important for realism, but they must appear delicate and not as hard lines. Do not overdraw them! Because they are recessed, there is subtle reflected light along the edges.

CHAPTER SIX
FABRIC & CLOTHING

Clothing is another important aspect of portrait drawing. I have seen excellent portraits fall short because the artist did not know how to draw clothing and fabric as well as the facial features. Always remember that your drawing is only as good as its weakest element. Whatever looks the least finished is the thing you will notice the most.

While drawing fabric and clothing may look really complicated, it is really just an illusion. Everything is created with the same theory of shapes, patterns of light and dark, blended tones and lifted-out light.

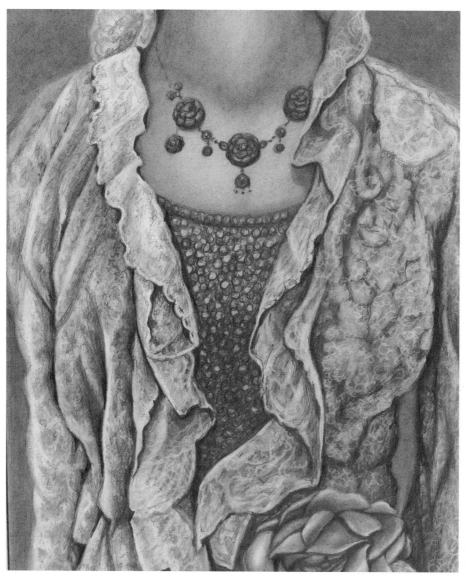

A Study of Lace
Graphite on smooth bristol
10" × 8" (25cm × 20cm)

Folds

When drawing fabric it is important to learn the different types of folds. Just like there are five elements of shading, there are four different folds. The five elements of shading are required to make each one of them look real.

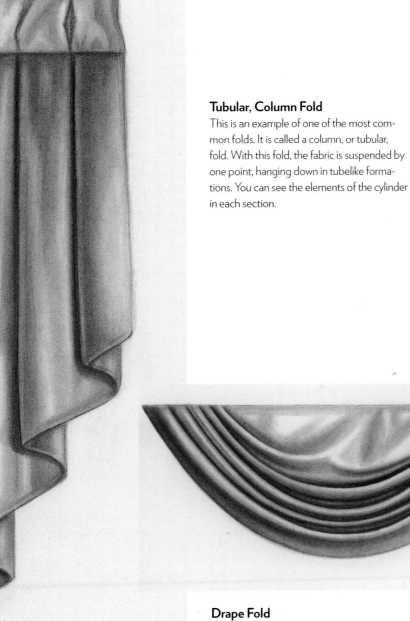

Tubular, Column Fold

This is an example of one of the most common folds. It is called a column, or tubular, fold. With this fold, the fabric is suspended by one point, hanging down in tubelike formations. You can see the elements of the cylinder in each section.

Drape Fold

In a drape fold, the fabric is suspended by two points, creating a U shape. You can see the same tubular shapes being created, but they do not hang loosely like a column fold. You would see this in cowl neck sweaters and scarves.

Spiral, or Coil Fold

You will see this type of fold in things such as socks, sleeves and pant legs. The fabric is in the form of a tube, wrapping around an arm or a leg. It resembles the drape fold, but this time the shapes go all around something instead of hanging loose. This is also an example of an interlocking fold. See how the fabric is nestled into itself?

Inert Fold

An inert fold is a collection of hard and soft edges. You will find inert folds in fabric that is at rest and is not being suspended or hanging from anything, such as with this ribbon and bow. The relaxed fabric creates a collection of different folds, which can go in every direction. There are both hard edges, where the fabric is overlapping or folded and creased, and soft edges, where the fabric gently rolls. The trick here is not making things appear too hard edged, unless it is in an actual crease. Study your reference photo carefully.

LEE'S LESSONS

Fabric is a study of hard and soft edges. Some are subtle, some are extreme.

Patterns

When fabric has a pattern, it is very important that the pattern follows the curves and creases of the fabric. The contours should be drawn first to create the shapes and form. Then the patterns should be added on top.

Segment drawing is an excellent way to practice the different folds and patterns of clothing. By concentrating on small sections and not an entire drawing, problem areas can be practiced and figured out.

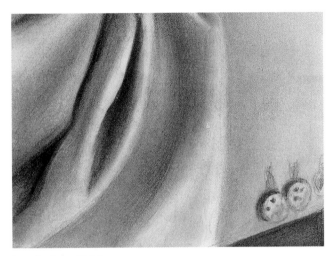

Interlocking Folds

This segment depicts interlocking folds. Look at how the folds nestle inside one another. This creates both hard edges, where things overlap and touch, and soft edges, where the fabric gently bends and curves.

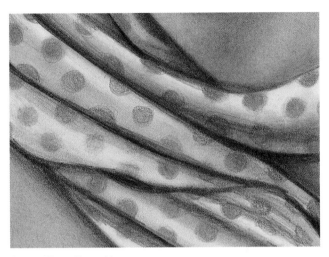

Shape First, Detail Last

This is another example of interlocking folds. Look at how the polka dots follow the shape of the fabric. Some seem like perfect circles, some are ellipses, and some are barely showing. It is important to develop the contours and shading of the fabric first, before adding the patterns. It is always shape first, detail last.

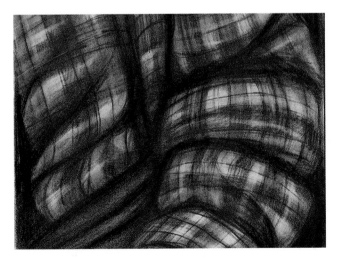

Go from Dark to Light

In this coil, or spiral, fold the fabric encompasses the arm and wraps around. The plaid was developed using a pencil, then lifting the lighter tones with an eraser. It is important to go back and forth, adding dark and lifting light to make the pattern look correct. Notice how the patterns follow the shape of the shirt and curve along with the fabric.

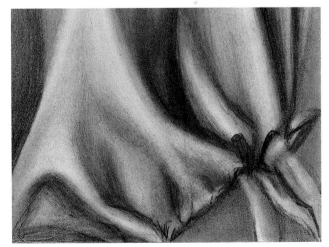

Combination Fold

This is a combination of column, tubular and inert folds. It starts out hanging in a cylindrical shape but then stops and rests. The bottom of the fold is more relaxed and becomes inert.

Draw a Towel with Column Folds

Cast shadows, shadow edges and the reflected light are very important to making the fabric look real. When doing this exercise, remember to refer to the cylinder as you go.

Follow the steps to draw a towel with column folds.

MATERIALS

drawing paper

kneaded eraser

mechanical graphite pencil

ruler

stump or tortillion

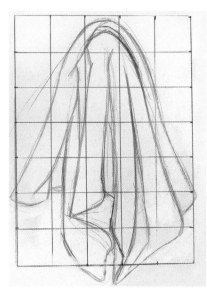

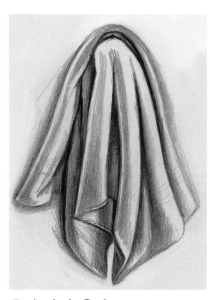

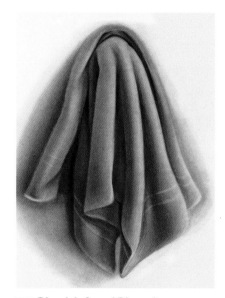

1 Create a Line Drawing
Use the grid method and a mechanical pencil to create a line drawing of a hung towel. Capture the cone-like cylindrical shapes of the column fold, the fabric suspended by one point.

2 Apply the Darks
When you are sure of your accuracy, carefully remove the grid lines with a kneaded eraser. Apply the darkest areas with a pencil. These are cast shadows where the fabric overlaps. Apply the shadow edges, leaving a small area for the reflected light. This is what makes the different columns look rounded.

3 Blend, Lift and Place the Background Shadow
Blend the tones smooth and lift some highlights in the areas where the fabric protrudes the most. Place a shadow into the background to make it appear more dimensional.

Draw a Sleeve

Drawing fabric requires restraint. It is important to not overdraw things but to allow the look of rolling fabric to occur. Too many hard lines and edges will make fabric look creased and folded.

Fabric follows the anatomy of the body underneath it, so soft edges are required. These gently raised areas must appear soft and believable.

Follow the steps to draw a sleeve. It will give you more practice drawing hands and spheres as well.

MATERIALS

drawing paper

kneaded eraser

mechanical graphite pencil

ruler

stump or tortillion

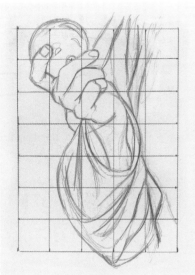

1 Create a Line Drawing
Use the grid method and a mechanical pencil to create a line drawing of a hand and sleeve. Capture the many shapes seen within the fabric of the clothing.

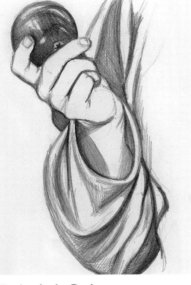

2 Apply the Darks
When you are sure of your accuracy, carefully remove the grid lines with a kneaded eraser. Apply the darkest tones with a pencil. The apple is the darkest area and closely resembles a sphere. Add some dark tones to the shadow areas of the clothing.

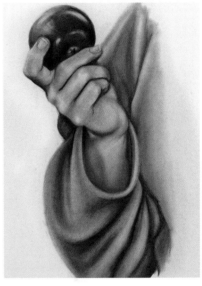

3 Blend and Lift
Blend the drawing with a stump or tortillion. Use a kneaded eraser to carefully lift the highlights in the sleeve. Be sure that these raised areas do not look hard edged and overly creased.

Refer to the previous exercise on drawing hands to render the hand and the apple.

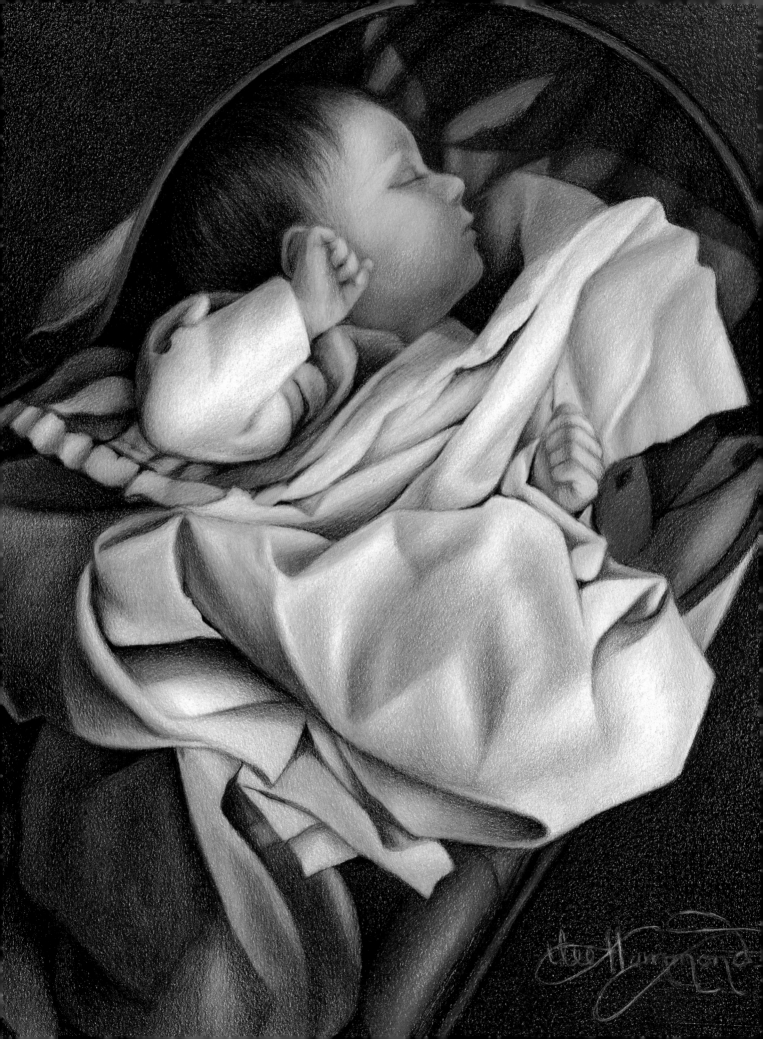

Part Two

COLORED PENCIL

Welcome to the world of colored pencil! We've seen how enjoyable graphite drawing can be. Now it is the time to explore color and all of the wonderful art that can be created with colored pencil as well.

Colored pencils can be overwhelming to shop for. There are so many different brands and varieties on the market. The choices can be staggering and confusing. Each brand is formulated differently and will give a different appearance to your work. To keep this book as simple as possible, I have reduced this entire section to using Prismacolor pencils only. I find this brand to be the most versatile of all the brands. It is also one of the easiest brands to find in stores.

I start off all of my students with graphite drawing first, then gradually move them on to more difficult mediums. If this is your first attempt at drawing in color, I strongly recommend that you fully exhaust the first section of this book on graphite before you go any further. In graphite drawing, you learn all about the use of light and shadows, as well as how to create realism, form and dimension. A good, solid understanding of these important principles will make learning colored pencil much easier.

Each one of the projects in this section builds on skills taught in previous projects, so please take them in the order they are presented and resist the temptation to jump ahead.

Colored pencil has a feel to it that only comes with practice. If you follow along, page by page, you will be surprised at the progress you will make. Have fun and enjoy the process!

Little Zane
Colored pencil on Artagain paper
14" × 17" (36cm × 43cm)

COLORED PENCIL BASICS

Many students get frustrated when attempting colored pencil for the first time, especially if they started out in graphite. While the five elements of shading all apply, the techniques for blending colored pencil are completely different from graphite.

When I was first learning how to draw with colored pencils, I failed miserably because I used the same graphite-blending application for everything. My results were colored-pencil drawings that looked more like crayon. However, once I learned techniques like layering and burnishing, everything fell into place.

Now follow along and let me show you the right way so you don't have to learn through mistakes like I did!

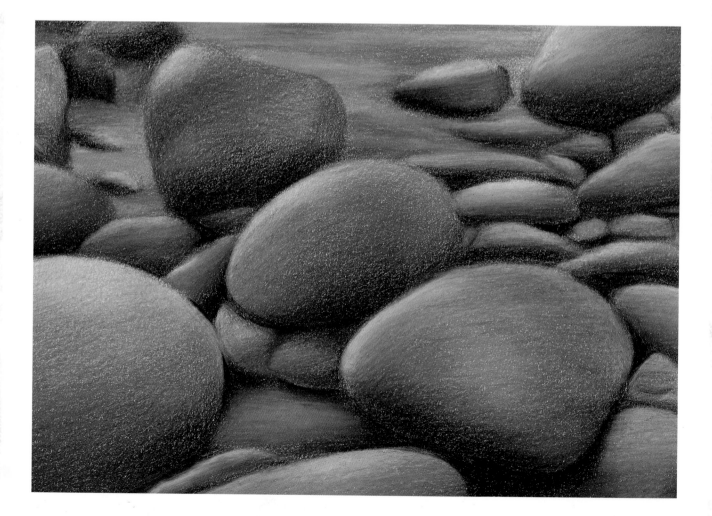

Pencils

The quality of your work is highly dependent on the materials you choose to work with. Below are some of my personal favorites that give my work a professional look. Prismacolor pencils are wax based and highly pigmented. I like them because of their versatility. When applied lightly in layers, the colors are soft and subtle. When applied heavily or burnished, they completely cover the paper with a rich, waxy finish that can resemble the look of paint. When both of these techniques are used together, the possibilities are endless.

Prismacolor also has the largest selection of colors available. They are currently 150 colors in their collection. You can find them in most art and office supply stores. They are sold individually as well as in sets.

Less Can Be More

It is not necessary to buy all 150 colors (although it is hard to resist!). Personally I like to keep two complete sets on hand—one to use and the other just to look at. It's possible, however, to produce quality work with just a few select colors. Higher-quality colored pencils and their professional grades are expensive, so a big set can be quite an investment. I like to keep things affordable for my students, so I tried to keep the colors for the projects in this book to what is found in the smaller sets of forty-eight.

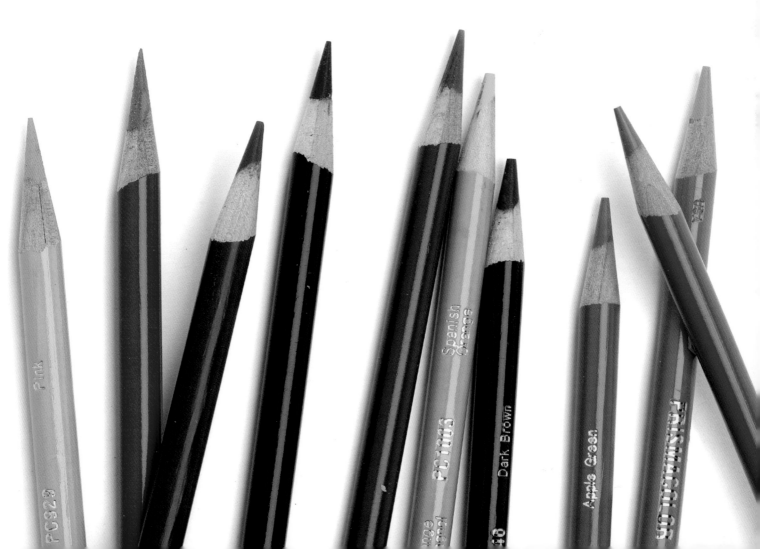

Color Swatches

The following pages show the variety of colors available in the Prismacolor line. Each swatch shows the color as it looks applied heavily, (on the left side of the swatch) and how it looks with a light touch (on the right side of the swatch).

Use these swatches for color references as you draw. They will help you decide which ones to choose in your drawings.

Warm Colors

Most of the colors on this page, with the exception of the last row, are considered warm colors.

914 Cream	915 Lemon Yellow	916 Canary Yellow	917 Sunburst Yellow	1003 Spanish Orange	1002 Yellow Orange
1012 Jasmine	940 Sand	1084 Ginger Root	942 Yellow Ochre	1034 Goldenrod	1033 Mineral Orange
997 Beige	927 Light Peach	939 Peach	928 Blush Pink	1001 Salmon Pink	929 Pink
1018 Pink Rose	1085 Peach Beige	1093 Seashell Pink	1080 Beige Sienna	1019 Rosy Beige	1017 Clay Rose
918 Orange	922 Poppy Red	1032 Pumpkin Orange	943 Burnt Ochre	945 Sienna Brown	944 Terra Cotta
921 Pale Vermilion	926 Carmine Red	923 Scarlet Lake	924 Crimson Red	925 Crimson Lake	1030 Raspberry
993 Hot Pink	994 Process Red	930 Magenta	995 Mulberry	1009 Dahlia Purple	931 Dark Purple
1092 Nectar	1031 Henna	1081 Chestnut	1029 Mahogany Red	937 Tuscan Red	1078 Black Cherry
1083 Putty Beige	941 Light Umber	1082 Chocolate	946 Dark Brown	947 Dark Umber	1095 Black Raspberry
1028 Bronze	1094 Sandbar Brown	949 Metallic Gold	950 Metallic Silver	948 Sepia	1099 Espresso
1026 Greyed Lavender	934 Lavender	956 Lilac	1008 Parma Violet	932 Violet	996 Black Grape

106

 1004 Yellow Chartreuse

 989 Chartreuse

 1005 Limepeel

 1098 Artichoke

1091 Green Ochre

911 Olive Green

 1097 Moss Green

988 Marine Green

 1090 Kelp Green

 909 Grass Green

1096 Kelly Green

908 Dark Green

 1089 Pale Sage

913 Spring Green

 912 Apple Green

 920 Light Green

910 True Green

1006 Parrot Green

 1020 Celadon Green

1021 Jade Green

 1088 Muted Turquoise

992 Light Aqua

907 Peacock Green

905 Aquamarine

1086 Sky Blue Light

1087 Powder Blue

 1024 Blue Slate

 1103 Caribbean Sea

1102 Blue Lake

904 Cerulean Blue

1023 Cloud Blue

1079 Violet Lake

 1025 Periwinkle

902 Ultramarine Blue

1007 Imperial Violet

933 Violet Blue

1040 Electric Blue

919 Non-Photo Blue

903 True Blue

1022 Mediterranean Blue

906 Copenhagen Blue

1027 Peacock Blue

 936 Slate Grey

 1100 China Blue

 1101 Denim Blue

 901 Indigo Blue

935 Black

938 White

 1059 Cool Grey 10%

1060 Cool Grey 20%

1061 Cool Grey 30%

 1063 Cool Grey 50%

1065 Cool Grey 70%

1067 Cool Grey 90%

 1050 Warm Grey 10%

 1051 Warm Grey 20%

 1052 Warm Grey 30%

1054 Warm Grey 50%

1056 Warm Grey 70%

1058 Warm Grey 90%

 1068 French Grey 10%

 1069 French Grey 20%

 1070 French Grey 30%

 1072 French Grey 50%

1074 French Grey 70%

1076 French Grey 90%

Cool Colors

Most of the colors on this page, with the exception of the Warm and French Greys, are considered cool colors.

LEE'S LESSONS

It is important to understand the traits of warm and cool colors. Warm colors are often used to reflect light off of subjects and appear to come forward. Cool colors are often used in shadows and appear to recede.

Study finished art and note how the artist uses warm and cool colors to create the piece's light source and center of interest.

Papers

When I draw with graphite, I use the same type of paper for everything. Smooth bristol allows me to achieve the smooth blend that I desire. But, with colored pencil, it is good to use a variety of papers to get different looks.

I personally like a heavier paper that resists creasing and buckling. When applying heavy, burnished applications of color, you want a paper that can withstand the abuse. Look for heavyweight papers and illustration boards. They will give you the best outcomes.

Always avoid a paper that is too smooth and slick. You need a paper that has no noticeable texture, but has enough "tooth" to hold the color evenly.

Here are a few you may want to look for:

- **Artagain paper by Strathmore.** This is a recycled, 60-lb. (130gsm) paper with a good surface and a variety of colors. It comes in both pads and single sheets. It also comes in black, which is a fun approach to colored pencil.

- **Stonehenge paper.** This was a paper originally designed for print-making. Its surface is excellent for colored pencil. It comes in pads and individual sheets, in a variety of pale colors.

- **Crescent mat board.** This is a board used for matting and framing. Its firmness makes it great for drawing on. It comes in a variety of surface textures, so check to make sure it is not too slick or has too much texture.

- **Bristol, regular surface.** Bristol comes in a more toothy texture than what I use for my graphite work. Canson make a double-sided bristol pad that I like, with one side smooth, the other more conducive to colored pencil.

There are a ton of different brands and types, which makes it impossible to cover them all. I suggest experimenting with different kinds of paper to find one that suits your needs. Remember that the paper will affect the look you are trying to achieve. Along with the illustrations in this book, I list the paper I used so you can see the differences.

Don't Be Afraid to Experiment
Papers come in a variety of weights, textures and colors. Experiment to see what you need for your project.

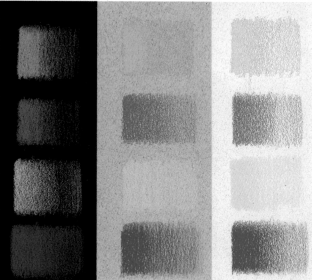

Paper Type Affects Color
The color you apply will look different on each paper. Here are four colors applied to three different types of paper. You can see the way the color of the paper affects the appearance of the colored pencil.

SAME PENCILS, DIFFERENT PAPERS

All of these were done with the same pencils. Each of these papers produces a different look.

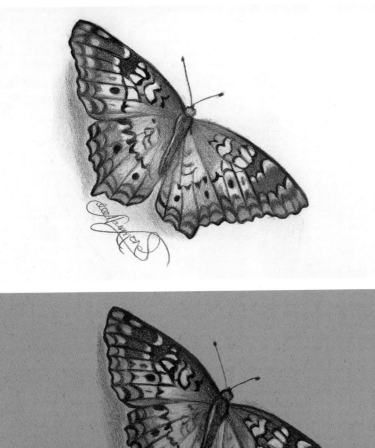

A butterfly on white regular surface bristol

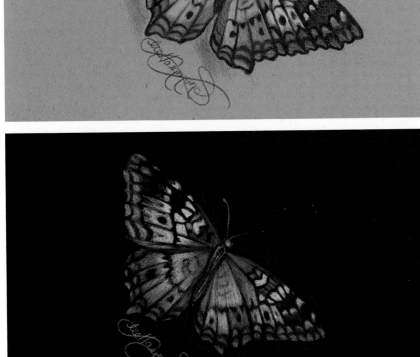

A butterfly on toned brown paper by Strathmore

A butterfly on black Artagain paper by Strathmore

Additional Tools

PENCIL SHARPENERS

Many of the techniques I will show you require a good, sharp point. A good sharpener is critical. Handheld sharpeners can work, but because of the twisting motion required to use them, it is easy to break off the point. I recommend a good electric sharpener so you can insert the pencil straight on. Battery operated sharpeners are also good, but when the batteries get weak, they lack the power to sharpen well.

ERASERS

Colored pencil can be difficult if not impossible to completely erase. But erasers can help lift and soften the colors. Here are a few I rely on:

- **Kneaded erasers.** These are squishy, claylike erasers. I use them with my graphite drawing. They are good for lifting out grid lines and the initial line drawing. They are also good for softening layered colors without damaging the paper surface. If you burnish heavily with the colored pencil, this eraser will not work at all.
- **Union erasers.** These erasers have two sides. One side is for general erasing, the other is designed for erasing ink and is more abrasive and gritty. They are great for removing stubborn stuff.
- **Typewriter erasers.** While these are hard to find now, there are some new versions that have replaced them. These pencil-shaped erasers are good for small areas and deliberate erasing.
- **Tuff Stuff and Mono Zero erasers.** These are like mechanical pencils with vinyl erasers inside. They are also good for targeting certain areas and getting into small areas.

MECHANICAL PENCILS

I use a mechanical pencil for my initial line drawing. Because the graphite is easy to erase with your kneaded eraser, you can alter your drawing until it is accurate. It is also good for creating grids that are easy to erase. Note: As you start to draw with color, *always* remove the graphite, and replace it with colored pencil. If you go over graphite with a light color, it turns very dark, and then you cannot remove it.

ACETATE GRAPHS

These overlays are perfect to grid out your photograph, and create an accurate line drawing on your paper. It divides your photo into increments that are easier to draw with accuracy, rather than freehanding your work. I recommend drawing one on white paper, using a fine-tip marker, and then having them copied on acetate at the office supply store or printer. I make them in both one-inch (25mm) and ½-inch (13mm) squares.

CRAFT KNIVES

A small knife blade can be used as a drawing tool. By scraping the color away gently, you can create fine white lines and areas of texture. You must be careful though so you do not gouge the paper and damage it.

SPRAY FIXATIVES

Fixatives bind and seal your work when you are finished. When using Prismacolor pencils, the wax will sometimes rise to the surface, giving your work a slightly foggy or dull appearance. By spraying your drawing when you are done, this will go away, and your colors will look bright again. I use two types.

- **Workable fixative.** This spray is undetectable. While it says "workable," I do not recommend trying to draw on top of it with colored pencil. It has a tendency to repel the pencil.
- **Damar varnish.** This spray gives a high-gloss shine to your work, making it appear like an oil painting. It makes heavily burnished colors appear vivid and bright, making it perfect for things like glass, fruit and shiny flowers.

DRAFTING BRUSH

Colored pencil leaves little specks of debris as you work. It is important to keep your drawing clean of this as you work. You can also use a new blush or cosmetic brush for this. Never wipe your work with your hand or you may smear it. And never blow on your work! You will spit on the paper!

COLOR FINDERS

Make this handy tool for identifying colors. Take two pieces of
white paper and punch holes in them with an ordinary hole punch.
Place one over your photo reference, and look at the color com-
pared to white. Place the other over your artwork in the same place,
or over test swatches of color, to see if you are accurate.

PENCIL EXTENDERS

These little tools are handy for extending the length and the life of
your pencil. When the pencil becomes short, an extender will allow
you to still stick the end in a pencil sharpener. When it gets really
short, you will have to use a handheld sharpener.

VIEWFINDERS

These are also handy tools for drawing. I cut 2- or 3-inch squares
(5-8 cm) into black paper. I then isolate a small section of a photo-
graph to draw. I give examples throughout the book.

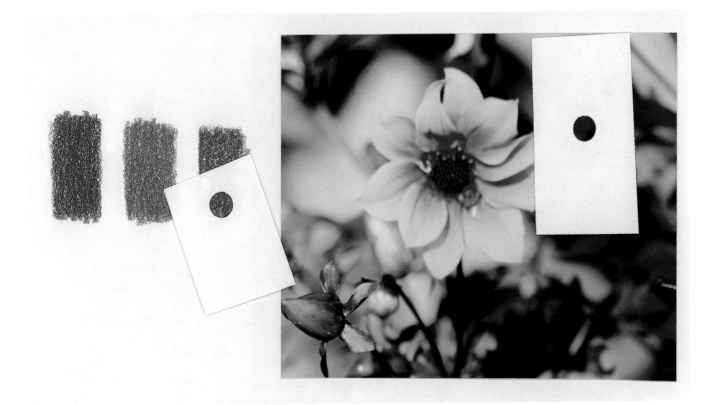

Color Finder
Use a homemade color finder to be accurate in your color choices.

Layering & Burnishing

There are two techniques I use when working with colored pencil. One is called "layering." This is when the colored pencil is applied with a very light touch, using a sharp point. This technique allows the colors to be transparent. Colors can be layered on top of one another, creating new colors, without covering the bottom layers up.

The paper still shows through with this technique, creating a grainy appearance. It creates a less vivid look and is good for creating porous surfaces.

The other application is burnishing. This is when the color is applied heavily, almost like paint. The colors blend together with pressure, and a lighter color is used to soften all of the colors together. Since this heavy approach creates a solid layer of color, subsequent layers of colors can be applied on top of one another and look independent. You can place a light color on top of a dark one since it is opaque.

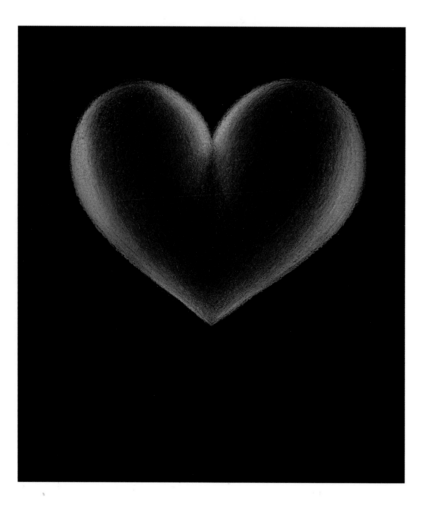

Heavy Layering
Sometimes you will use heavier layering. When using a dark paper, you can layer almost to a burnish. This heavier approach to layering, builds up the color enough to cover the paper, but it does not get heavy. The texture and the color of the paper still show through. In this example, the darkness of the paper was used to create the darker tones in the center.

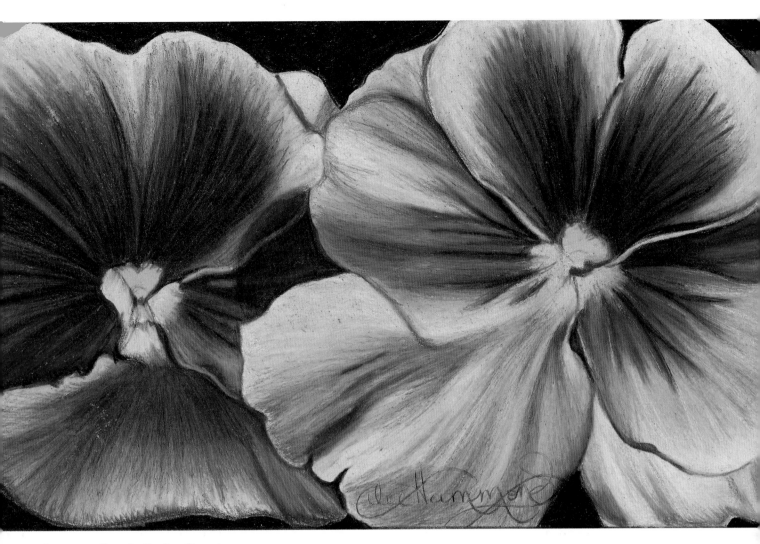

Pansies on Regular Surface Bristol

This is an example of burnishing. It creates a shiner appearance. The complete coverage of the paper makes the colors look more painterly and opaque. In this example, you can see how heavy the colors appear, and how the white shows when placed over the dark.

LEE'S LESSONS

Remember to always keep a sharp point on your colored pencil when you are layering. If you attempt to layer with a dull point on your pencil, the results will look more like crayon. However, for burnishing you'll want to use a dull pencil point. Burnishing with too pointy a pencil will break the tip.

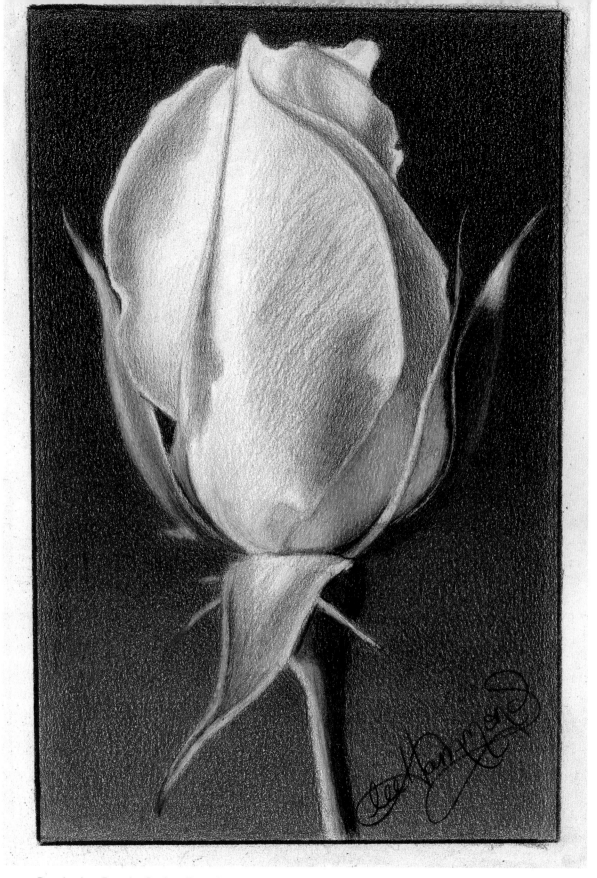

Rosebud on Regular Surface Bristol

This is an example of the layering technique. You can see the paper coming through the colors in a speckling effect in both the flower and the background. This gives it a porous, grainy appearance. It makes the tones more subtle.

Basic Shapes & the Five Elements

To draw anything well, it is important to fully understand the basic shapes that can be found in everything you draw. That, along with the five elements of shading, is what creates realism. The examples below were all drawn on beige drawing paper using the layering approach.

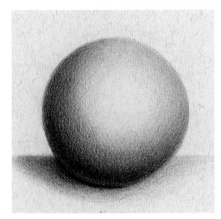

The Sphere

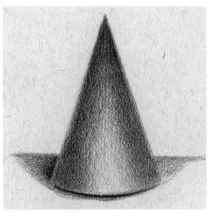

The Cone

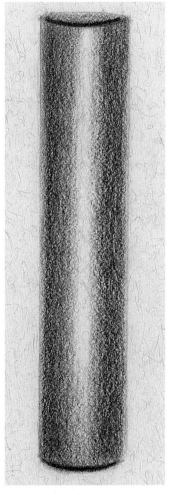

The Long Cylinder

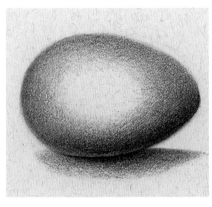

The Egg

The Cylinder

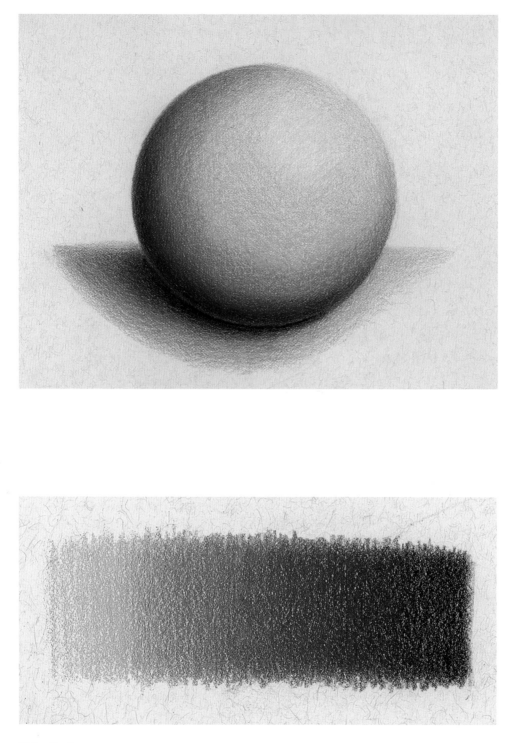

Sphere in Warm Colors

The sphere is the answer to most of your drawing concerns. It shows on its curved surface everything you need to know about creating form and realism. It is also a perfect way to practice layering with your colored pencils. This sphere is done in warm colors. Unlike graphite, where we go from dark to light, colored pencils require undertones. An undertone is the lightest color that can be see underneath all of the rest. In this sphere, yellow is the undertone. The darker colors of orange, red and brown are then placed on top.

Value Scale

To make your colors appear to blend together seamlessly, it is important to practice a value scale first. First apply the yellow. On top of that, apply the other colors. Use an up-and-down stroke, and go back and forth at the same time. This helps reduce the look of pencil lines. A very sharp pencil is needed at all times. If the pencil tip becomes blunt, the lines will appear wide and show too much.

To make the colors blend, it is important to overlap all of the colors. Do not apply one next to another and allow it to be independent. In this scale, each color added is then softened with the previously applied color. For instance, once the orange tones were added, the yellow was then overlapped. When the red was added, the orange was then overlapped. This process integrates the tones more evenly.

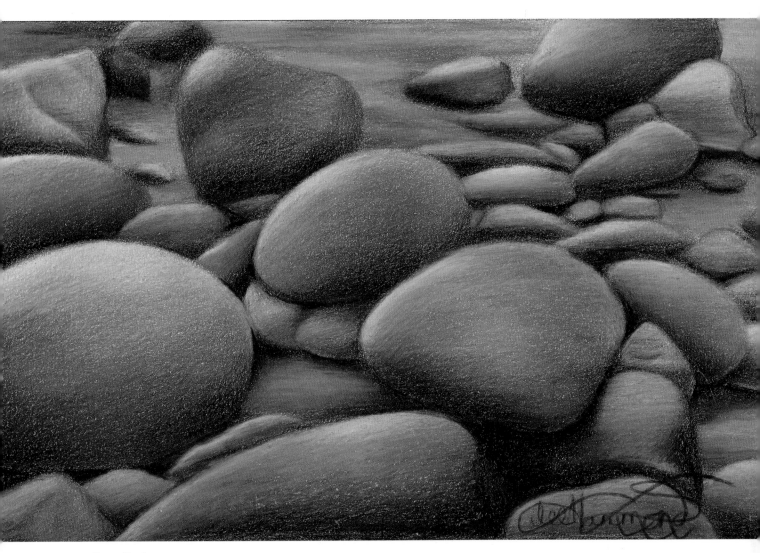

River Rocks

You can see in the drawing of the river rocks what an important role the egg shape plays. A drawing such as this is a good way to experiment with color. I used more than twenty colors here, layering each one of them over each other. The undertone on many of the rocks is Canary Yellow and Neon Orange. This gives them a warm glow. The cooler colored rocks are undertoned with Electric Blue.

This is an example of opposite colors. If you look at a color wheel, blue and orange are opposite one another. This contrast of opposites is what makes these colors appear so brilliant.

This drawing is mostly done in layering. If you look closely, you can still see the texture of the paper coming through. In some areas, however, I used White with a heavier touch to create highlights. Often you will use different approaches and pencil pressure in one drawing. Rarely does one technique alone do the entire job.

Draw a Sphere

The following exercises will show you how the five elements of shading are created on a sphere and an egg. After drawing them, come back and draw each one again using a different color. Practice the value scales first. This sphere is done with yellow and green tones.

Follow the steps to create a sphere in colored pencil.

MATERIALS

Paper
regular surface bristol

Colored Pencils
Chartreuse, Dark Green, Lemon Yellow, True Green

Other
circle template or compass
kneaded eraser
mechanical graphite pencil

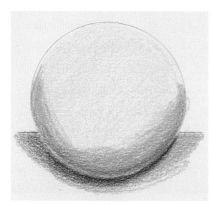

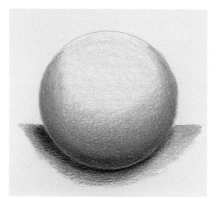

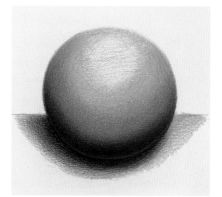

1 Draw the Shape
Use a template to create a circle with a mechanical pencil. (A drinking glass works well.) Apply a layer of Lemon Yellow as the undertone. Apply a cast shadow underneath the sphere with Dark Green. Soften the edges of the shadow with Chartreuse. Add Chartreuse to the shadow edge. This is parallel to the actual edge of the sphere. Add some Dark Green to deepen it.

2 Build up the Shadows
Add more Chartreuse to the shadow edge, and fade it up into the halftone area. Add True Green to the shadow edge and soften into the Chartreuse. Be sure to leave the reflected light area Chartreuse. Do not cover it up. Deepen the lower part of the shadow with Dark Green. Deepen the cast shadow underneath the sphere with True Green. All of these colors must overlap each other to soften the blend. Keep a sharp point on your pencils at all times.

3 Deepen the Tones
Continue to deepen the tones by reapplying all of the colors previously used, and overlapping them for a seamless appearance. Build the colors slowly and evenly until it looks like the example. Remember, always keep a sharp point on your pencils!

Draw a Brown Egg

The egg shape is a very important shape used in drawing. Along with the sphere, it is found in most curved objects. Learning how to do this early on will help you later when you try more difficult subjects such as still life and portraiture. The more you practice things like this, the better your colored pencil skills will get.

Follow the steps to draw a brown egg.

MATERIALS

Paper
regular surface bristol

Colored Pencils
Black, Dark Brown, Mineral Orange, True Blue, Yellow Ochre

Other
kneaded eraser
mechanical graphite pencil

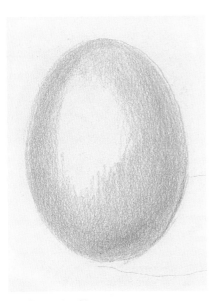

1 Draw the Shape
Lightly draw the shape of an egg and cast shadow with a mechanical pencil. Add the undertone of the egg with Yellow Ochre. Lightly apply the shadow edge to the lower right side of the egg with Dark Brown.

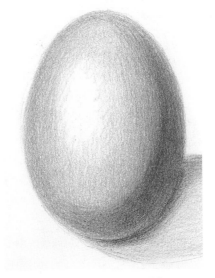

2 Create the Halftone and Deepen the Shadows
Add Mineral Orange to the egg to create a halftone. Deepen the shadow edge with Dark Brown. Start the cast shadow by using True Blue for the undertone. Add some Black directly under the egg.

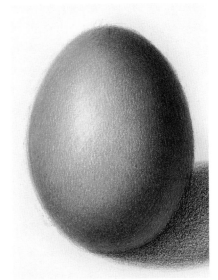

3 Finish the Cast Shadow and Deepen the Colors
Deepen the color of the egg by reapplying all of the colors. Be sure to overlap them for a smooth look. Allow the white of the paper to show in the full light area on the middle left side. Layer more True Blue and Black to finish the cast shadow. Allow the color to fade as it goes towards the right.

Draw Candy

It is important to practice using both the layering and burnishing techniques to fully master colored pencil. When I was creating this book for you, I tried to find as many different subjects and unusual things as possible. I found these peppermints to be a perfect project for the burnishing technique.

Follow the steps to draw pretty pieces of candy.

MATERIALS

Paper
regular surface bristol

Colored Pencils
Black, Dark Purple, Scarlet Lake, Tuscan Red, White

Other
kneaded eraser
mechanical graphite pencil
ruler

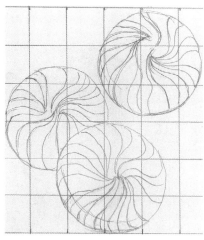

1 Create a Line Drawing
Use the grid method and a mechanical pencil to create a line drawing of some peppermint candies. Make sure the stripes follow the contours of the mints.

2 Fill in the Stripes
When you are sure of the accuracy, carefully remove the grid with a kneaded eraser. Lightly fill in the stripes with Scarlet Lake. This establishes their patterns.

3 Burnish the Stripes and Place the Cast Shadow
Burnish the stripes with Scarlet Lake to make them look vivid and bright. Place a light cast shadow beneath the mints with Tuscan Red.

4 Deepen the Darks and Cast Shadows, Burnish the Lights
Deepen the dark areas of the stripes with Dark Purple to make the mints appear curved and rounded at the edges. Burnish the white part of the mints with White. Burnish the entire area on the sides. Allow the color to smear into the white areas to create form and make the mints look realistically shiny. Deepen the cast shadow with Tuscan Red and Black using the layering technique.

Segment Drawing

One of my favorite things to do is segment drawings. By placing a viewfinder over a small portion of a photo, you can practice techniques without getting overwhelmed by a huge project. I recommend my students create a segment drawing notebook to work through technique problems and to try different subject matter.

If you are having problems learning the different colored pencil techniques, this is a great way to practice. This is an example of one page out of my colored pencil segment notebook. I hope you will do these too. You will learn a lot.

Rose
This is a good example of layering over burnishing. The undertones of the rose were burnished with yellow and orange, and the lines of the petals were then layered on top with various shades of red. I even added a water drop.

Seashell
This is an example of the layering technique. This shell had a lot of interesting textures to capture.

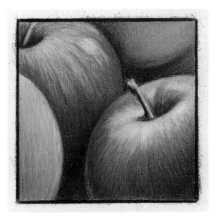

Apples
Apples are always a great way to practice the five elements of shading.

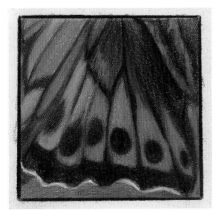

Butterfly Wing
This would give you practice drawing patterns of color.

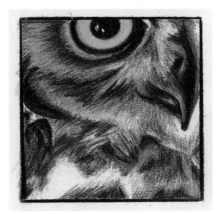

Owl
Drawing birds is not easy. They have a lot of textures and characteristics that must be done right. Drawing a small piece like this is a good way to concentrate on the details.

Tennis Shoe
Even a tennis shoe can make for good practice. This complicated web of laces was a challenge, and it made me really study how light affects the edges of each lace.

Draw in Segments

What you will learn by doing these exercises will help you immensely with your colored pencil skills. Select many different subjects and colors to expand your practice and apply the various techniques.

Follow the steps to create a segment drawing.

MATERIALS

Paper
regular surface bristol

Colored Pencils
Black, Burnt Umber, Dark Green, Dark Umber, Green Ochre, Lemon Yellow, Poppy Red, Spanish Orange

Other
kneaded eraser
mechanical graphite pencil
viewfinder

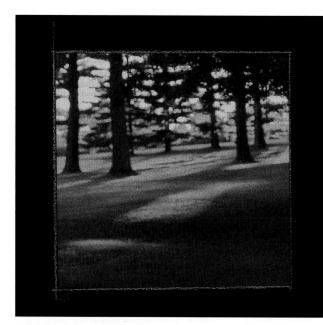

1 Crop with a Viewfinder
Select a large photo and use a viewfinder to crop just a section. You can purchase a viewfinder in an arts and crafts store, or make your own. This viewfinder is a 3-inch (8cm) square that I made out of construction paper.

2 Sketch the Shapes, Begin Laying in Color
Lightly sketch the shapes you see inside the square with a mechanical pencil. If it is a complex pattern or subject, use a grid or divide the square into four boxes. In this example, the shapes were drawn freehand.

Landscapes always start with a horizon line, where the sky and ground meet. Once you've drawn that, place vertical lines for the tree trunks. Lay in the foreground with Lemon Yellow. Carry this color up above the horizon line behind the trees. Use Spanish Orange to deepen the lower right area and to create a shadow diagonally across the middle. Use this color along the horizon line as well.

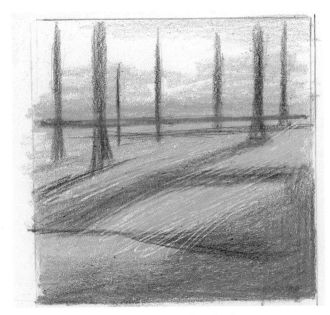

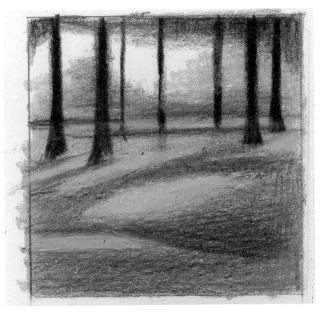

3 Build up the Layers, Develop the Shadows

Built up the colors slowly in layers. Deepen the shadow areas with Dark Umber to develop the light and dark patterns of the shadows. Use this same color to build up the shapes of the tree trunks. Layer over the shadow in the lower right with Green Ochre.

4 Deepen the Shadows and Lay in the Foliage

Layer Green Ochre on top of the shadow areas, then add some above the horizon line. Add some Poppy Red to the edges of the shadows to make them glow orange. Use this same color to suggest the tree row above the horizon line. With Burnt Umber, deepen the upper corners and across the top of the paper to start the illusion of tree foliage.

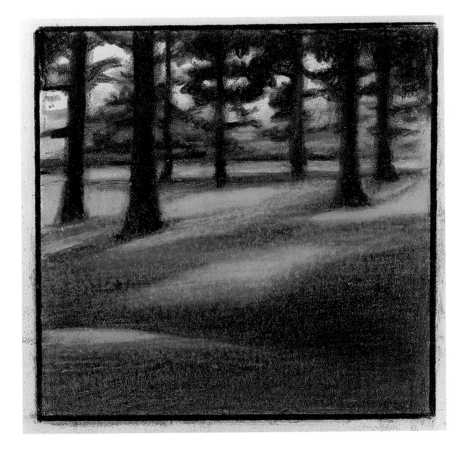

5 Deepen the Trees and Foliage, Finish the Foreground

Deepen the trees with Burnt Umber and build up the illusion of foliage using circular strokes. Deepen them even further with Black. Add Poppy Red to the edges of the tree trunks to make them reflect a look of sunlight. Add Dark Green to the grass areas on the bottom of the drawing. Layer some Black into the center of the shadow to create an illusion of a small hill.

CHAPTER EIGHT
STILL LIFE

Still life drawing is a wonderful way to learn different colored pencil techniques, while getting continuous practice applying the five elements of shading to your work. The roundness seen in fruit, vegetables, jars, vases and pitchers will help train your eye to see form, contours and dimension.

Many common still-life subjects such as fruit also present a great opportunity to practice color theory. The following pages will show you how color can be used to grab the viewer's eye. You'll get to have some fun exercising your artist's license—experiment with enhancing the colors as you work to make your art more appealing.

Plums in a Bowl
Colored pencil on regular surface bristol
8" × 8½" (20cm × 22cm)

Fruits & Vegetables

Fruits and vegetables are the perfect next step when exploring colored pencil. Their rounded shapes closely resemble the sphere and the egg shape, so you can continue your practice with the five elements of shading. They also provide practice with layering and burnishing.

Combining Techniques

These apples are a good example of using a combined technique. The drawing is burnished with layering on top. This allows a shiny surface to appear glossy while still showing surface texture and color.

Burnished, Then Blended

This area is heavily burnished. The yellow and white are burnished and blended together like paint.

Burnished, Then Layered

This area shows the small striations seen in apple skin. These were created using layered pencil strokes on top of an area that had already been burnished.

Burnishing

The technique you choose should be dependent on the look of your subject matter. The bright, smooth colors of this apple were created with heavy burnishing. The black background was also heavily burnished. (The paper is actually an ivory color.) The striations of the apple skin were drawn on top of the burnished surface. It was sprayed with a glossy varnish to make it look even shinier. While this effect is often hard to see in a reproduction, the look of it in person in amazing.

Burnishing and Layering

These oranges have a textured skin but are solid in color. Burnishing was used first, followed by a heavy application of yellow and orange tones. Then the red and brown tones were layered on top. The illusion of the dimpled surface was created using circular strokes. The background was also layered.

Draw Grapes

For practice with the burnishing technique, a few grapes have been isolated from the larger drawing below.

Follow the steps to draw grapes.

MATERIALS

Paper
regular surface bristol

Colored Pencils
Carmine Red, Crimson Red, Pink, Tuscan Red, White

Other
kneaded eraser
mechanical graphite pencil

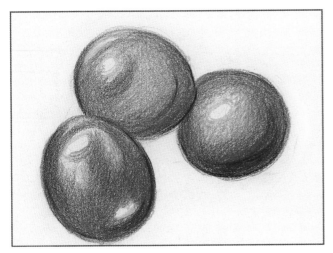

1 Draw the Shapes and Begin Layering
Lightly draw the shapes of grapes with a mechanical pencil. Their shape resembles a mix of the egg and the sphere shapes. Undertone the grapes with Pink. Use a layered approach for the first application. This creates a color map. Add Carmine Red around the edges. Allow it to fade into the Pink. Add Crimson Red to the lower right of each grape. Create shadow edges with Tuscan Red. Allow the white of the paper to represent the highlights.

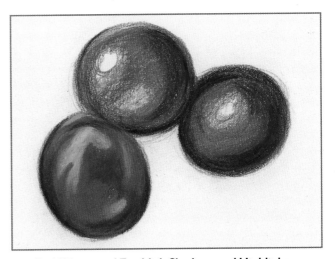

2 Build Tones and Establish Shadows and Highlights
Increase the pressure on your pencil to start burnishing. Reapply all of the previous colors. Burnish over them with Pink, softening each color into another. Establish the pattern of shadows and highlights while the colors build up. Once the colors are burnished together, heavily apply White to the highlight areas. This will give the grapes a smooth, shiny appearance.

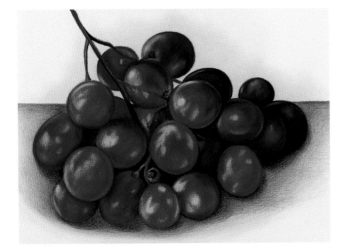

The Finished Drawing
Each grape in this finished drawing has a unique pattern of highlights and shadows. You can see how important burnishing is in creating a shiny look. For textural contrast, layering was used underneath in the cast shadows. Dark Purple and Black were applied to the shadow areas on each grape. Those colors are reflected underneath in the cast shadows on the table. The cool blue contrasts the red colors of the grapes.

Draw Water Droplets

You can add water droplets to emphasize the shiny surfaces of fruit. While water drops may appear difficult to draw, they are actually nothing more than little sphere exercises.

Follow the steps to draw water droplets.

MATERIALS

Paper
regular surface bristol

Colored Pencils
Crimson Red, Orange, Spanish Orange, Tuscan Red, White

Other
kneaded eraser

1 Lay in the Undertone, Create Shapes and Shadows
Lay down the undertone with Spanish Orange. Draw the shape of water droplets with Crimson Red. Leave the top of the circles open—do not outline them all around. Create a little cast shadow underneath with Crimson Red. Add a small shadow inside of the drops.

2 Deepen the Colors and Add Cast Shadows
Deepen the color around the drops with Orange. Add some Orange inside the drops on the left side. With Tuscan Red, add cast shadows directly underneath the drops.

3 Continue to Deepen the Tones and Shadows, Add Highlights
Deepen the red tones on the right side with Crimson Red. Deepen the cast shadows with Tuscan Red. Burnish in the highlights with White.

Draw Onions

This exercise will give you some practice using both layering and burnishing together. While the colors of these onions are very light, some burnishing was still required to make them look real. It is the light coating of white over the colors that makes them look authentic.

Follow the steps to draw onions.

MATERIALS

Paper
regular surface bristol

Colored Pencils
Black, Dark Umber, Lavender, Mineral Orange, Salmon Pink, Tuscan Red, White, Yellow Ochre

Other
kneaded eraser
mechanical graphite pencil
ruler

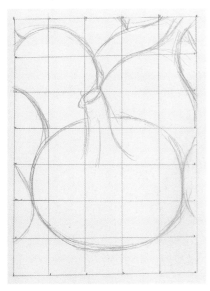

1 Create a Line Drawing
Use the grid method and a mechanical pencil to create a line drawing of onions.

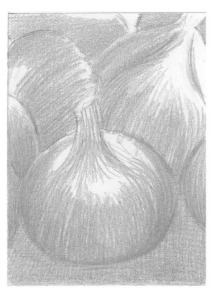

2 Lay in the Undertones, Build up Texture and Form
When you are sure of your accuracy, carefully remove the grid lines with a kneaded eraser. Lay in the undertone of the onions with Yellow Ochre. Since there are a lot of white areas on the onions, do not fill them in completely. Allow the pencil lines to show through. This helps the look of the onion skin. Add some Salmon Pink to the onions with the same streaked look. Follow the contours to show the roundness. When drawing rounded objects it is important to add color in a way that creates the five elements of shading. But, unlike the sphere exercises, you are addressing the patterns and textures of the onion skin at the same time. Add pencil lines in a way that creates texture and form.

3 Continue Building Layers
Add a layer of Mineral Orange. Follow the rounded contours to deepen the color on the lower portion of the onions. Leave the upper part lighter. With Tuscan Red, apply cast shadows into the V-shaped areas where the onions overlap as well as to the onion in the middle left. Apply a cast shadow below the onions with Tuscan Red. Deepen it with Dark Umber. Add some dark Umber to the wood grain of the table. Add Lavender to the center of the main onion, going up into the stem. Use light Black squiggly lines to create the end of the onion behind it.

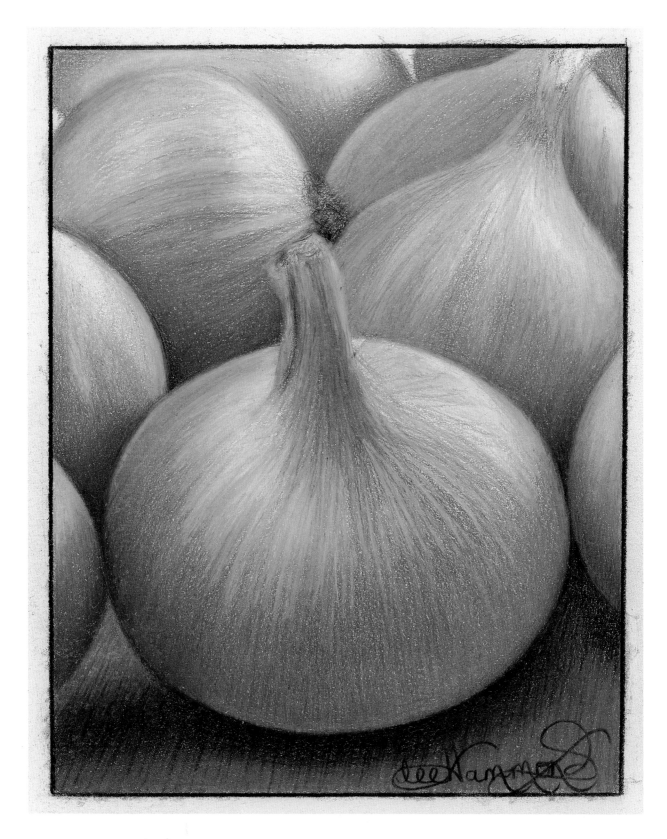

4 Deepen the Colors and Burnish

Continue adding colors until everything appears more filled in and colorful. Continue to use pencil lines to replicate the onion skin. Add Dark Umber to the stems of the onions. Deepen the color of the wood table with Yellow Ochre, Mineral Orange and Dark Umber. Use Yellow Ochre to lightly burnish over it to make it look shinier. With White, lightly burnish over the colors to make them appear smoother. Reapply any colors that need to be brighter.

Pencil Strokes Create Surface Texture

It is important to remember that the lines you draw with the pencil create the surface texture of your subject. This drawing has many of the same elements as the onions, but the type of pencil lines used to create them was different. Instead of curved lines that follow the contours, small circular strokes were used.

The wood grain of the table and the wooden bowl were created with the same colors, but the grain itself was created with carefully placed pencil lines. The wood grain on the table is straight to depict a flat surface. The wood grain of the bowl is curved to depict a rounded surface.

Notice how the wood grain of the table is much more obvious up front because it is more in focus. As it recedes, the colors are burnished together to lose the definition and make it look blurry. This gives the illusion of depth.

A craft knife was used to scrape some of the light lines into the wood grain. My signature was also scratched out. Scratching is a wonderful method for creating tiny, thin lines in your work. However, it should only be used with heavy burnishing. Be careful not to go too deep or you might gouge a hole in your paper.

Glass

We've covered how to draw shiny things in previous sections, and glass is definitely shiny. But what should you do when something is transparent? It certainly adds a new challenge into the mix, but transparency can be fun to draw. I'll show you the tricks to making an object appear see-through and dimensional all at the same time.

To create a look of transparency, it is important to capture the patterns of light and dark reflecting off the glass. These patterns are caused by light reflection, shadows and surrounding surfaces shining through. It is the way you capture the patterns that tells you which surface you are looking at.

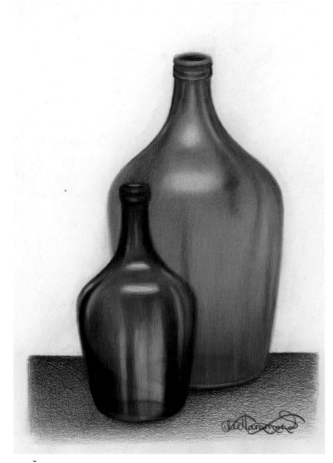

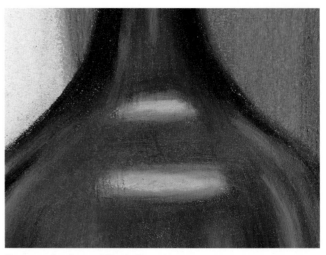

Extreme Light and Dark Contrasts
The extreme contrasts between dark and light make this bottle look very transparent. The highlights and shadows on this bottle are much deeper and brighter than the bottle behind it.

Less Is More with Pencil Pressure
These bottles with their rich deep colors were perfect for burnishing. They are the same general color, but the smaller one is highly transparent, while the larger one is more opaque. Creating these differences is less about the pressure of your pencil, and more about the colors you use. Do not push too hard when applying multiple layers of color. It is important to lighten your touch as you build it up. Pushing too hard will simply push the wax layer aside and remove what you already did. A light touch with a lighter color will burnish the darker colors together. More contrast between light and dark makes things appear shinier.

Allow Background Shapes to Show Through
Transparency is depicted by allowing shapes to show through a subject from behind. Here you can see the bottom of the bottles through the glass. The tones going vertically down across this area make it look like the outside surface of the bottle. The bottoms now look like they are coming from behind.

PAY ATTENTION TO PATTERNS

Glass has a lot of varying characteristics. Sometimes it will appear extremely smooth and almost frosted. Other times it will have many patterns created by the shape of the glass itself and the contents within it. The most important thing to keep in mind when drawing glass and other transparent things is to pay attention to the patterns of color and the patterns of light and dark.

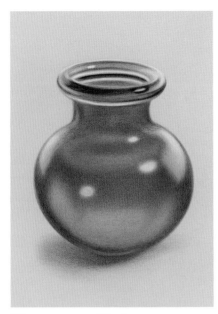

Observation and Replication

This drawing of a vase started out with a very slow buildup of layers of color. But the more color that was added, the more color I began to see in my reference. At first glance, the vase looked blue. Then I noticed the pink tones. Then I needed to add purple, violet, lavender and more deep pinks. Before I realized it, the blue was no longer as noticeable. Remember it is about observation and replication. Quality is more important than speed. Never rush!

Distinct Patterns

Unlike the little vase, this drawing is heavily burnished. It actually was easier to draw although it appears more difficult. When something has a lot of distinct patterns, as seen here in the ice cubes and the shape of the glass, it is easier to capture. All of the geometric shapes come together like a puzzle. It is the smooth stuff that requires a seamless application over a wide area, which takes the most patience.

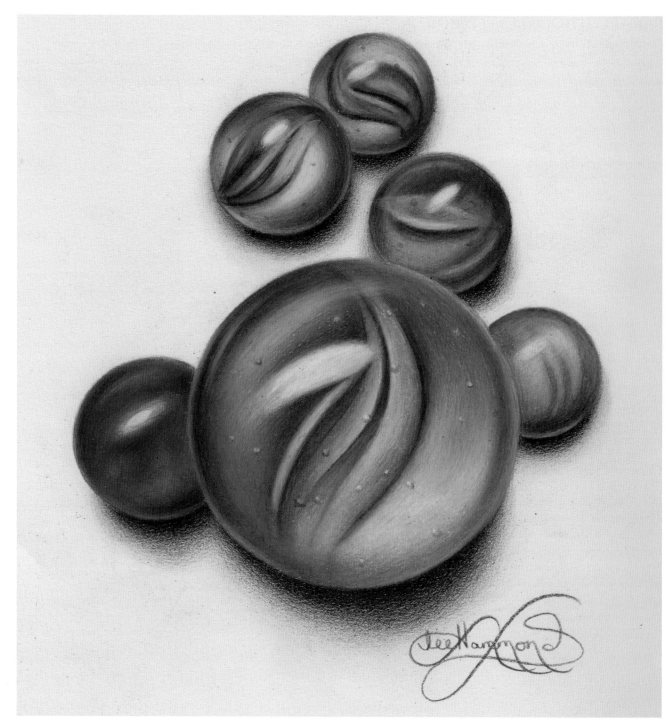

Patterns of Color

Color is very reflective, and marbles are made up of patterns of color. Heavy burnishing makes them glassy and shiny. The small air bubbles make them appear transparent. The color of the marbles bounces down into the shadow areas.

Abstract patterns are often seen in glassware, especially with swirled colors. But in these marbles, the rules somewhat change. When they have a definite shape inside, it is important to maintain it.

Here you can see two areas of patterns—the colored centers and the colors being reflected on the outer shiny surfaces. The way you apply the outer reflected colors is what makes them look round and dimensional.

GLASS ON A BLACK BACKGROUND

Drawing on a black background requires a lot of burnishing to cover the paper surface. Remember that color will appear much different on black than it does on white. I suggest testing your colors on a scrap of paper to see how they will look.

Keep in mind that some colors are more opaque than others. Not all colors will cover the black. A good rule of thumb is to select colors that have a touch of white in them. Any color with white in its makeup will cover better. For instance, Carmine Red will cover better than Crimson Red. Jasmine will cover better than Canary Yellow. True Green will cover better than Grass Green.

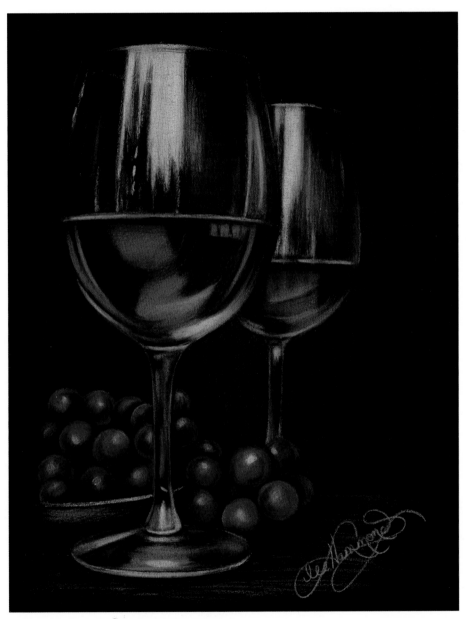

Black Backgrounds Create Dramatic Effects

Drawing on a black background can give a drawing a dramatic effect. To enhance it further, you can add just a hint of color. (I placed a touch of green into this background.)

Due to the heavy burnishing, this drawing required spraying with workable fixative when completed. Black paper will make the wax bloom more obvious, causing it to look dull and hazy. Spraying with fixative will make the colors vivid once more.

DEMONSTRATION

Draw a Crystal Goblet

When learning anything, it is important to start slow and not tackle things that are too difficult too soon. This exercise will show you how to draw glass using only gray tones.

Follow the steps to draw a crystal goblet.

MATERIALS

Paper
regular surface bristol

Colored Pencils
Black, Cool Grey 10%, Cool Grey 30%, Cool Grey 70%, White

Other
kneaded eraser
mechanical graphite pencil
ruler

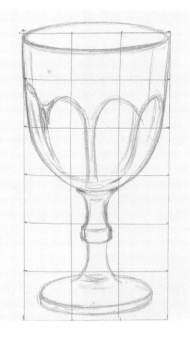

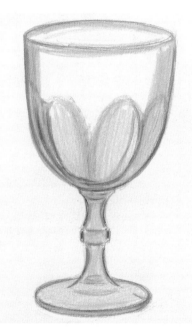

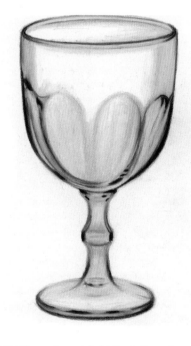

1 Create a Line Drawing
Use the grid method and a mechanical pencil to create a line drawing of a glass goblet.

2 Apply the Shadow Areas and Deepen the Edges
When you are sure of your accuracy, carefully remove the grid lines with a kneaded eraser. Apply the shadow areas of the glass with Cool Grey 10%. They are on the bottom and the sides. Deepen the lower edges and the motifs with Cool Grey 30%.

3 Burnish and Add Dark Details
Burnish over the tones with White to soften the colors together. Add the darker details with Black to finish the drawing.

DEMONSTRATION
Draw a Drinking Glass

The shape of this drinking glass is not perfectly symmetrical. The edges are somewhat irregular. The different blue tones and the patterns they create are easier to draw than you might think.

Follow the steps to draw a drinking glass.

MATERIALS

Paper
regular surface bristol

Colored Pencils
Black Grape, Cool Grey 90%, Non-Photo Blue, Parma Violet, Violet Blue, White

Other
kneaded eraser
mechanical graphite pencil
ruler

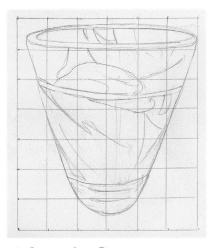

1 Create a Line Drawing
Use the grid method and a mechanical pencil to create a line drawing of a drinking glass.

2 Begin Laying in Color
When you are sure of your accuracy, carefully remove the grid lines with a kneaded eraser. Study the shapes and colors of the glass. You can see how the geometric patterns have been assigned a color at this stage. Apply the colors listed above and shown here. This is called a color map.

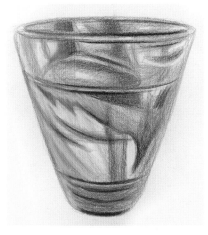

3 Deepen and Darken the Tones
Deepen the colors you first applied. Then add darker colors. (You can see where Black Grape has been applied.) The glass should now appear abstract.

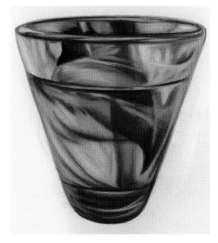

4 Burnish
Burnish the colors smooth with White. Continue to deepen the colors as needed and burnish them smooth. Anytime you add a color, reburnish it with the White. This glass had swirled colors in the glass itself, so the patterns you create do not need to be exact.

Draw a Marble

Many of my students think marbles are beautiful but much too difficult to draw. However, they are not as hard to master as you might think.

Follow the steps to draw a marble.

MATERIALS

Paper
regular surface bristol

Colored Pencils
Black, Canary Yellow, Cool Grey 70%, Orange, True Blue, Ultramarine Blue, White

Other
circle template or compass
kneaded eraser
mechanical graphite pencil

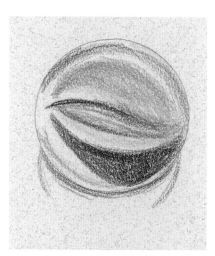

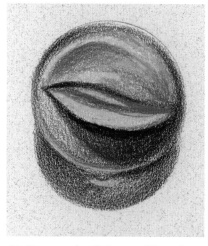

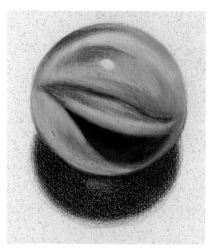

1 Draw the Shape and Begin Layering Colors
Use a circle template or compass and a mechanical pencil to draw a perfect circle. Study the patterns and apply them from light to dark. Add Canary Yellow first, then add Orange. Next, add the True Blue and Ultramarine Blue. Leave a bit of reflected light around the edges. This is very important for making the marble appear round and spherical. (Always remember the sphere!) Add a small amount of the Cool Grey 70% underneath to start the cast shadow.

2 Deepen the Colors and Develop the Cast Shadow
Deepen the colors as shown. Further develop the cast shadow underneath with Black. Notice the small amount of yellow in it.

3 Burnish
Burnish over the colors with White. This is what makes the marble look like glass. You can deepen the colors numerous times, but be sure to burnish them with White each time. Burnish a bright circular highlight with White in the upper middle. Finish the cast shadow using the layering approach. It has a small amount of Orange around the edge.

Metal

Drawing metal is very similar to other shiny materials like glass. But metal is much more reflective of color, and the lights and darks can be extreme. Few take into consideration the amount of reflective color there is when drawing realistically.

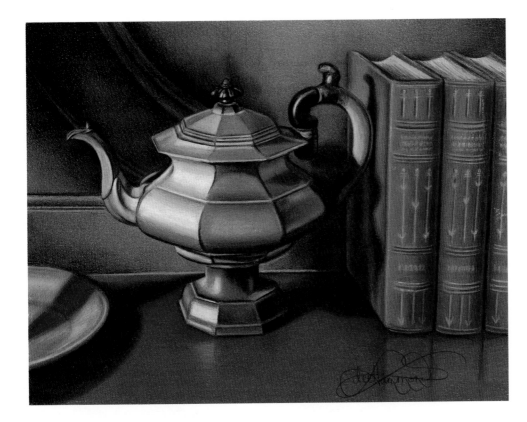

Achieving Reality Through Color

This drawing is a great example of using colored pencil tricks to achieve the look of metal. You can see all of the applications we've been exploring for making things look real with color, especially when there are a lot of different textures to capture. Note: This drawing is not entirely burnished. The background is actually repeatedly layered. It took a lot of time to build up the colors without burnishing too much.

Reflected Highlights and Colors

The hallmark indications of a metal surface are the many highlights and colors reflected in it.

Mirrored Image

This shiny wood tabletop reflects the colors of the books above. It is like a mirrored image.

Undertones and Layering

The spines of these books were a bit of a challenge. Spanish Orange was applied heavily to create the yellowish undertone. Then Crimson Red and Poppy Red were layered on top. To create the illusion of lettering and detail, designs were scratched out with a small craft knife. This revealed the yellow tones below.

Draw a Pitcher

Drawing metallic surfaces in colored pencil opens the door for all kinds of interesting drawings. Sometimes it is helpful to start with black-and-white objects. This silver pitcher shows how metal creates distinct patterns of light and dark. As always, remember the sphere and the five elements of shading as you draw. You can definitely see shadow edges (turning shadows) and reflected light along the edges.

Follow the steps to draw a pitcher.

MATERIALS

Paper
regular surface bristol

Colored Pencils
Black, Cool Grey 90%, Warm Grey 50%, White

Other
kneaded eraser
mechanical graphite pencil
ruler

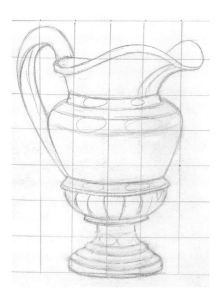

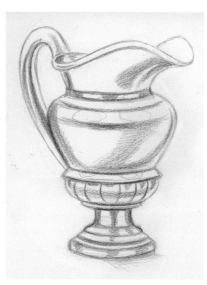

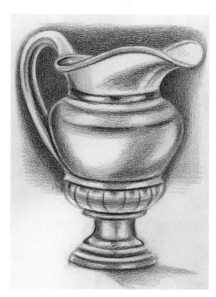

1 Create a Line Drawing
Use the grid method and a mechanical pencil to create a line drawing of a silver pitcher. Make sure it appears symmetrical. Refer to the information on drawing ellipses from earlier in the book.

2 Apply the Shadow Edges
When you are sure of your accuracy, carefully remove the grid lines with a kneaded eraser. Lightly apply the shadow edges with Cool Grey 90%, using the sharp point of your pencil. This creates the illusion of form. Be sure to leave areas for the reflected light around the edges.

3 Create Light Edges and Deepen the Shadows
Add some Cool Grey 90% into the background to create the light edges of the pitcher. (Remember, dark creates light.) Add the cast shadow below the pitcher on the right side with Cool Grey 90%. Deepen the dark shadow areas on the pitcher with Cool Grey 90%. To transition the shadows into the full light areas, apply some of the Warm Grey 50% next to them. This creates a value scale from dark to light.

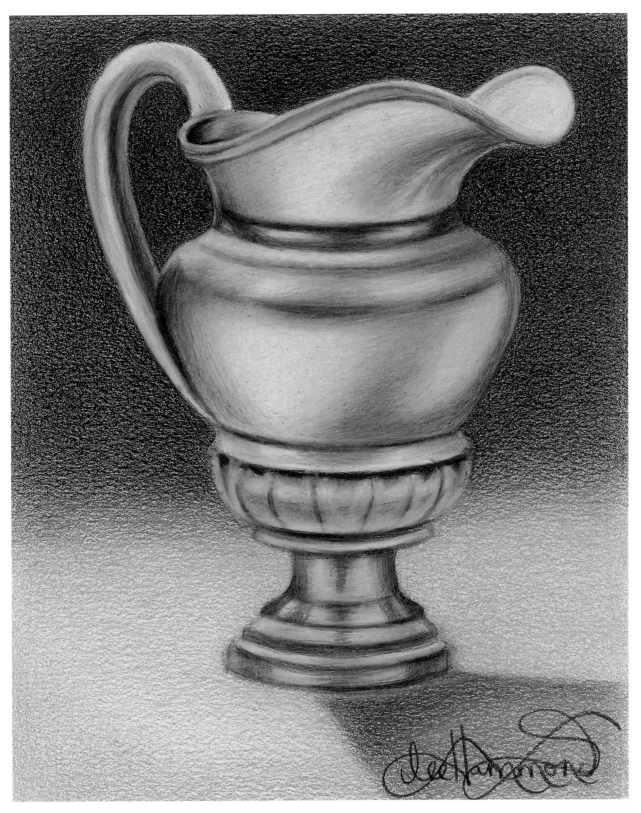

4 Burnish and Finish the Background

Burnish the entire drawing with White to soften the colors and make it look shiny. You can reapply any of the Grey tones once more if they appear too light now. But you must burnish with White afterwards to blend it together.

Finish the background by creating another value scale from dark to light. Layer it slowly. Start the dark areas with Cool Grey 90%, then add Black on top. Apply the midtone with Warm Grey 50%. Add the cast shadow with Cool Grey 90%. The cast shadow should slowly get lighter as it moves away from the pitcher.

Draw a Spittoon

This drawing is similar to drawing the sphere shapes found in nature, but its colors require a different approach. Brass is very colorful, and the colors of the background reflect into it as well. This drawing is heavily burnished to make it look shiny and reflective.

Follow the steps to build up the colors and patterns of a spittoon.

MATERIALS

Paper
Strathmore toned gray paper

Colored Pencils
Aquamarine, Cool Grey 90%, Pale Vermilion, Sunburst Yellow, White

Other
kneaded eraser
mechanical graphite pencil
ruler

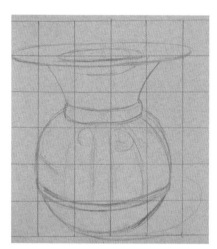

1 Create a Line Drawing
Use the grid method and a mechanical pencil to create a line drawing of a spittoon. Make sure it appears symmetrical.

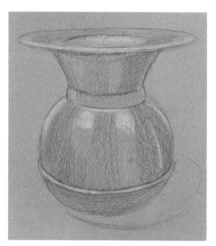

2 Map in the Tones and Apply Highlights
When you are sure of your accuracy, carefully remove the grid lines with a kneaded eraser. Map in the tones and patterns with Sunburst Yellow as shown. Then add Pale Vermilion. Apply the highlight areas with White. You can see how bright it appears against the toned paper.

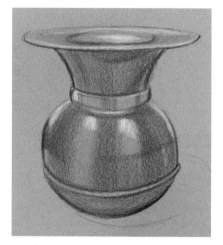

3 Build up the Tones
Build up the previous tones to make them brighter and more filled in. Apply some Cool Grey 90% into the darker areas as shown.

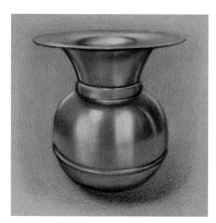

4 Continue Adding Layers and Burnishing
Burnish the colors to make them appear shiny. Apply a layer of White to blend. You can reapply any of the colors as needed, but be sure to burnish them each time with White. Layer Aquamarine into the background. Add Cool Grey 90% to the cast shadow below using the layering technique. You can see some of the Sunburst Yellow reflecting into it. To soften the background, layer—don't burnish—some White over the Aquamarine to make it look smoother.

Textures

You should always look for the small nuances of color and patterns in everything you draw. However, this is especially true when drawing textures. The close-ups below illustrate the importance of small details when drawing textures realistically.

One Drawing, Many Surfaces
This vase is a good example of combining different types of surfaces and techniques in one drawing. It required the burnishing technique for the metallic gold, the red glass and the wood grain. The background was done with the layering technique.

Extreme Highlights
The gold metal surface reflects all of the red tones seen in the vase. The extreme highlights make this area appear very shiny.

Transparent Effect
The glass here looks transparent. The yellow highlights make it appear as if you are looking through it.

Reflected Colors and Highlights
The colors of the vase reflect down into the table. The highlights make the surface appear like polished wood.

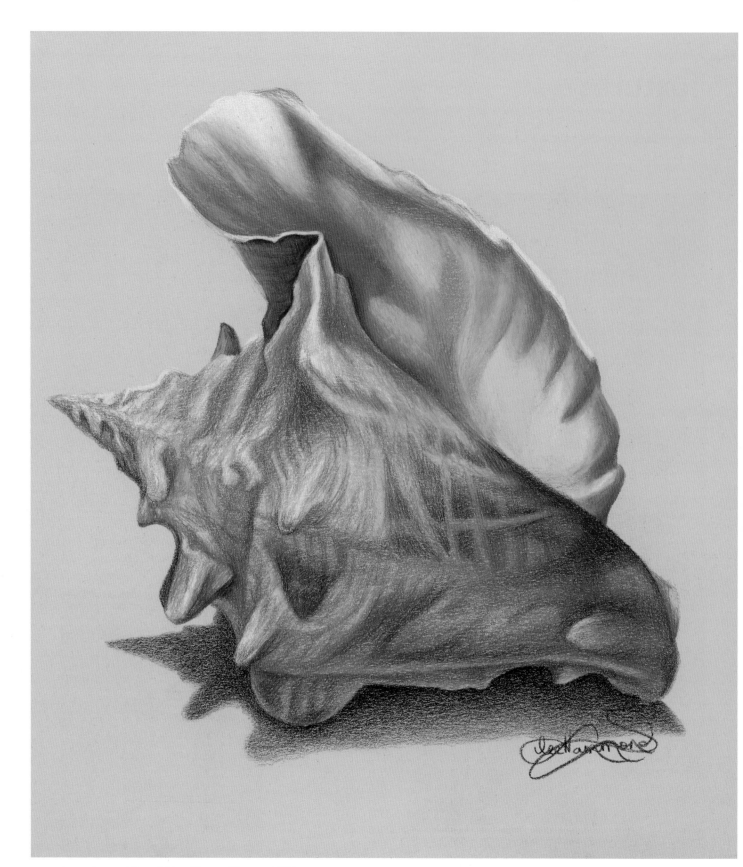

Layering and Burnishing Create Textured Effects

This shell was drawn using both layering and burnishing. The outside of the shell is very rough and porous, so layering was required. The cast shadows were also created with layering.

 The inside of the shell is very shiny and smooth, so burnishing was used to make it appear glossy.

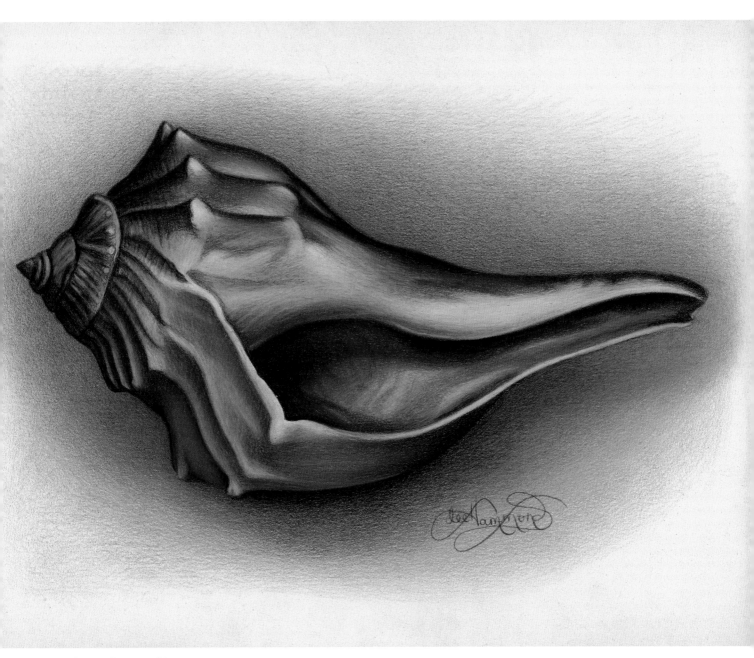

Warm Colors Create a Glow

This shell is much smoother than the conch shell, so it was drawn with the burnishing technique.

The background colors help enhance the drawing by utilizing opposite colors—green and blue opposite the red and orange tones of the shell. The warm colors under the shell reflect up onto it, making it glow.

Draw Wood Grain

This exercise shows many of the tricks that can be used for creating various textures and how these types of small realistic details are done in colored pencil. As we covered in the Graphite section, drawing wood is not as difficult as it may appear.

Follow the steps to draw wood grain.

MATERIALS

Paper
regular surface bristol

Colored Pencils
Black, Chocolate, Sand, Terra Cotta, Tuscan Red

Other
craft knife
kneaded eraser

1 Lay in the Undertone
Lay in the light undertone. In this case the yellow color of Sand is applied first.

2 Apply Vertical Strokes and Shadows
Start creating the look of wood grain with vertical strokes of Terra Cotta. Add a hint of the shadow area with Chocolate. Add some Chocolate into the wood grain as well, using the same vertical strokes.

3 Build up the Colors and Burnish
Build up the colors until they burnish. Add some Tuscan Red into the wood with vertical strokes. Burnish everything with Sand. Use Chocolate and Black in the shadow areas, then burnish those with Sand as well. You can add some tiny light lines into the wood grain with a small craft knife. This gives it the illusion of texture.

Draw a Pearl

This exercise creates various textures using a segment drawing. The multiple textures, including the smoothness of the shell, the glossy sphere of the pearl and the texture of the sand, make this a great little practice piece. This drawing is also an example of warm and cool colors. The shell picks up the warm colors of the sand, and the pearl picks up the cool colors of the sky.

Follow the steps to draw a pearl.

MATERIALS

Paper
regular surface bristol

Colored Pencils
Black, Cool Grey 50%, Dark Brown, Sand, True Blue, White

Other
kneaded eraser
mechanical graphite pencil
ruler

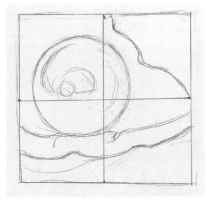

1 Create a Line Drawing
Use a mechanical pencil to create a line drawing of the shapes seen within this small segment. The four squares will help you be more accurate. Draw lightly.

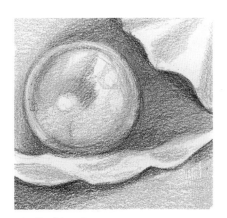

2 Build up Layers
When you are sure of your accuracy, carefully remove the squares with a kneaded eraser. With a light layered approach, apply a color map as shown. Apply Sand behind the pearl on the right and under the shell on the bottom. Add Cool Grey 50% to the shadow areas on the pearl, along the left side of the pearl and under the scalloped edges of the shell. Add Dark Brown to the inner shell on the right to create a shadow. Do the same under the shell on the left side. Add some Sand to the right side of the pearl. Add a small amount of Black to deepen the cast shadows under the shell and the turning shadows of the pearl. Add True Blue to the recessed areas of the shell, as well as to the area left of the pearl, and into the contour of the pearl on the left.

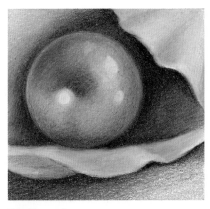

3 Burnish
Burnish the shell and the pearl with White, Burnish all of the colors of the pearl and the shell, but do not burnish the sand. It needs to remain grainy. When burnishing such a glossy surface, you will need to add color and burnish in repeated layers. Do not press too hard or you will push through the wax, removing it. After the first heavy burnishing, a light touch with the colors is the trick to adding more without ruining the underneath layers.

CHAPTER NINE
NATURE

This chapter will show you how to create some of the gorgeous images found in nature. All of the colors of the rainbow are found in natural settings, from extreme to subtle hues.

Being the color fanatic that I am, I often find myself creating pieces of art with nature at its core. I love drawing flowers, leaves and butterflies because of their amazing colors, but I also love the many textures and shadows seen within them. These types of subjects will test your drawing skills and force your artist's eye to really see.

The beauty of nature offers the artist an endless array of subject matter. As I always say: There is never a lack of subject matter, just an absence of creativity.

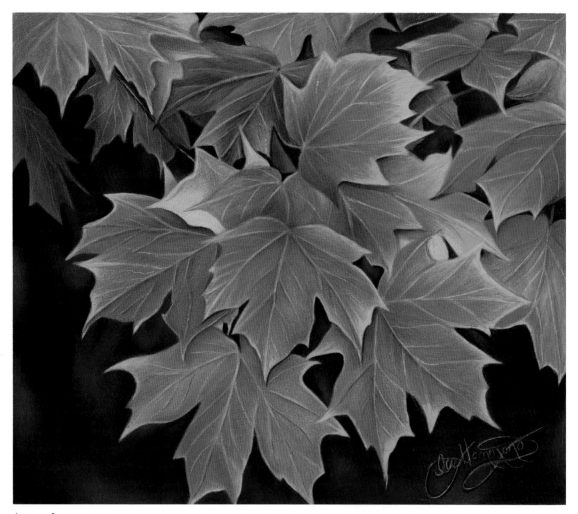

Autumn Leaves
Colored pencil on heavy mat board
13" × 14" (33cm × 36cm)

Layering & Burnishing

The different techniques that can be applied and the various looks that can be achieved with colored pencil are endless. Both of the flowers below were created with the same colors. However, the closed flower was done with layering, while the full bloom was done mainly with burnishing.

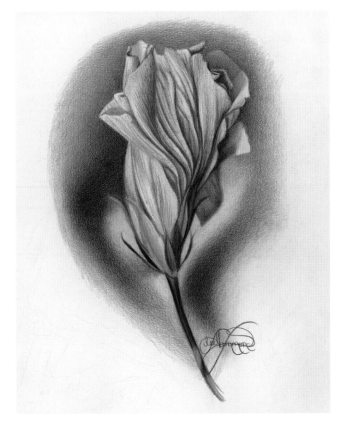

Fine Lines with Layering
The layering process allows you to get very fine lines with colored pencil, giving the wilted petals of the flower a crepe-like surface.

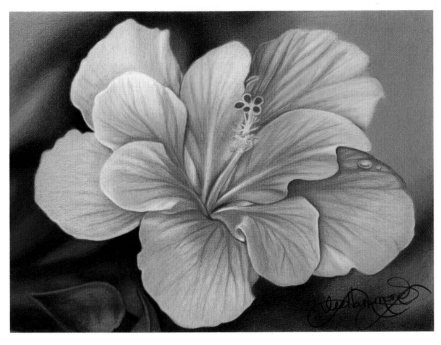

Burnishing for Smooth Tones
Burnishing allows you to get deep, smooth tones as with the background in this piece. It appears blurred and out of focus, directing all of the attention to the flower. The surface of the flower was layered first, then lightly burnished with White to soften the surface.

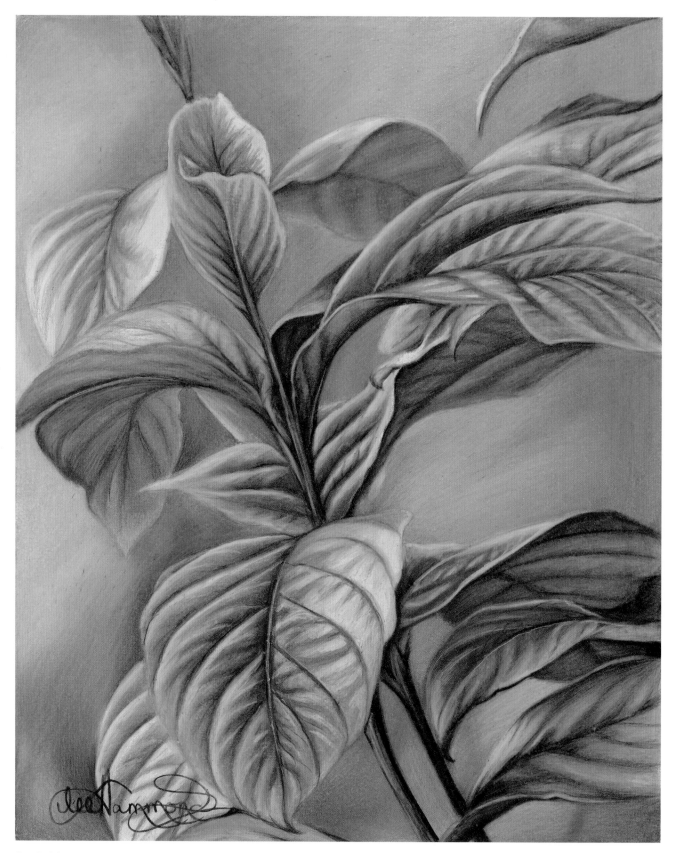

Bright Tones and Heavy Burnishing
Vibrant colors and heavy burnishing were used to
make these leaves look extra bright and shiny.

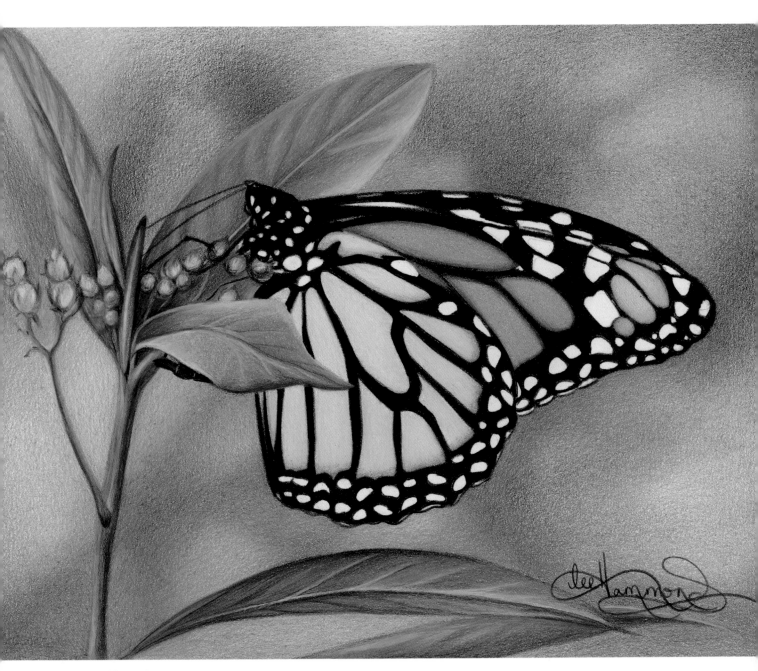

Layering and Burnishing

This drawing was done with both the layering and burnishing techniques. The orange colors of the butterfly were heavily burnished. So were the leaves of the plant.

The background was slowly layered with overlapping colors to give it a diffused, out-of-focus appearance.

The spots of the butterfly were burnished in with White. If I had just left the white of the paper, they would not have appeared as bright.

Black was burnished in after everything else was completed. Leaving it for last prevented smearing.

Draw a Spring Leaf

Follow the steps to draw a bright, shiny spring leaf.

MATERIALS

Paper
regular surface bristol

Colored Pencils
Black, Dark Green, Grass Green,
Yellow Chartreuse

Other
kneaded eraser
mechanical graphite pencil

1 Draw the Leaf Shape, Begin Applying Color
Start the leaf by drawing the overall shape with a mechanical pencil. Lighten up your pencil lines with a kneaded eraser so they won't be too dark when you apply the color. (Applying light layers of colored pencil over graphite makes the lines look black, and they are not easy to remove.)

Fill in the entire leaf with Yellow Chartreuse. Begin the look of veins with Grass Green.

2 Build up the Leaf
Continue adding the veins of the leaf with Grass Green. Add more Grass Green to the upper portion.

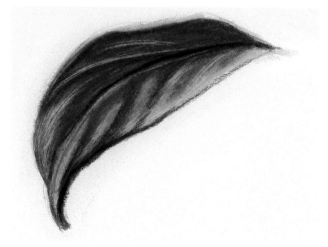

3 Deepen the Tones
Add Dark Green to deepen the tones, allowing the lighter colors to show in highlight areas. With Black, deepen the color of the veins and the lower edge.

Draw an Autumn Leaf

Now let's draw a leaf that is a little more advanced. This maple leaf has a lot of colors. Autumn leaves are a great combination of shapes and colors. Their noticeable veins will also give you an opportunity to practice using a craft knife.

Follow the steps to draw an autumn maple leaf.

MATERIALS

Paper
regular surface bristol

Colored Pencils
Black, Canary Yellow, Grass Green, Orange, Poppy Red, Tuscan Red, Warm Grey 70%

Other
craft knife
kneaded eraser
mechanical graphite pencil
ruler

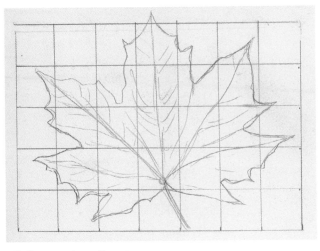

1 Create a Line Drawing
Use the grid method and a mechanical pencil to create a line drawing of a maple leaf.

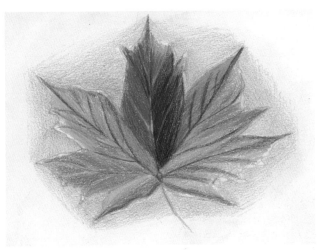

2 Begin Applying Color
When you are sure of your accuracy, carefully remove the grid lines with a kneaded eraser. Lay in the entire leaf with Canary Yellow. Add Orange to the veins of the leaf and the surface.

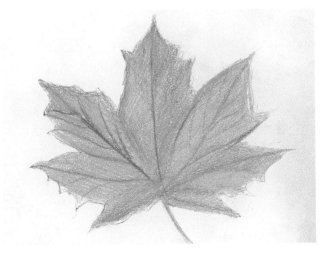

3 Deepen the Tones and Lay in the Background
Deepen the color of the middle area of the leaf with Poppy Red. Add this color to the lower leaf as well. It is not necessary to use a lot of pressure in this step. Deepen the red tones in the middle with Tuscan Red. Add Grass Green in the areas shown. Apply a light application of Warm Grey 70% to the background.

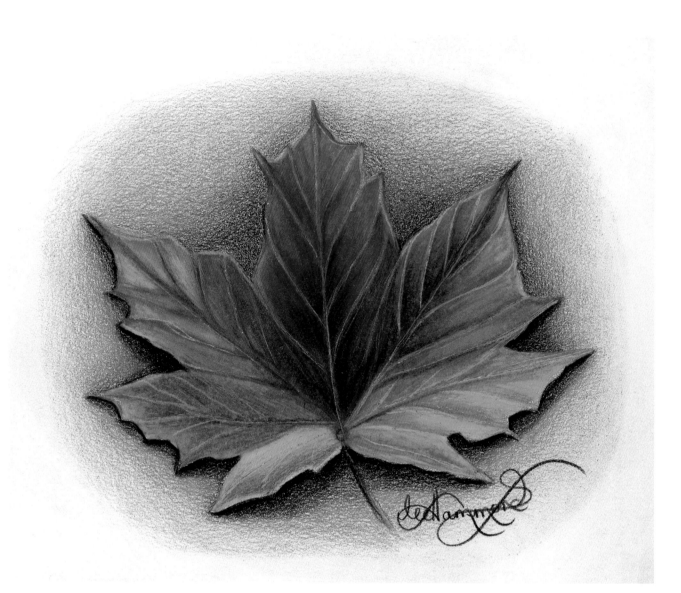

4 Burnish and Apply Cast Shadows

Burnish the entire drawing with a heavy coating of Canary Yellow. Deepen all of the colors again and continue burnishing them down with Canary Yellow as you go. Since you will be building up a heavy wax layer, you can scratch the small veins of the leaf out with a craft knife. The Canary Yellow you first applied will be revealed underneath. Deepen the shadow behind the leaf with Black. Apply cast shadows with Black underneath the lower leaf.

LEE'S LESSONS

If you are doing heavy burnishing on mat board, be careful not to overdo it. Mat board is made in plies of multiple layers of paper fused together. Too much repeated pressure can separate the plies, causing the paper to chip and creating a hole. You are better off using illustration board for heavy burnishing. Keep the mat board reserved for the layering technique.

Draw an Open-Wing Butterfly

This butterfly drawing will give you practice drawing many distinct patterns. The grid method will help you capture them accurately.

Follow the steps to draw an open-wing butterfly.

MATERIALS

Paper
regular surface bristol

Colored Pencils
Apple Green, Black, Blue Slate, Lemon Yellow, Light Aqua, Orange, Terra Cotta

Other
kneaded eraser
mechanical graphite pencil
ruler

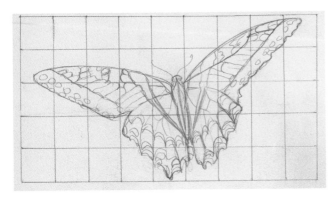

1 Create a Line Drawing
Use the grid method and a mechanical pencil to create a line drawing of a butterfly. Capturing the distinct shapes is very important when drawing this species.

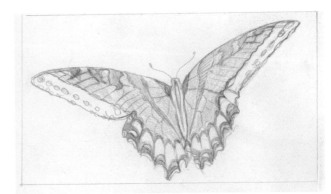

2 Fill in the Wing Patterns and Begin Laying in Color
When you are sure of your accuracy, remove the grid lines with a kneaded eraser. Use a mechanical pencil to fill in the dark patterns of the wings. This helps you see the patterns better and makes it less confusing. Fill in the wings with Lemon Yellow.

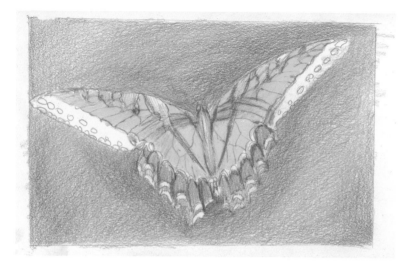

3 Continue Building Color and Start the Background

Add some Terra Cotta and Orange into the center of the wings. Fill in the small patterns of the lower wings with Blue Slate. Deepen the Lemon Yellow to make it appear brighter. Add some Light Aqua into the lower portion of the body.

Move to the background and add Orange lightly, using the layering technique. Add Apple Green to the corners of the drawing and around the butterfly. Overlap the Orange and Apple Green so they create new colors. Overlapping also creates a blurred effect in the background.

4 Deepen the Tones, Continue Layering and Add Details

Deepen the background with more Orange and Apple Green. Lightly layer Black over them to make the background darker. Be sure to keep overlapping the colors to get an out-of-focus look. Add Black to the butterfly. Be sure to follow the patterns well. Deepen the blue tones of the lower wings with a little Black on the lower part of the pattern. Add some Orange into the small dots on the lower wings.

Draw a Closed-Wing Butterfly

Here is another butterfly to draw. This one has its wings closed, but the patterns and subtle colors are still beautiful.

Follow the steps to draw a closed-wing butterfly.

MATERIALS

Paper
regular surface bristol

Colored Pencils
Black, Cool Grey 30%, Crimson Red, Dark Brown, Lemon Yellow, Moss Green, Pink, Terra Cotta, White

Other
kneaded eraser
mechanical graphite pencil
ruler

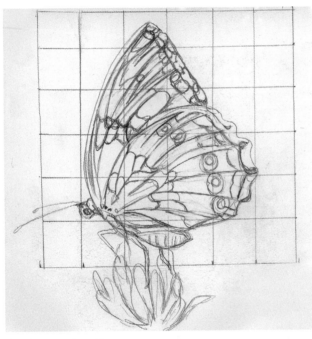

1 Create a Line Drawing
Use the grid method and a mechanical pencil to draw a butterfly with its wings closed. The patterns are very important, so draw as accurately as possible. The grid lines and boxes will help you to capture the shapes.

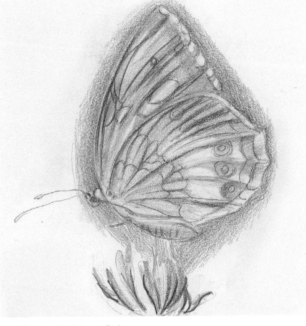

2 Begin Building Color
When you are sure of the accuracy, carefully remove the grid lines with a kneaded eraser and lighten up the other pencil lines to make them as faint as possible. This will help reduce smearing when the undertones are put in. Add Lemon Yellow and Terra Cotta into the wings. Add Cool Grey 30% into the shadow areas to make the wings look dimensional. Add this same color into the body of the butterfly as well. Layer some Terra Cotta in the background. Start the flowers with Pink and Crimson Red.

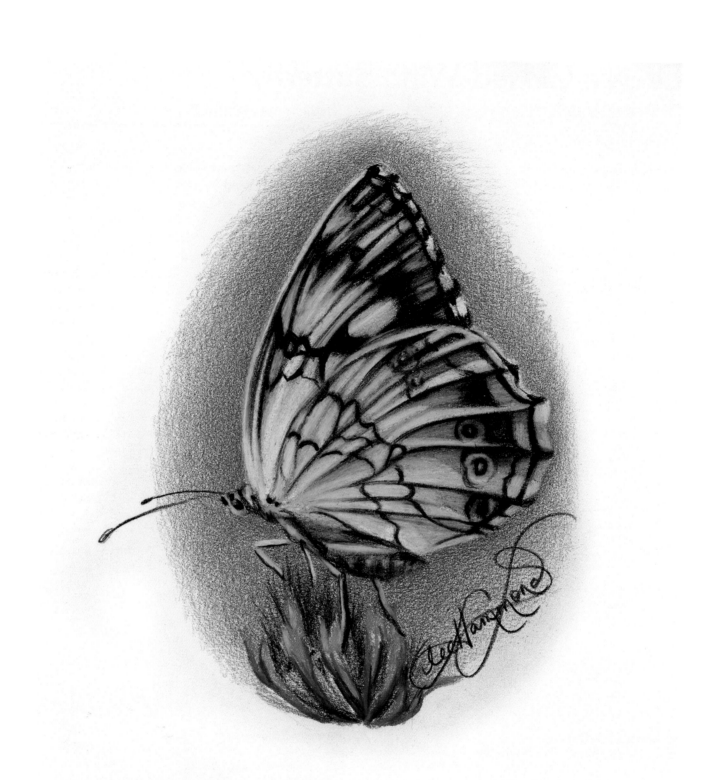

3 Burnish and Continue Layering

Burnish White into the wings to make them bright. Add Black to create the patterns. Adding Black can make everything look pale, so reapply the other colors to deepen them if necessary. Deepen the color in the background with more Terra Cotta. Add some Moss Green and Black into the flower.

Edges & Overlapping Surfaces

One of the most important aspects of drawing the many plants and flowers found in nature is properly capturing the edges and areas of overlapping surfaces. I recommend reviewing the nature chapter in the graphite section for the information there. It is very important for making flowers look real and dimensional.

This drawing below is a good example of overlapping surfaces. The edge of each leaf must be carefully analyzed to see if it is light-over-dark and casting a shadow, or dark-over-light. In the detail shots you can see how the curves have been created with gradual changes of layered tones.

Gradual Blending of Tones

This drawing was created with very slow applications of layered color. The shape of the leaves and the gentle curves of their surfaces are fun to draw, but they can also be challenging. As always, the five elements of shading come in. The gradual blending of tones is essential.

It's important to keep in mind that layering is a slow process. It takes a lot of time to create smooth transitions within the tones and colors. If you want instant gratification with your art, this technique may not be for you!

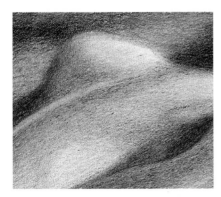

Shadow Edges Create Raised Areas
The raised areas were created with carefully placed shadow edges. The tones blend into one another seamlessly. You cannot see where one tone ends and another begins.

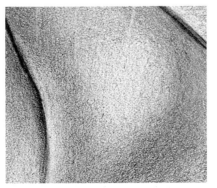

Bright Highlights and Layered Tones
These bright highlight areas are very light in color. The tones have been layered very lightly. The slight cast shadow under the vein gives it a lot of dimension.

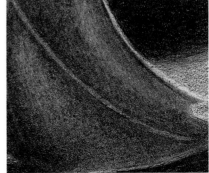

Illusion of Transparency
Color is important when depicting the effects of lighting. The yellow and red tones here give the leaf an illusion of sunlight shining through, making it appear transparent.

Create a Segment Drawing

Segment drawing is an excellent way for you to practice the colors and nuances of different types of flowers and leaves. This project was created using a viewfinder cut with a small 2-inch (5cm) square.

Follow the steps to create a segment drawing. You will gain valuable practice without being overwhelmed by a large project.

MATERIALS

Paper
regular surface bristol

Colored Pencils
Chartreuse, Cool Grey 50%, Pink, Spring Green, Tuscan Red, Yellow Chartreuse, White

Other
kneaded eraser
mechanical graphite pencil
ruler

1 Capture the Shapes
Draw a 2-inch (5cm) square with a mechanical pencil. Lightly draw the shape of the leaves within the square.

2 Begin Building Layers
Apply a light application of Yellow Chartreuse using the layering technique. Add Chartreuse to the vein and leaves.

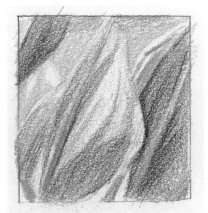

3 Continue Adding Color
Add Pink to create the color of the leaves. Add Tuscan Red on top to deepen the tones. Apply Cool Grey 50% to the background.

4 Burnish
Burnish over the entire drawing with White to soften the tones.

Draw Overlapping Petals

This rose has some very unusual colors. Drawing things in a way that we are not used to makes us look even more closely, forcing us to really see rather than drawing from memory.

This exercise will give you practice drawing overlapping flower petals. When drawing flowers and plants, always look for the V shapes where things overlap and recede. Also pay attention to the edges. Are they dark over light or light over dark?

Follow the steps to draw the overlapping petals of a multicolored rose.

MATERIALS

Paper
regular surface bristol

Colored Pencils
Non-Photo Blue, Pink, Process Red, Salmon Pink, Tuscan Red, Warm Grey 70%, White

Other
kneaded eraser
mechanical graphite pencil
ruler

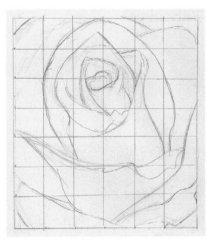

1 Create a Line Drawing
Use the grid method and a mechanical pencil to create a line drawing of a rose. This is basically a large segment drawing.

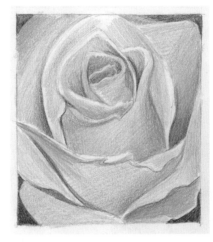

2 Begin Layering Color
When you are sure of your accuracy, remove the grid lines with a kneaded eraser. Start laying in the lightest colors first. Apply Salmon Pink, then add Non-Photo Blue, followed by Pink. Add Warm Grey 70% to the background and V areas.

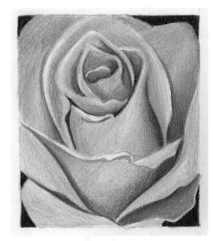

3 Continue Building and Deepening Colors
Continue deepening the colors using a slow, layered approach. Study the example to see where the colors overlap. Deepen the recessed areas with Process Red, and add Tuscan Red into the V shapes. Place some Tuscan Red over the Grey background.

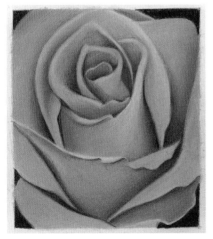

4 Burnish
Burnish the entire flower with White to soften the color and make it look smooth. Adding White makes the colors appear more pastel in appearance. At this stage you can go back and add more color as many times as you like. Just make sure you burnish it down with White to make it soft.

Distance & Atmosphere

Nature contains many elements, such as distance and atmosphere, that other subject matter does not have. Study the examples here. Each one has important things to consider when drawing landscapes and scenery.

Foreground

The foreground color was laid in horizontally. This makes it look like solid ground. Only after it has been drawn in can vertical strokes be placed on top to resemble grass and weeds. The vertical lines here resemble tall grass, and light ones were scratched out with a craft knife for more effect.

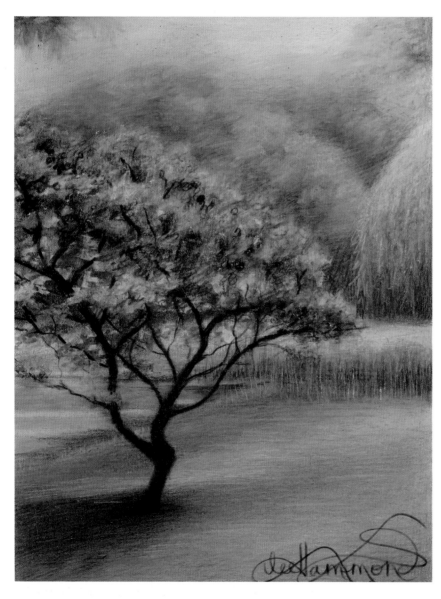

Foliage from a Distance

Here the foliage appears like clumps and patterns of light and dark. A heavy burnished layer of Yellow Chartreuse was laid down first. Then darker shades of green and black were placed on top. A small craft knife was used to scrape away the top layer, revealing the Yellow Chartreuse again. This makes the bright color appear to be on the outside surface rather than drawn around. The branches were drawn using a broken line, making them appear to go in and out of the foliage.

Background

Things in the distant background are not nearly as brilliant in color, and small details fade away. The farther away something is, the more the sky color gets between you and it. Here the trees have a subtle light blue added to them. The look of the foliage is much less distinct and appears out of focus.

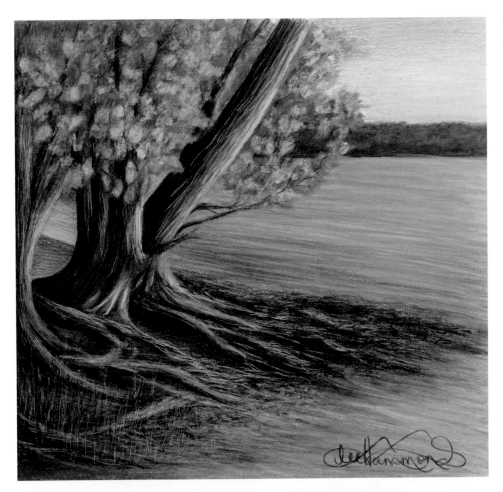

Foreground Subject Matter Appears More Detailed

This beach scene appears more detailed because the tree is much closer in the foreground than the one on the previous page.

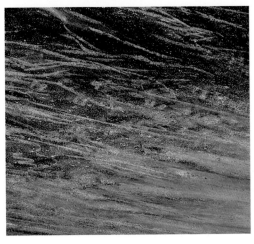

Scratching

This area looks rough like the sandy ground. A craft knife was used to pick out little light areas, making it appear textured. You can also see where the knife was used to scratch out little blades of grass as well. A craft knife is an essential tool for drawing with colored pencil.

Burnishing, Layering and Scratching

Drawing a tree trunk is like drawing a long cylinder. In this example there is a light side and a dark side due to the placement of the sun. First the light colors (Sand and Cream) were burnished into the entire shape. Then darker colors (Terra Cotta, Dark Brown and Black) were added on top. The texture to create the tree bark was created by scratching out the fine lines with a craft knife.

Burnishing and Scratching

This area was first heavily burnished with Yellow Chartreuse. Then Olive Green and Dark Green were added to create the clumps that leaves form. To create the round light leaves, the round shapes were scratched out with a craft knife to reveal the Yellow Chartreuse once more.

Clouds

I strongly recommend looking for as many different references of clouds as you can find to practice your colored pencil skills. It can open up a whole new world of drawing possibilities for you.

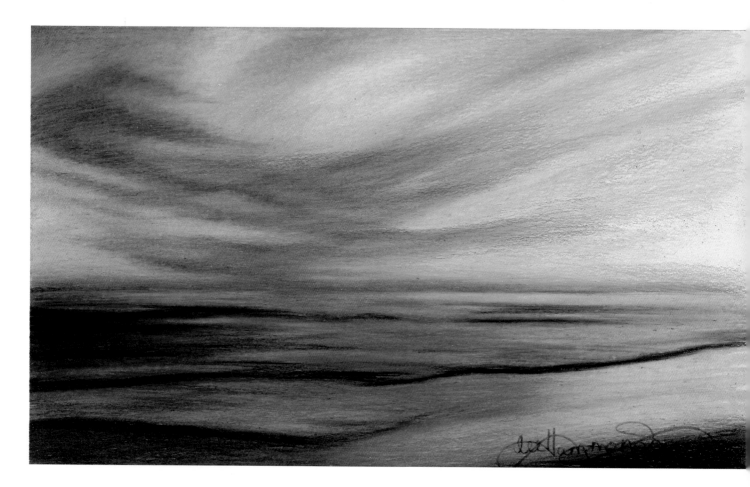

Drawing vs. Painting

This is a good example of how colored pencil can resemble a painting. Sometimes it can actually be easier to draw clouds than paint them because you have more control over the shapes when drawing.

LEE'S LESSONS

No two landscape drawings will ever look alike, and that is OK. So don't stress if your drawings do not turn out exactly like mine. It is important, especially with skies, to be a little more free and experiment with color. For instance, if you would prefer more blue in your drawings, then by all means add more. Do not be afraid to try different things.

Draw Clouds

There are so many types of clouds, I could write an entire book on clouds alone. The trick to drawing them is to really study what it is you are looking at. Always remember that clouds are not solid objects; they are made of air, so they should never appear too hard edged or outlined. Clouds reflect the colors around them in the sky as well as the rays of the sun. If they are heavy with moisture, they will have gray in them. No two clouds ever look alike.

Follow the steps to practice drawing clouds.

MATERIALS

Paper
Strathmore toned gray paper

Colored Pencils
Black Grape, Cool Grey 90%, Non-Photo Blue, Salmon Pink, White

Other
kneaded eraser

1 Draw the Shapes and Begin Adding Color
Start with some light colored pencil lines showing the basic cloud formations. Air always moves horizontally. Start adding the color with light layers of Salmon Pink and Non-Photo Blue.

2 Deepen the Colors and Build up Layers
Deepen the Non-Photo Blue, then add Black Grape to build the cloud layers. Use a light touch to make sure the clouds look transparent and airy.

3 Continue Deepening Colors and Building Layers
Deepen the dark tones of the clouds with Cool Grey 90%. With White, lightly layer over all of the colors to make them a bit softer. Do not burnish.

Draw a Tropical Sunset

Landscape drawing usually starts with a horizon line. This is where your eye falls in the distance, where the sky and land meet. It is important to identify where the horizon line is before you start. Rarely will you ever place it right in the middle of page—this creates an awkward composition. In this piece the horizon line is very low, giving priority to the sunset up above.

Follow the steps to draw a tropical sunset.

MATERIALS

Paper
regular surface bristol

Colored Pencils
Black, Hot Pink, Imperial Violet, Pink, Process Red, Salmon Pink, Sky Blue Light, Ultramarine Blue, White

Other
craft knife (optional)
kneaded eraser
mechanical graphite pencil

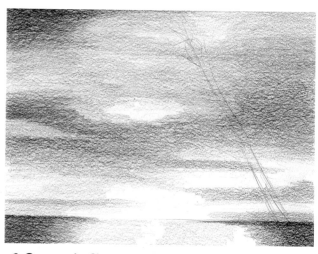

1 Capture the Shapes and Begin Laying Color

With a mechanical pencil, lightly draw the horizon line across the page, about one inch up. Then do a color map to create the patterns seen in the sky.

Draw the trunk of a palm tree with a mechanical pencil. Do not put in further detail at this point or it will smear as you work in the color.

Begin layering and overlapping the lightest colors. Air and the sky move in a horizontal fashion, so the layers of color should be applied horizontally as well. Apply Pink to the upper right corner and across the center. Apply Salmon Pink to the center of the water and into the sky in the lower third of the drawing. Add Hot Pink to the pink area in the upper right corner. Add Process Red into the cloud areas in the middle. Add the blue tones next with Ultramarine Blue in the upper left corner of the sky and both lower corners of the water. Add this color lightly into the middle area as well. Add Sky Blue Light below the Ultramarine Blue in the upper left corner. Below that, add some Imperial Violet to merge with the darker blue.

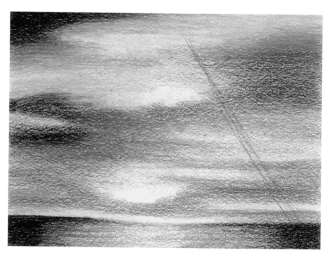

2 Continue Adding Layers and Burnish

This is the awkward stage, when the colors are deepened, but there is still not enough detail to make it appear finished and realistic. Deepen all the colors using the same colors as in the previous step. Continue adding them with a layered approach.

All of these colors will dramatically change once the burnishing process is started. In the upper left, burnish Ultramarine Blue to make it smooth. Then burnish in Sky Blue Light as well. This will transition the colors together like paint. In the upper right, burnish White in to soften the pink areas. Notice how different the Hot Pink appears now.

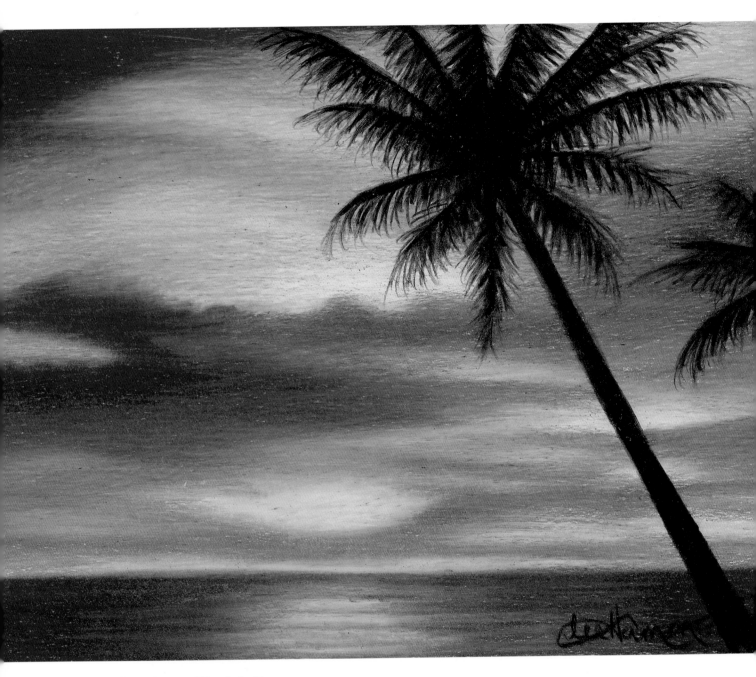

3 Continue Burnishing and Finish the Tree

Burnish all of the colors to a smooth finish. This takes time, so go slow. Do not push too hard, or it will push the wax aside instead of softening the colors together.

Burnishing can be done with any light color. In this piece, use White for the highlight areas of the sky and the very light colors. Or if you prefer, you could burnish with Sky Blue Light and Salmon Pink as well. Just keep going, adding color and burnishing it down until you like the look of your sky. Have fun with it; do not try to be too exact to the example.

When you are happy with the water and sky, fill in the palm tree with Black. You may need to go over it a few times with firm pressure to make it appear dark enough. If you have never drawn a palm tree, practice on a separate piece of paper first. It can be very disappointing to work really hard on a sky and then mess up on the tree. Once you put the Black on, it will be pretty close to impossible to remove the Black. Small things, however, can be scratched out with a craft knife.

CHAPTER TEN
ANIMALS

Drawing animals with colored pencil is an incredibly fun adventure. Nothing is more rewarding than capturing your favorite pet or animal species in living color. But as with any other subject, it is important to make sure you have the basics covered before delving into the details. So before you turn your focus to elements such as texture and fur patterns, you must capture the shape and form first. This chapter will show you how to accomplish that.

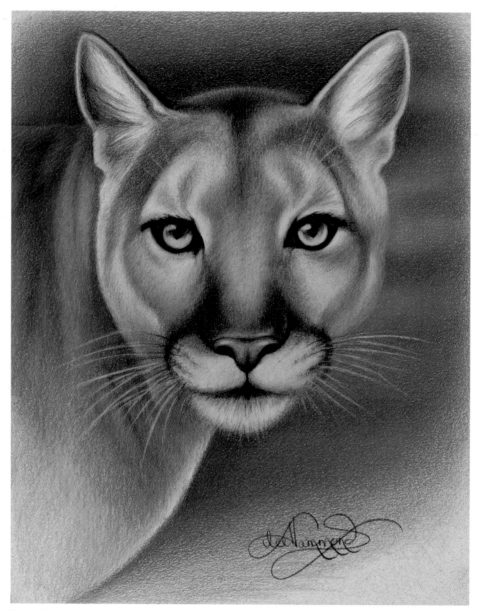

Florida Panther
Colored pencil on Beach Sand Artagain paper
14" × 11" (36cm × 28cm)

Features

When drawing animals, it is important to study and understand the particular anatomy of the species you are trying to depict. Small things are critical. Segment drawing is an excellent way to practice the different elements of drawing animals in colored pencil. Since each animal species has unique facial features and body shapes, this is a good way to familiarize yourself with them. By drawing these small versions of animal subjects, you'll be able to focus on the unique qualities of the animals' features.

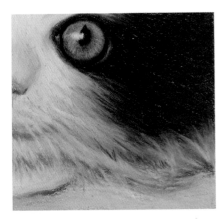

Cat Eye and Long Fur
This was good for practicing long fur. Notice how much pink is reflecting into the white fur. The eye was done with heavy burnishing to make it look wet and shiny. (Many people over-humanize animal features; be careful not to make the pupils too round.)

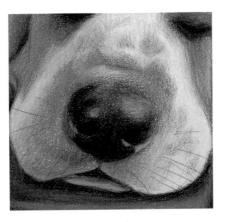

Dog Nose
It is important to know the anatomy of your subject. A close-up of a nose like this can help you learn the features. Notice all of the orange tones reflecting into the white fur.

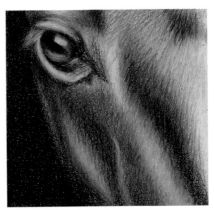

Horse Eye
This horse's eye is quite different from the cat's eye. While the cat's pupil is like a vertical slit, the horse's pupil is horizontal and elongated. Notice there is not white of the eye (sclera) showing. You can see a peach color reflecting into the left side and a slight touch of blue on the right.

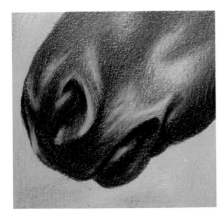

Horse Muzzle
Each animal has characteristics only seen in their species. You can see how unique the nostril is on a horse. These small things are what make your drawing accurate and realistic.

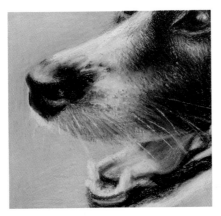

Dog Mouth
It is important to study the shapes created by the teeth and tongue. Look how the light reflects off the front of the tongue. The aqua color of the background can be seen in the fur. The whiskers have been scratched out with a craft knife.

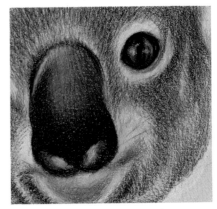

Short Fur
Short hair takes a lot of patience. You can see all of the tiny pencil lines required to make the fur of this koala.

Draw Dog Eyes

The eyes are the most important aspect of drawing any living thing. This exercise will give you practice rendering eyes for one of the most popular animals to draw—a dog.

Follow the steps to draw a dog's eyes.

MATERIALS

Paper
regular surface bristol

Colored Pencils
Black, Dark Brown, Spanish Orange, Terra Cotta, White

Other
kneaded eraser
mechanical graphite pencil

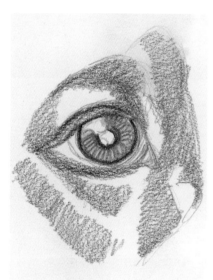

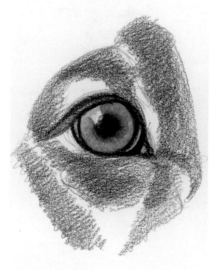

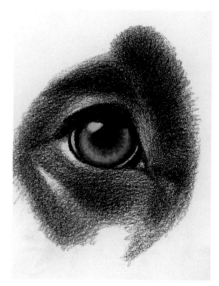

1 Sketch the Shapes and Begin Laying Down Color

Lightly sketch the shapes of the dog's eye with a mechanical pencil. Go around the pupil and the outside edge of the iris with Dark Brown. Fill the entire iris with Spanish Orange. Add Terra Cotta on top using a starburst pattern. Be sure to leave the white spot on the upper left open for a light reflection (catch light). Create the patterns of the fur around the eye with Dark Brown.

2 Build up the Eye and Burnish

Fill the pupil with Black. With White, burnish the iris to make it look glassy. Add some more Dark Brown around the iris and burnish again with White. Using firm pressure, edge the eye with Black. Then with light pressure, add some Black to the fur patterns.

3 Continue Building Depth and Tone

Build up the depth of tone in the fur with repeated layers. Fill in the upper eyelid with Black. Add some shadow onto the eye. Burnish White into the catch light.

Draw a Dog Nose

The nose of an animal is more important than you might think. Each animal has a nose with very distinct shapes and anatomy to it. This exercise will point out some of the most important things to look for.

Follow the steps to draw a dog's nose.

MATERIALS

Paper
regular surface bristol

Colored Pencils
Beige Sienna, Cool Grey 90%, Dark Brown, Yellow Ochre

Other
kneaded eraser
mechanical graphite pencil

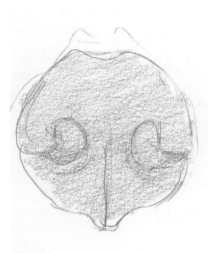

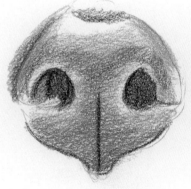

1 Sketch the Shapes and Begin Laying Down Color

Lightly sketch the shapes of a dog's nose with a mechanical pencil. Apply a light layer of Beige Sienna to the entire nose.

2 Darken the Nostrils and Continue Building Layers

Darken the inside of the nostrils with Cool Grey 90%. Notice a dog's nostril is not a continuous circle; it has a definite separation on the side where it splits. This is true for all dog noses. Apply Cool Grey 90% to the nose. Be sure to leave an area of reflected light around the nostrils and the top of the nose where the reflection is.

3 Deepen the Colors and Add Details

Deepen the color of the nose with Dark Brown and more Cool Grey 90%. Do not burnish; a dog's nose is textured, not smooth and slick. Add some color around the nose with Yellow Ochre. Add Dark Brown on top and Cool Grey 90% around the edges. Add some pencil lines below the nose with very quick strokes to suggest the look of hair and whiskers.

Fur

It is important to remember that the length of fur is illustrated by the length of the pencil lines you use.

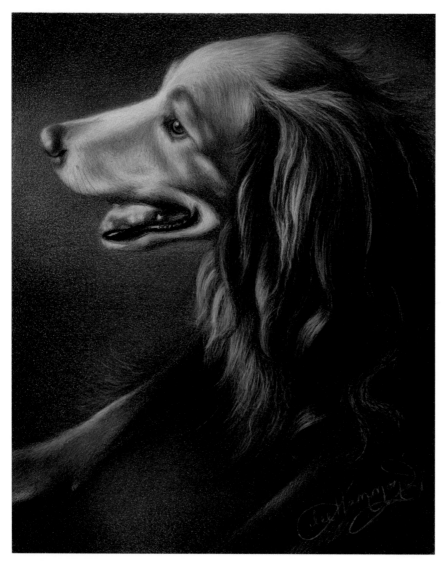

Short Fur

This detail image shows how short fur looks in colored pencil. The light colors were placed first, with the darker colors added on top using short, quick pencil strokes. Cream and Peach were laid in first for the light undertones. Then some color and texture were applied with Pumpkin Orange in short strokes. Short, quick strokes of Terra Cotta and Dark Brown were added on top to finish.

Repeating Layers

This is a portrait I did of Penny the Wonder Dog. This was on her last day before she died, and it is my tribute to her.

The soft look of this drawing was created with the layering technique. Very little was burnished. The entire background was done with repeated layers of color, allowing the paper to still show through.

Long Fur

Here we see how long hair is created. Black was used first to establish the patterns of darkness and show the thickness of the fur. A medium-toned color, Terra Cotta, was laid down next. The direction and wave of the fur was created with long curved pencil lines. White was added on top to create highlights and make it appear reflective.

Draw Fur

Follow the steps to draw long and short fur.

MATERIALS

Paper
Strathmore toned gray paper

Colored Pencils
Black, Cream, Dark Brown, Peach, Pumpkin Orange, Terra Cotta, White

Other
kneaded eraser
mechanical graphite pencil

LONG FUR

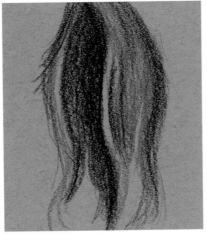

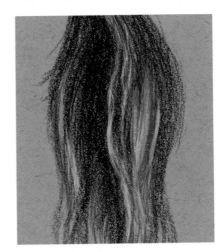

1 Sketch the Overall Shape and Establish Shadows
Lightly sketch the shapes and patterns of long fur with a mechanical pencil. Use Black to establish the darkest shadows as well as the length and direction of the fur.

2 Apply Color and Create Depth
Add Terra Cotta using long curved strokes. This will help the Black to look more like a shadow.

3 Add Highlights
Add highlights using long curved strokes of White. Now the fur should look shiny.

SHORT FUR

1 Lay Down the Undertones
Apply an even undertone layer of color with Cream and Peach.

2 Build up Layers of Color
Add some Black into the background area. Create the illusion of fur with quick pencil strokes of Pumpkin Orange.

3 Deepen the Tones
Add Dark Brown with quick, short strokes to complete the furry appearance.

Combining Techniques

All complicated drawings should begin with an accurate line drawing, followed by a color map of where the colors will be. Most complicated compositions will require several layers of color along with the application of multiple techniques to create a realistic and beautiful final result.

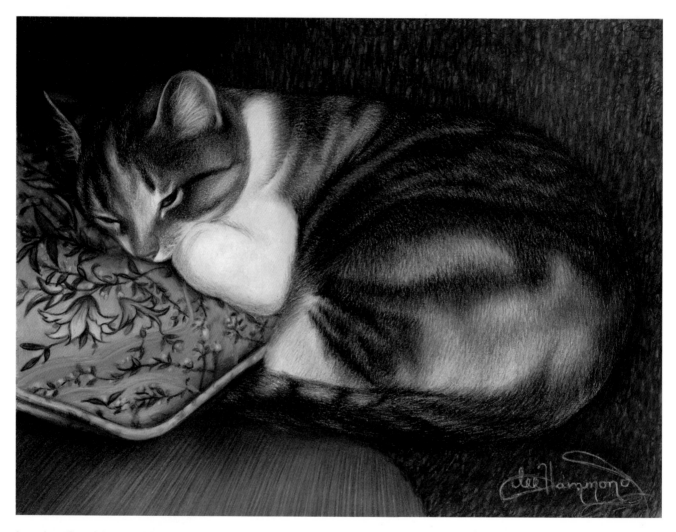

Layering, Burnishing and Scratching
This drawing of my cat Mindy required many different techniques to make it look real. Some areas were layered, some areas were heavily burnished, and some areas were scratched out with a craft knife.

LEE'S LESSONS

Great results take time! Often the only difference between my work and my students' work is the amount of time devoted to the piece. The drawing above has more than thirty hours in it.

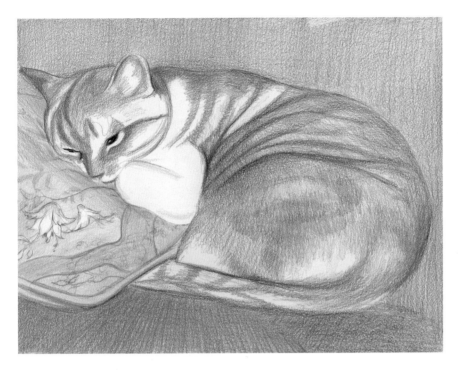

Layering
The fur of this kitty was developed with layering. It required many layers of quick strokes and overlapping colors to make it look real. In this area you can see how the Black and Terra Cotta overlap, but the white of the paper was left for the light areas.

Color Map
A complicated drawing should begin with a color map. Once an accurate line drawing is completed, either through the grid process, or a projector or careful freehanding, the colors are put in to begin the process. Just by doing this, you can see the contours slowly starting to take shape.

Heavy Burnishing
The pillow was heavily burnished because the fabric was very smooth and silky with no visible texture. Once the pattern was drawn in with the pencil, it was very much like a coloring book, filling in the appropriate colors with a heavy, burnished application.

Light Burnishing
The crocheted blanket was burnished with short strokes. Many shades of blue were used from light to dark. Black was used to create the dark patterns, making it look textured and yarn-like.

Scratching
The white hairs inside the ear were scratched out with a craft knife. White was then applied with a sharp point to make them stand out. The craft knife is very handy for small details like this. Even my signature was scratched out at the bottom.

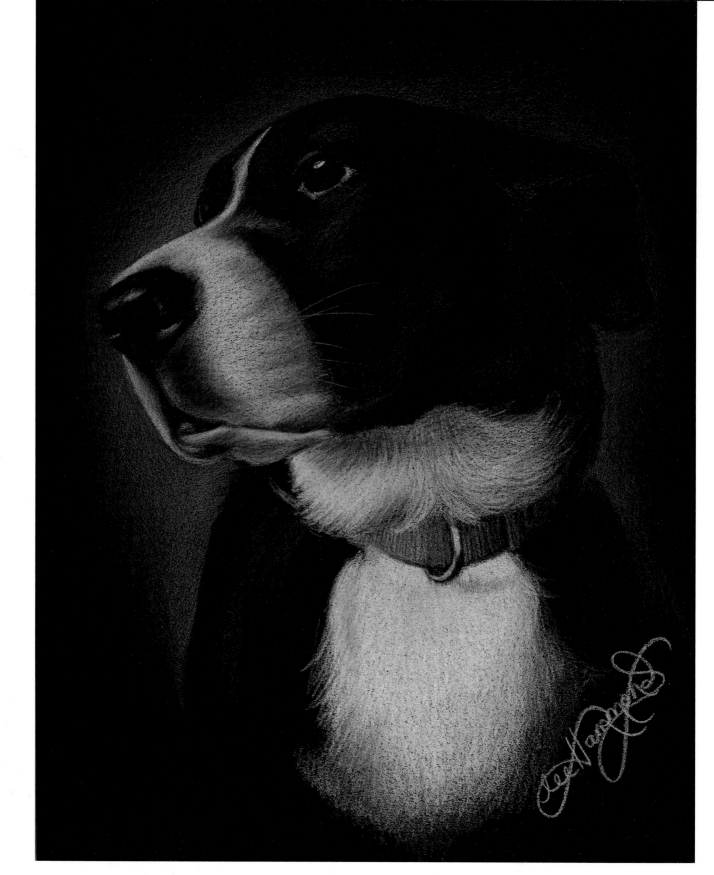

Layering on Black Paper

This portrait of my dog, Jackie, was done on black Artagain paper. It shows how bright and vivid colored pencil can be when placed on black. More layers are required in order for color to show up on a black background. Most areas of this drawing were done with multiple layers of color.

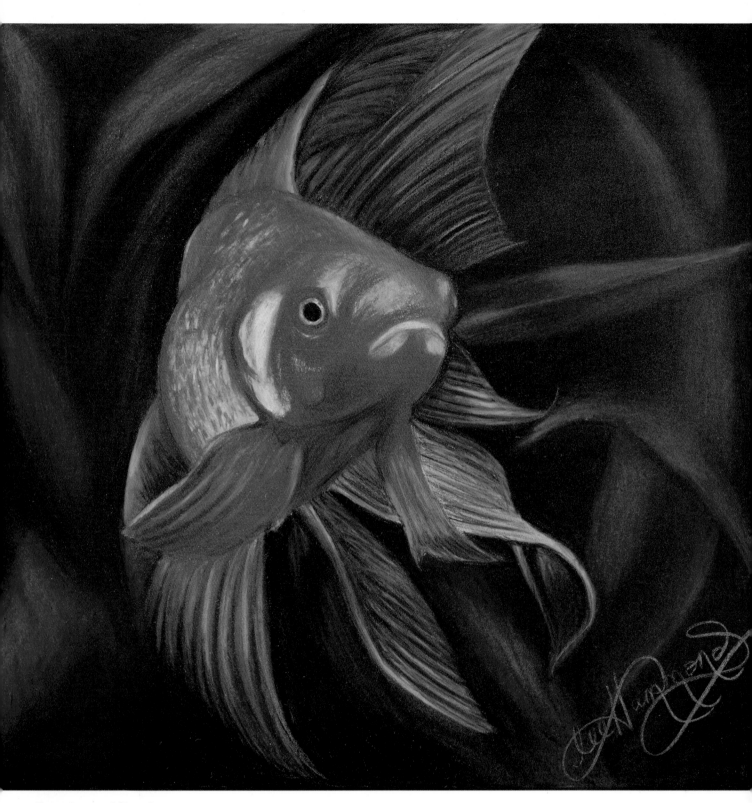

Burnishing and Scratching

This entire drawing was heavily burnished to make it bright and vivid.
Some of the highlights of the scales and fins were scratched out with a
craft knife.

Draw a Horse

A drawing does not have to have a lot of color to it to be beautiful. This project shows how a white and Grey dappled horse can be captured with colored pencil. What makes this horse particularly pretty is the way the blue tones of the background sky reflect onto the fur.

It is important to study the contours of the horse before you begin. Horses have a magnificent muscle structure, which has intrigued artists for centuries. Their faces also have defining details that must be rendered, such as the vein that goes from under the eye down to the nose.

Follow the steps to draw a horse.

MATERIALS

Paper
regular surface bristol

Colored Pencils
Black, Cool Grey 90%, Non-Photo Blue, Sky Blue Light, Ultramarine Blue, Warm Grey 30%

Other
kneaded eraser
mechanical graphite pencil
ruler

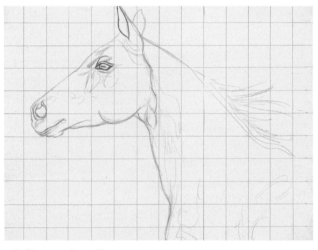

1 Create a Line Drawing
Use the grid method and a mechanical pencil to create a line drawing of a horse.

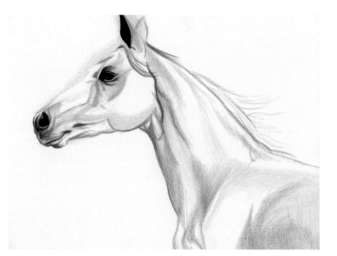

2 Build up Layers and Start the Background
When you are sure of your accuracy, carefully remove the grid lines with a kneaded eraser. Add deep tones to the inside of the ear and nostril with Black. Then starting with the outside edges of the pupil, add Black to the eye. Remember, the pupil is elongated horizontally. Apply a layer of Cool Grey 90% to the lighter area around the pupil, then burnish with Sky Blue Light. Using Warm Grey 30% and Cool Grey 90%, lightly layer the contours of the muscles. (Warm Grey on the upper portions, Cool Grey for the shadow areas.) Deepen the shadows around the nose with Black. Add Sky Blue Light to the areas as shown. Place some of this same color above the edge of the face to start the background.

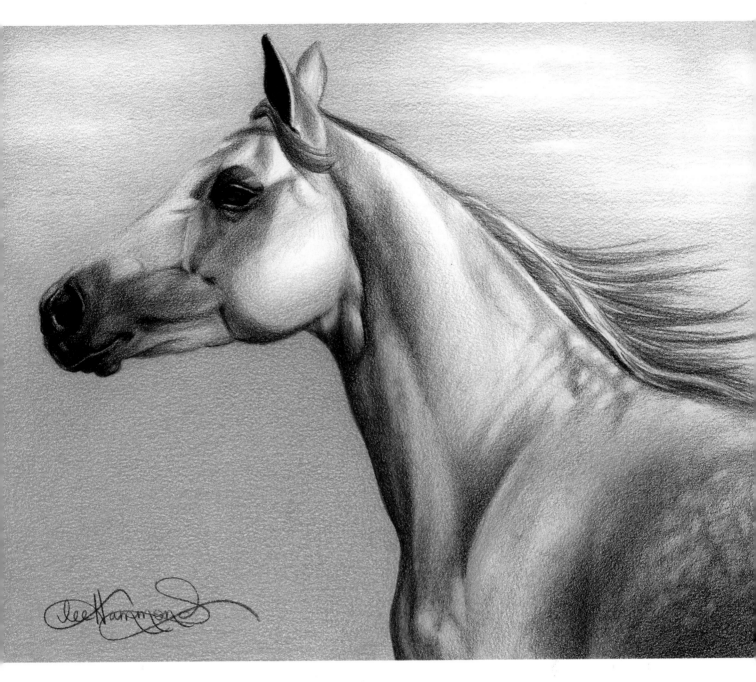

3 Continue Layering, Deepen the Tones and Finish the Background

Finish the drawing by slowly deepening all of the colors with the layering technique. Go slow and allow the colors to overlap gradually. Deepen the blue tones on the horse first. Use Sky Blue Light and Non-Photo Blue. Deepen the gray tones with Cool Grey 90%. Create the dappled look by allowing light spots to show. Deepen the shadow areas on the face and neck with Black. Finish the background with a smooth layered application of Non-Photo Blue. Allow some streaks of white to show through to create an illusion of sky in the background. Enhance this area with a small amount of Ultramarine Blue.

Draw a Leopard

Drawing an animal with lots of markings and patterns in their fur can be a fun challenge. The main thing to remember is that if there is black in the markings, it should be placed later in the process. That will help to keep the undertone colors clean and looking fresh.

Don't worry if you don't have all the colors listed. The same look can be achieved using similar colors. This can also be done on a different type of paper if you can't find Artagain. While the blue tones helped create the background, you could create this same look with colored pencils on white paper.

Follow the steps to draw a leopard.

MATERIALS

Paper
Storm Blue Artagain

Colored Pencils
Black, Bronze, Chartreuse, Cool Grey 70%, Cream, Dark Brown, Henna, Mineral Orange, Pale Vermilion, Periwinkle, Sand, True Green, White

Other
kneaded eraser
mechanical graphite pencil
ruler

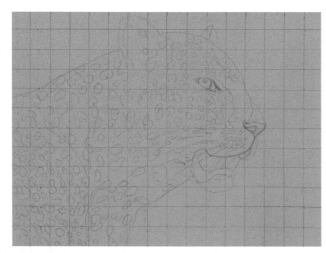

1 Create a Line Drawing
Use the grid method and a mechanical pencil to create a line drawing of a leopard. Every cat has slightly different markings, so don't worry if you are not exact here. Getting the main shapes is what's important.

2 Create a Color Map and Begin Laying in Color
When you are happy with your line drawing, carefully remove the grid lines with a kneaded eraser. Create a color map by following the example here and placing the colors accordingly. This stage should be done with a layering process. Allow the colors to overlap one another as they come together. Start with the light colors first—Cream, Sand and Pale Vermillion. Consult the example to see where they go. Add the darker colors second—Periwinkle, Dark Brown and Mineral Orange. Then add some Chartreuse under the chin to begin the background. Create the eye with burnishing. Start with Bronze and burnish it with White to make it appear shiny. Then outline the eye with Black using firm pressure. Put some Black into the inner edge of the ear as well.

3 Deepen the Colors, Burnish and Finish the Background

To finish the drawing, all of the colors need to be deepened with more repeated layers. It is important to not burnish, so the texture of the paper can still show through for the look of fur. You can see in the lower left area how the pencil strokes resemble the direction of the fur.

Deepen the colors of the leopard before you add the darkness of the spots. Create the inside of the mouth and teeth with Henna and Cream. Use Dark Brown for the shadow on the tongue. Once the colors of the fur have been deepened, add the spots with Black. Use Black to finish the ear and the mouth as well. Layer the chin area with Cream and White. Stipple small dots on top with Black. Scratch out the whiskers with a craft knife. Apply White on top of the scratches to make them stand out. Repeat the same process inside the ear.

The background was created with random patches of overlapping colors, making it appear as out-of-focus foliage. You can see how the light tones stand out against the blue/gray color of the paper. Apply multiple shades of Chartreuse, True Green, Cool Grey 70% and Periwinkle. Finish with a light layer of White on top to soften the tones.

Birds

Birds are perfect subjects for drawing in colored pencil. Their bright colors and textures not only make them fun to draw, they also make quite striking artwork. I recommend experimenting with different approaches because the possibilities are endless.

Contrasting Colors Enhance a Composition

This drawing has gorgeous colors. The red and orange of the robin contrast beautifully against the blue and green of the background. This use of contrasting colors can really enhance a piece of artwork.

PAPER COLOR AFFECTS THE FINISHED LOOK

These two examples show just how much the color of paper you use can affect the look of your drawing.

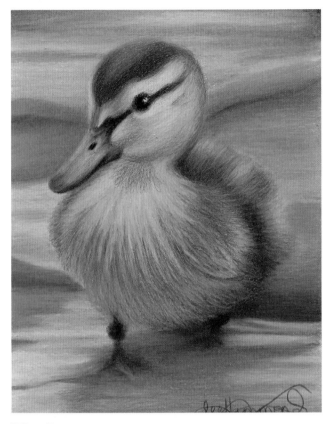

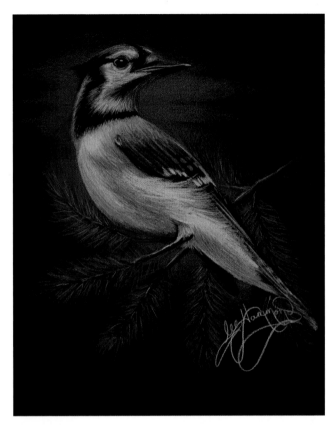

White Paper
This duckling was drawn on white paper, so it has a bright vivid look.

Black Paper
This blue jay was drawn on black paper, which gives it a much more dramatic appearance.

LEE'S LESSONS

Keep in mind that some feathers are distinct while others are less defined and appear more fuzzy. Compare the feathers of the robin's wings on the previous page with the duckling's feathers above. When drawing birds, it is imperative to closely observe your subject matter and be as accurate as possible in creating their details.

Draw a Swan

This is an example of "white isn't white." While a swan's color is white in reality, very little White colored pencil should be used in this drawing. That's because all the surrounding colors reflect onto the feathers. It is important for you to develop the ability to override the information your brain tells you is true and just draw what your eyes see. This project will help you shift outside the box of logical understanding towards a more artistic way of viewing things.

Follow the steps to draw a swan.

MATERIALS

Paper
regular surface bristol

Colored Pencils
Black, Blush Pink, Indigo Blue,
Light Cerulean Blue, Lilac,
White, Yellow Orange

Other
kneaded eraser
mechanical graphite pencil
ruler

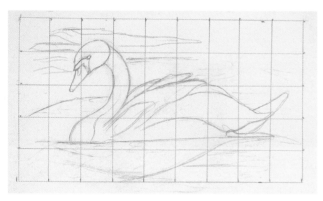

1 Create a Line Drawing
Use the grid method and a mechanical pencil to create a line drawing of a swan in the water.

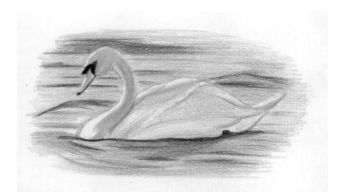

2 Create a Color Map and Begin Layering Colors
When you are sure of the accuracy, carefully remove the grid lines with a kneaded eraser. Create a color map for your drawing, starting with the lightest colors first. Lay Blush Pink into the water and the swan. Add Yellow Orange into the neck, tail and on the top of the wings. Apply Lilac to the head, neck and back. Leave the truly white areas of the swan the white of the paper.

To create the water, lay in Light Cerulean Blue first. Use Indigo Blue for the waves and ripples. Water moves horizontally, so draw your pencil strokes to match. (Only directly under the swan's chest does the water change directions.) Add Black to the swan's eye, beak and the area where the swan and the water meet.

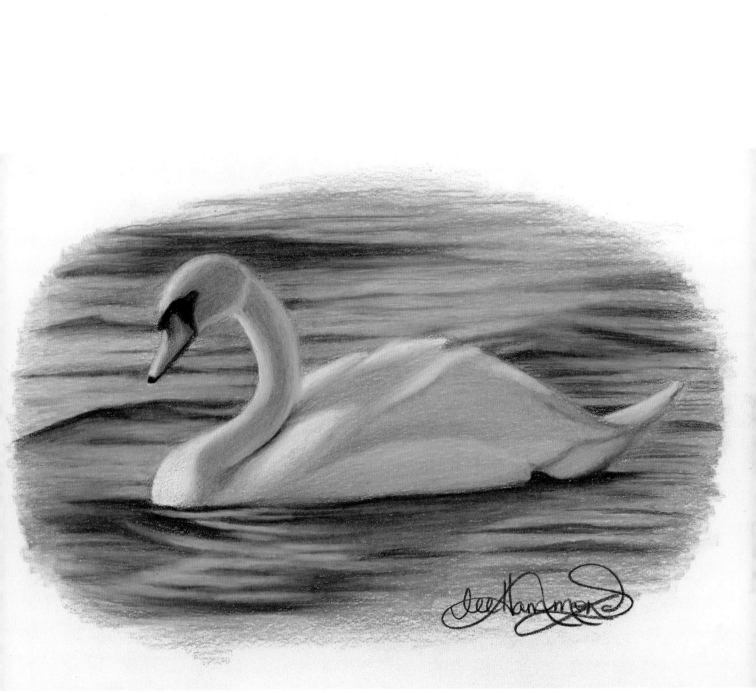

3 Deepen the Colors and Burnish

Deepen all of the colors and then burnish to make them look soft and smooth. Burnishing everything with White will change the colors to a more pastel version of themselves. You may need to reapply some of the colors and reburnish until you achieve the result you desire.

LEE'S LESSONS

Drawing realistically does not mean being completely literal. Enhancing color will make your artwork more visually appealing. Remember, color is reflective, and there is usually a lot more color to a subject than you might think.

Draw a Sparrow

This project will give you practice using more texture and natural colors. The earth tones of the sparrow and the background help give this a realistic look.
Follow the steps to draw a sparrow.

MATERIALS

Paper
regular surface bristol

Colored Pencils
Black, Burnt Ochre, Limepeel, Sand, Terra Cotta, Tuscan Red, White

Other
kneaded eraser
mechanical graphite pencil
ruler

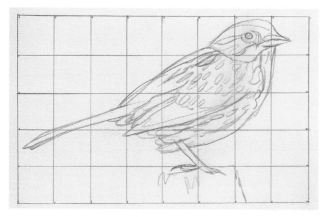

1 Create a Line Drawing
Use the grid method and a mechanical pencil to create a line drawing of a sparrow.

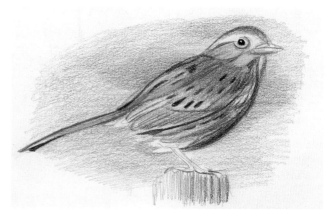

2 Create a Color Map and Begin Layering Color
When you are sure of the accuracy, carefully remove the grid lines with a kneaded eraser.

Create a color map, starting with the lightest colors first. Apply Sand to the bird as the undertone, leaving the white areas exposed. Add Terra Cotta to the rust-colored areas. Add Black to the spots, the eye, under the tail and to the chest area. Start the background colors with Limepeel, Burnt Ochre and Tuscan Red. Overlap these colors to create an out-of-focus appearance. Lightly add some vertical lines into the wood stump the bird is perched on. Use the same colors seen in the bird. It has a light side (left) and a dark side (right).

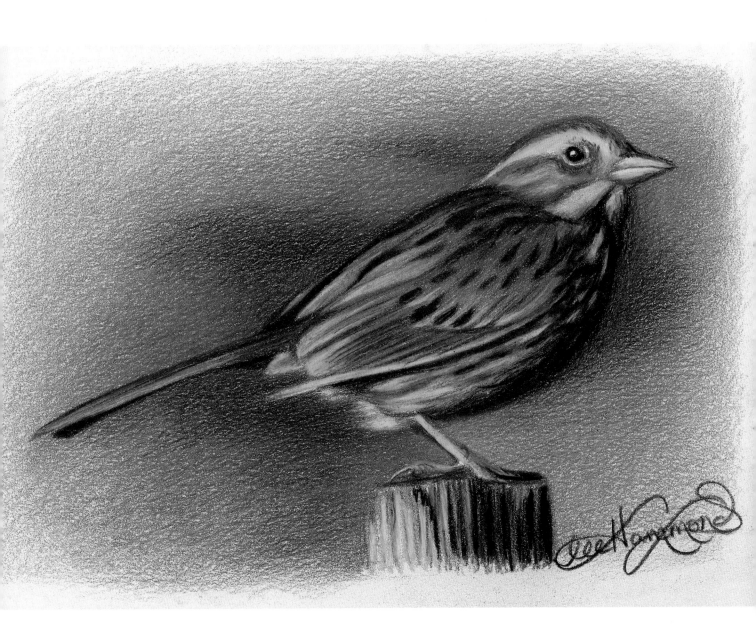

3 Deepen the Colors and Burnish

Deepen and intensify all the colors. Burnish most of the bird, and the background is layered. Follow along to finish the drawing of the sparrow. Burnish the Sand color to make it brighter. Deepen the Burnt Ochre on top in the wings with firm pressure. Deepen the black spots with Black. On the upper portion of the wings, use Terra Cotta to darken the color. Use Terra Cotta in the tail feathers as well. Burnish White into the white areas and onto the beak to make it look shiny.

Finish the background with continuous, overlapping layers of color.

Deepen the colors of the wood stump with vertical strokes and firm pressure.

CHAPTER ELEVEN
PEOPLE

Adding color into the mix can bring your drawings of people to life, but it can also make the drawing process even more complex. In this chapter, we'll continue to practice the important basics like drawing facial features, then progress to the challenges specific to drawing people in color, such as skin tones.

Just remember that portrait drawing is not something you can learn in a day. It takes a solid understanding of anatomy and a lot of practice to draw people accurately. So be prepared to do a lot of work before you dive in and try to draw the favorite people in your life.

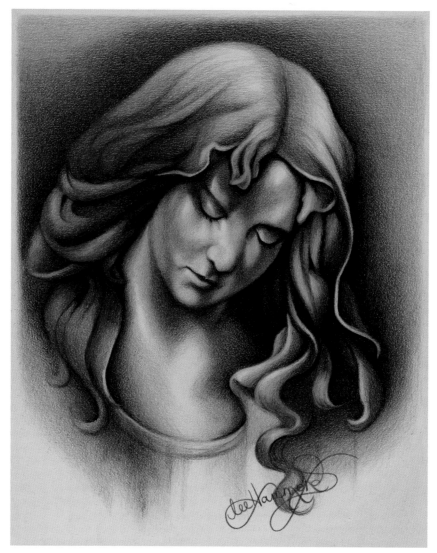

Angelic Statue
Colored pencil on light blue mat board
14" × 11" (36cm × 28cm)

Monotone Color Schemes

When teaching portraiture, I always have my students begin with graphite to get a solid foundation in the essentials first. Once a student is ready to move on to colored pencil portraits, I often have them start with a monotone study. A monotone color palette uses a limited color scheme, keeping to lights, mediums and darks of the same tone. This way realistic color does not overwhelm the student, and they can concentrate on the technique while getting used to the feel of colored pencil.

Both the drawing on this page and the next were done in blue monotone palettes, but they appear very different because of the different pencil line applications.

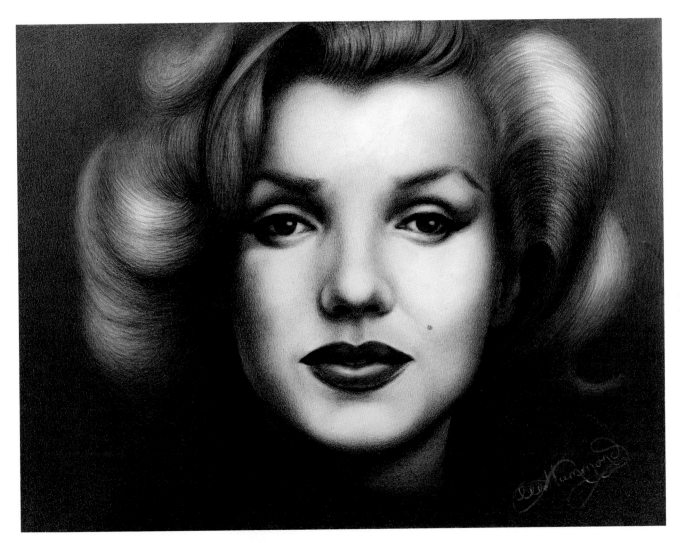

Monotone with Fine Pencil Lines

The soft look in this portrait of Marilyn Monroe was crafted with a fine touch of the pencil, using an extremely sharp point at all times. The drawing was supplemented with Verithin pencils. They are made by Prismacolor but have sharper, thinner and less waxy leads than standard colored pencils. Using the Verithin pencils in the face area helped the tones appear refined and smooth. This drawing was done with three colors—Indigo Blue, True Blue and Black.

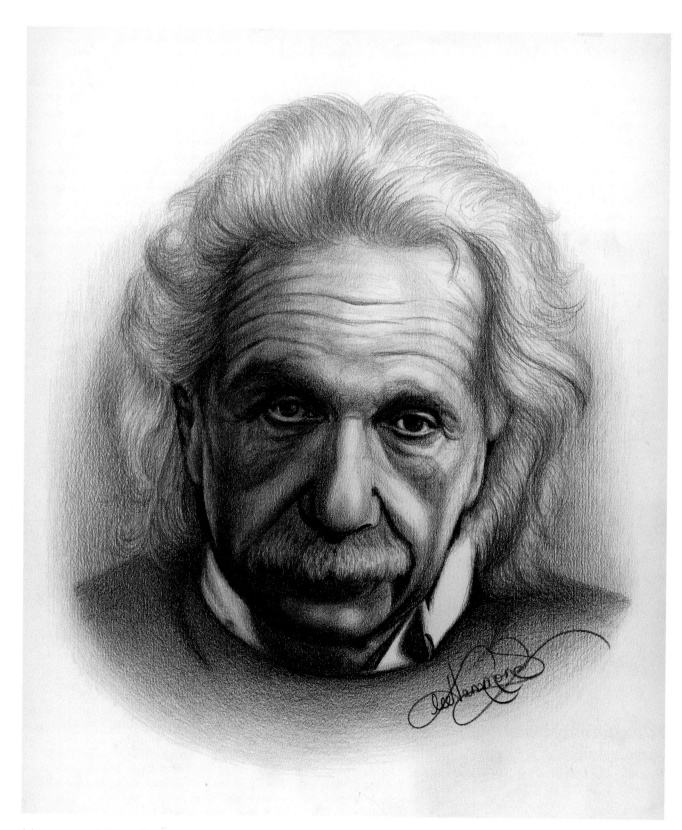

Monotone with Heavy Pencil Lines

This portrait of Albert Einstein appears a little more textured and sketchy than the one of Marilyn Monroe. It was done with only two colors—Indigo Blue and Black. The heavier pencil lines allow the texture of the paper to come through and give it a rougher, more masculine appearance.

Skin Tones

Drawing skin tones is not easy. Every person has a different complexion, and lighting affects how these colors look. Too many times I have seen students trying to draw from memory instead of observing their subject. If they know the person or are familiar with a particular skin tone, they often miss the reflected color seen in their subject's face in the reference. Yet it is these additional colors that make the drawing look real.

Many will resist using dark colors out of fear the finished result won't look like the person. However, because skin color is affected dramatically by light and shadow, a light-skinned person posing in dark lighting may appear darker than a person with dark skin in bright sunlight would. If you want to capture realistic skin tones, you must observe and replicate what you see, not just draw what you think you know.

The following color swatches represent the colors I use most frequently when drawing people in colored pencil. Keep in mind that these are just a guide. You may see many more depending on the surrounding colors and light source.

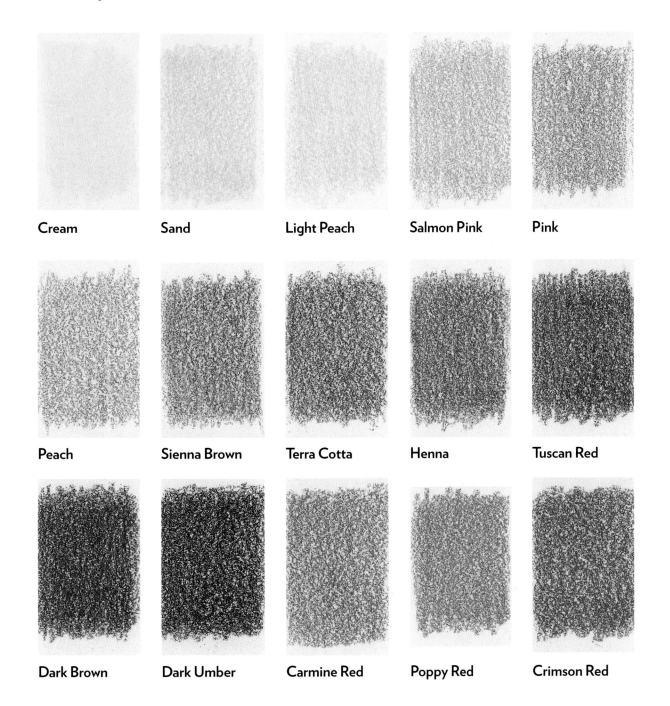

| Cream | Sand | Light Peach | Salmon Pink | Pink |

| Peach | Sienna Brown | Terra Cotta | Henna | Tuscan Red |

| Dark Brown | Dark Umber | Carmine Red | Poppy Red | Crimson Red |

Noses & Mouths

When drawing people, one of the most important things to consider is the way the nose connects to the rest of the face. Many beginning artists will forget to address the space between the nose and the mouth.

Study the two drawings below to see how important that area between the nose and mouth is to creating the shapes of the rest of the face.

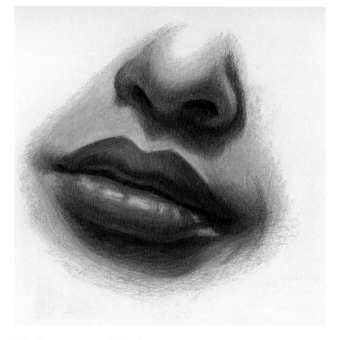

The Importance of Shadows
Don't be afraid to get dark with your art! Dark tones and shadows are critical for creating a three-dimensional appearance in your artwork.

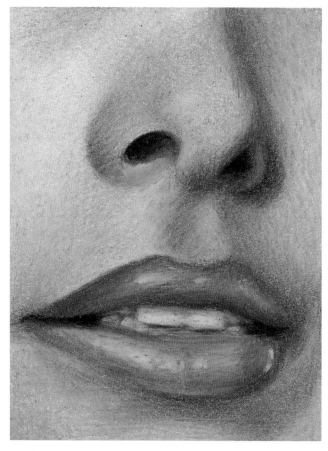

Layering and Burnishing
This segment drawing shows how a combination of layering (the nose and skin) and burnishing (the lips) can be used to create a realistic look.

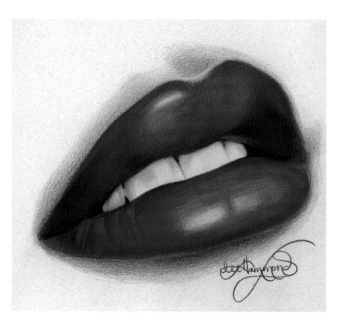

Burnishing
Using heavy applications of bright colors makes these lips look shiny and vivid.

Draw a Nose with a Dark Skin Tone

When teaching portrait drawing, I always start with the nose. It has the same elements as found in the sphere, which makes it a good place to practice creating form in facial features. This exercise will also show you how to create a dark skin tone.

Follow the steps to draw a nose with a dark skin tone.

MATERIALS

Paper
regular surface bristol

Colored Pencils
Black, Dark Brown, Peach, Terra Cotta, Tuscan Red

Other
kneaded eraser
mechanical graphite pencil
ruler

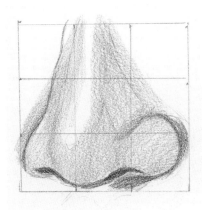

1 Create a Line Drawing, Begin Adding Color and Shadows

Use the grid method and a mechanical pencil to create a line drawing of a nose turned slightly to the left. Begin to lightly apply color, starting with Peach. Keep the highlight areas the white of the paper. Add the cast shadow to the right side and below the nostrils with Dark Brown.

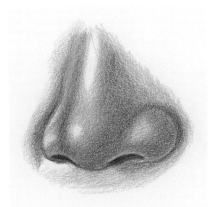
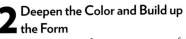

2 Deepen the Color and Build up the Form

When you are sure of your accuracy, carefully remove the grid lines with a kneaded eraser. Deepen the color of the skin with Terra Cotta. Apply the pencil strokes in a way that creates form and curve. Allow the highlights to still show through. Allow for the reflected light around the edge of the nostrils.

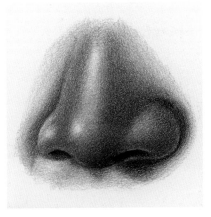

3 Continue Deepening the Colors and Shadows

Deepen the color once more with Tuscan Red. To ensure that the drawing looks smooth and not crayon-like, keep a sharp point on your pencil at all times. Deepen the shadow areas with Dark Brown. Deepen the inside of the nostrils with Black.

LEE'S LESSONS

Ironically, a light skin tone could be created with the exact same colors used to create the dark skin tone. It is simply the amount of each color used that changes the appearance of the complexion.

Draw Smiles

Drawing teeth is challenging. They are rarely drawn accurately if you have not had a lot of practice doing them. If each tooth is not drawn perfectly, however, the result will not look like your subject. Like fingerprints, our teeth are unique to each of us, so they must be drawn accurately in order to capture a good likeness.

Follow the steps to draw male and female smiles.

MATERIALS

Paper
regular surface bristol

Colored Pencils
Black, Blush Pink, Cool Grey 50%, Cream, Crimson Red, French Grey 50%, Henna, Light Umber, Peach, Sand, Tuscan Red, White

Other
kneaded eraser
mechanical graphite pencil
ruler

FEMALE SMILE

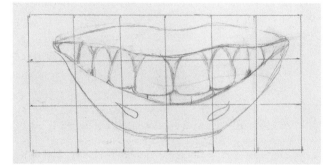

1 Create a Line Drawing
Use the grid method and a mechanical pencil to create a line drawing of a female smile. Each tooth is unique so watch for the angles, curves and contours. Pay attention to the shapes in the gum line and the small shapes under the edges of the teeth.

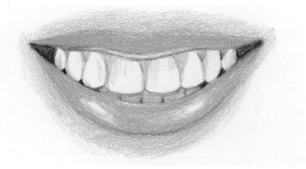

2 Begin Adding Color and Shadows
When you are sure of your accuracy, carefully remove the grid lines with a kneaded eraser. Apply Blush Pink to the lips. Use a fairly heavy layer since they will be burnished later. Leave a bit of reflective light along the edges. Add Tuscan Red in the corners (also known as the pit of the mouth). Add Peach to the skin area around the mouth as well as to the gums and lower teeth. Add shadows on and under the teeth with Cool Grey 50%. Use a small amount of Black to add the little triangles of dark under the corners of the teeth.

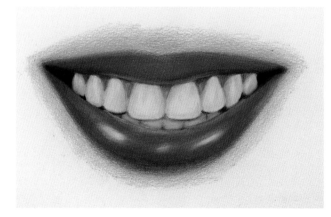

3 Deepen the Colors and Shadows and Burnish
Deepen the color of the skin and gums with Peach. Burnish the teeth with White to make them look shiny. Reemphasize the shadows with Cool Grey 50%, then burnish with White again. Add some Peach into the upper teeth (they are reflective), then burnish that in with White. Do the same for the lower teeth. Deepen the color of the lips with Crimson Red. Add Tuscan Red to the shadow areas of the lips to create contours. Burnish the lips with Blush Pink, leaving the bright highlights on the bottom lip white. Then burnish the bright highlights on the lower lip with White.

MALE SMILE

A man's features are generally more subtle than a woman's. In this exercise, you will see how much less dramatic a male mouth appears compared to the previous example.

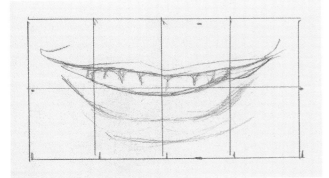

1 Create a Line Drawing
Use the grid method and a mechanical pencil to create a line drawing of a male smile.

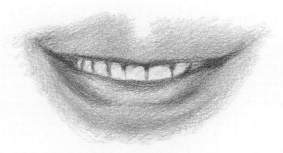

2 Begin Adding Color and Develop the Shapes
When you are sure of your accuracy, carefully remove the grid lines with a kneaded eraser. Add Peach to the skin area around the mouth. Add Light Umber under the mouth in the chin crease. Develop the shapes of the lips, gum lines and teeth with Tuscan Red.

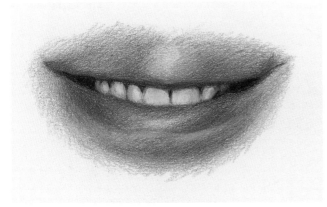

3 Deepen the Colors
Add Cream to the teeth to remove the white of the paper. Use Sand to deepen the color of the teeth in some areas. Add French Grey 50% to the shadows of the teeth to make them look dimensional, then burnish with White. Deepen the color of the skin with more Peach. Deepen the color of the lips with Henna. Do not burnish these lips or it will appear as if he is wearing lipstick!

LEE'S LESSONS

There are several important aspects to remember when drawing teeth. Here are just a few tips:
- You will capture the shapes of teeth most accurately by drawing the shape of the gum line and shape of the space under the teeth.
- Never draw dark lines between teeth. Darkness represents space, so it will only make the teeth look separated.
- Never leave teeth the white of the paper. This lacks realism. In reality, teeth are not a perfect white—they reflect color and highlights.

DEMONSTRATION

Draw a Mouth with Facial Hair

It is important to know how to draw facial hair when drawing the male mouth. This exercise will help you. (Note: This drawing was done on speckled white drawing paper, but regular surface bristol can also be used.)

Follow the steps to draw a mouth with facial hair.

MATERIALS

Paper
speckled white drawing paper or regular surface bristol

Colored Pencils
Black, Dark Umber, Peach, Tuscan Red

Other
kneaded eraser
mechanical graphite pencil
ruler

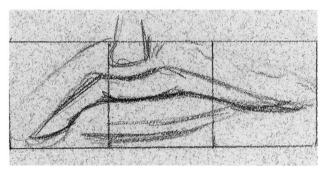

1 Create a Line Drawing
Use the grid method and a mechanical pencil to create a line drawing of male lips.

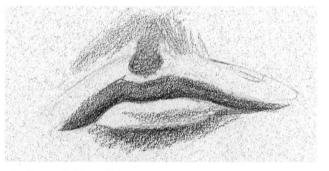

2 Begin Adding Color
When you are sure of your accuracy, remove the grid lines with a kneaded eraser. Add Tuscan Red to the upper lip, under the lower lip and to the contours around the mouth.

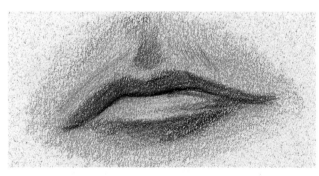

3 Layer the Skin Tone
Layer Peach over the entire area to create the skin tone. It's very important to layer the skin tone color in the mustache area first. If you laid in the mustache directly onto the white of the paper, it would not look realistic.

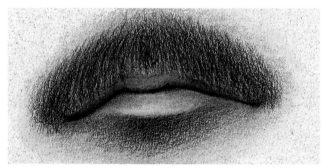

4 Deepen the Colors and Shadows, Add the Mustache
Deepen the line between the lips with Dark Umber. Deepen the shadow below the lower lip with Dark Umber. Add the mustache with Dark Umber using short, quick pencil lines. Be sure to keep a sharp point on your pencil. Allow some of the color underneath to show through. Do not make it appear too solid. Deepen the mustache with Black using the same quick pencil strokes.

Eyes

It's often said that the eyes are the window to the soul. Whether or not that is true, they are certainly the most important aspect of a portrait. This is where your subject connects with you, and the spirit of the subject really comes alive.

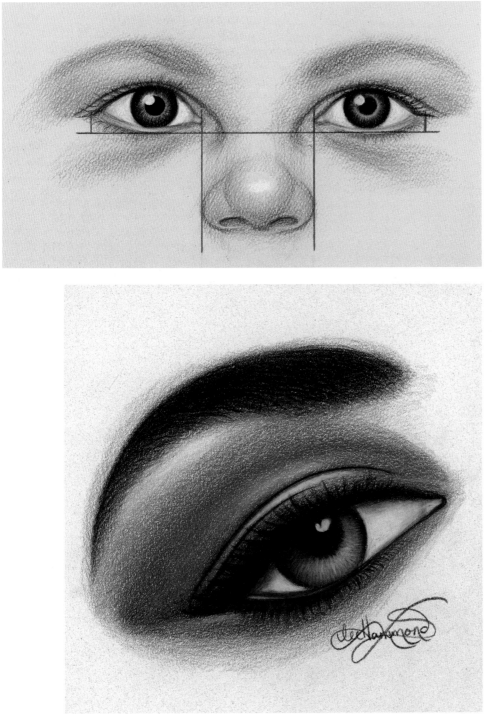

Eye Placement

In most cases, there is always one eye width between the eyes. And if lines are drawn down from the corner of the eyes, they will be same width as the nose. Remember, these are generalities, and will not always be true for all people of all races. We all have different bone structures. This example is simply meant as a general rule for drawing eyes.

Layering and Burnishing Produce Dramatic Effects

This shows how dramatic an eye can look. The decorative color and fashion appearance of this eye was fun to draw. You can see both the layering and burnishing techniques here.

LEE'S LESSONS

Just like teeth should never be left the white of the paper, neither should the white of the eye, or sclera. This is a sphere, and some shadow and color is required to make it appear rounded.

Draw an Eye

The eye never just has a line drawn around it. Its individual shapes are important to remember. One of the most forgotten shapes of the eye is the lower lid thickness. Many beginning artists leave it out, drawing just a dark line underneath the eye. This exercise will demonstrate the importance of this shape along with others.

Follow the steps to draw an eye.

MATERIALS

Paper
regular surface bristol

Colored Pencils
Black, Blush Pink, Light Cerulean Blue, Light Peach, Mahogany Red, Peach, Pink, Ultramarine Blue, White

Other
circle template
kneaded eraser
mechanical graphite pencil

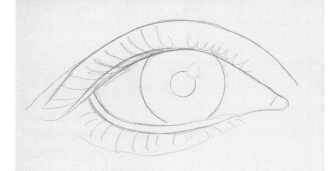

1 Draw the Eye Shapes
Lightly draw the shapes of the eye with a mechanical pencil. Since it's looking straight at you, make the pupil and iris perfect circles. Freehand the circles for placement, then crisp up their shapes with a circle template for accuracy.

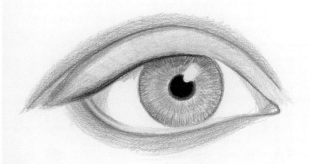

2 Begin Adding Color
Fill in the upper and lower eyelid areas with Light Peach. Apply Pink to the area above the lid, along the lid edge and into the corner membrane. Put some Pink onto the sclera to create roundness in the corners. Add Blush Pink under the eye, below the lower lid thickness. Add Light Cerulean Blue to the iris first. Put in the color using radiating lines out from the edge. Do not take it clear to the pupil. Add Peach to the iris, radiating out from the pupil. Be sure to leave a white spot for the catch light. Deepen the blue area with Ultramarine Blue, radiating out from the edge. Add a heavy application of Black into the pupil. Add a light layering around the edge of it to appear softer. Add a shadow onto the iris below the lid with a light layering of Black.

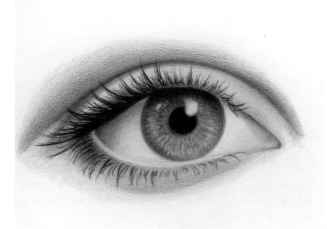

3 Deepen the Colors, Burnish and Add Eyelashes
Deepen the skin tone using a combination of Pink and Blush Pink. Add Mahogany Red to the eyelid crease and into the left corner of the eye. Add Light Cerulean Blue into the sclera to create more roundness. Burnish the sclera and iris with White. Create the patterns of the iris by reapplying small lines of Ultramarine Blue with a sharp pencil point. Reapply Peach to the iris and add Mahogany Red. Burnish with White. Draw the eyelashes with light, quick strokes of Black. Be sure the pencil point is very sharp for this. Pay attention to the direction of the lashes, keeping in mind that they grow in clumps. (Nothing looks worse than harsh pencil lines all in a tidy row.)

Draw Eyes & a Nose Together

The following exercise will give you practice drawing two eyes together and connecting them with a nose.

Follow the steps to draw eyes and a nose together.

MATERIALS

Paper
regular surface bristol

Colored Pencils
Black, Cool Grey 30%, Indigo Blue, Light Umber, Salmon Pink, Terra Cotta, White

Other
circle template
kneaded eraser
mechanical graphite pencil
ruler

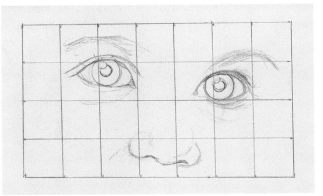

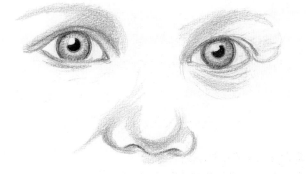

1 Create a Line Drawing
Use the grid method and a mechanical pencil to create a line drawing of eyes and a nose. (Note that this composition is slightly off center.) You can see the tilt when you look at the lineup of the eyes within the grid.

2 Begin Adding Color and Start the Eyebrows
When you are sure of your accuracy, remove the grid lines with a kneaded eraser. Use a template to crisp up the circles of the pupils and irises. Apply Salmon Pink to the contours of the nose, eyes and eyebrow area. Create the lid crease and lash line with Terra Cotta. Use Terra Cotta to deepen the eyebrows as well. (They are in shadow form now—the hair will be applied in the next step.) Add Indigo Blue around the edge of the irises. Radiate some of the color into the irises. Leave some white around the pupil. Fill in the pupil with Black, using firm pressure. Leave an area for the catch light.

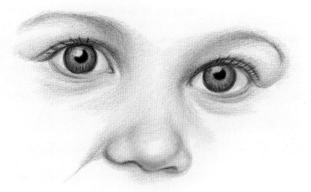

3 Deepen the Tones and Finish the Eyebrows
Deepen the skin tone with Salmon Pink. This is very fair skin, so allow the white of the paper to show through. Suggest hair on the eyebrows with quick strokes of Light Umber. Pay attention to the direction of the hair growth. Babies have very thin hair, so keep it subtle and light. Deepen the color of the lid creases and nostrils with Terra Cotta. Burnish the irises with White. Add Cool Grey 30% to the sclera to make it look rounded, like a sphere. Keep it very light. Burnish it in with White, then add the eyelashes very lightly with Black. Use a sharp point and keep a light touch.

Draw an Ear

Ears may not seem like the most exciting features to draw, but they are very important to creating realistic portraits. Drawing ears can be confusing and difficult if you have not had a lot of practice. They have complicated shapes—shapes within shapes, in fact. This exercise will show you the anatomy of an ear and what to look out for when drawing them.

Follow the steps to draw an ear.

MATERIALS

Paper
regular surface bristol

Colored Pencils
Burnt Umber, Dark Umber, Goldenrod, Peach, Pink, Poppy Red, Tuscan Red

Other
kneaded eraser
mechanical graphite pencil
ruler

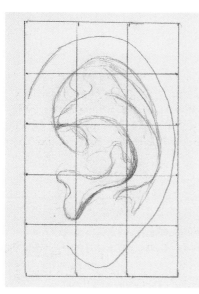

1 Create a Line Drawing
Use the grid method and a mechanical pencil to create a line drawing of an ear. Go slow because all of these shapes are unusual. Just approach it like a puzzle.

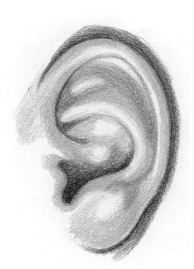

2 Begin Adding Color and Build the Shadow Shapes
When you are sure of your accuracy, remove the grid lines with a kneaded eraser. Establish the shadows within the ear, which will help to establish all of the overlapping surfaces and edges. With Dark Umber, place some tone behind the ear and on the inside area where it is the darkest. Add the shadow shapes on the inside of the ear with Tuscan Red. Start the skin tone with Peach. Leave some reflected light around the edges. Leave the white of the paper exposed in certain areas as shown. Add some Pink into the inner area of the ear.

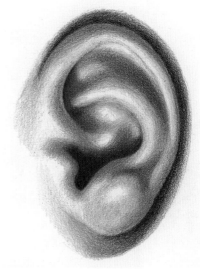

3 Deepen the Tones and Shadows
The ear has a lot of contrast. There are extremes of light and dark where things protrude and where things are recessed. Do not burnish, but instead deepen the skin tone with more Peach and some Poppy Red. Add Goldenrod to the edges of the reddish areas to soften and lighten them up. Burnish the ear canal with Dark Umber. Deepen the cast shadows with more Tuscan Red. Deepen the dark tones around and under the ear with Burnt Umber. The area under the earlobe should resemble a value scale of all the colors from dark to light.

Hair

This full-color portrait shows how reflective color can be. If you look closely, you can see the subtle blue tones reflecting onto the skin and hair of the subject. I love drawing hair and all of the waves and colors being reflected throughout it.

These close-up images show different hair types and how they are drawn. By viewing them up close, you can see how critical the pencil strokes are to creating texture.

Burnishing for Long Waves
The curves and waves of the hair were done with long, curved pencil strokes. It required many layers. The blue and orange tones were added on top with a burnished approach.

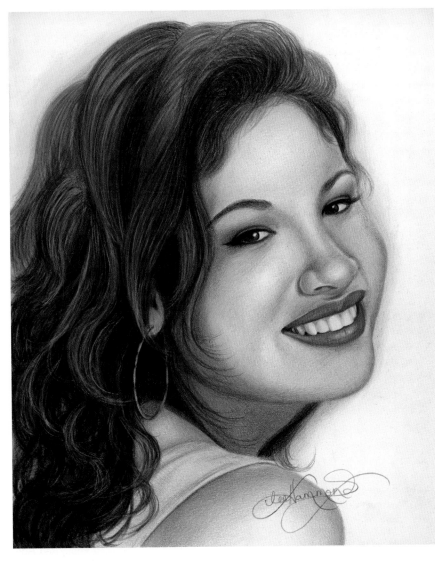

Reflective Properties of Color
Here we see how reflective color can be. The subtle blue tones reflect onto the skin and hair of the subject.

Band of Light
This shows the band of light, where the hair creates a tubular shape. This occurs when long hair follows a curve, and the protruding areas gather light. You will see this band in curls where the hair bends as well.

DEMONSTRATION

Draw Hair

There are endless styles, textures and colors when it comes to drawing hair, so it would be impossible to cover them all in this book. But it is important to know how to draw as many different types as possible if you want to excel at portraiture. This exercise will give you some practice with two common types of hair.

Follow the steps to draw different types of hair.

MATERIALS

Paper
regular surface bristol

Colored Pencils
Dark Umber, Light Umber, Peach, Terra Cotta

Other
kneaded eraser
mechanical graphite pencil

LONG WAVY HAIR

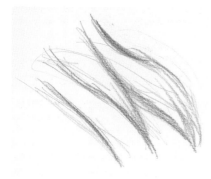 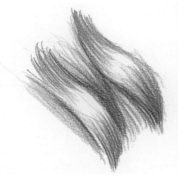 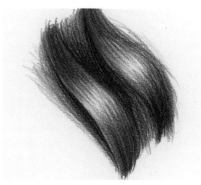

1 Draw the Shapes
Lightly draw the shapes of the hair with a mechanical pencil. Go over it with some Dark Umber to separate the layers of the hair.

2 Create the Hair Strands
Add Light Umber to the hair, then deepen the dark areas with Dark Umber. Leave the highlight area exposed. Use a very sharp pencil point and long, quick pencil strokes to create the appearance of hair strands.

3 Deepen and Darken
Add Terra Cotta to the hair to give it a reddish shine. Deepen the recessed areas with Dark Umber. Leave a band of light in the protruding areas so the hair looks curved and wavy.

SHORT CURLY HAIR

 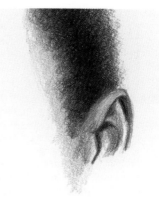

1 Draw the Shapes and Start the Skin Tone
Lightly draw the shapes of the hairline, ear and overall shape of the hair with a mechanical pencil. Lay in Peach to start the skin tone. When drawing very short hair, take the skin tone up into the hair area.

2 Build up the Hair
Apply small, circular strokes to the hair area with Terra Cotta. Use a light touch, taking it out into the skin area to create a hairline.

3 Continue Layering
Layer the hair with Dark Umber over Terra Cotta. Keep it lighter on the outside edge where the light comes through, as well as where it grows out of the hairline. Fill in the center area deepest and thickest.

Hands & Feet

Hands and feet are so important when drawing portraits because they help to tell the subject's story and convey the mood of a piece. Just as with any other features, the more you practice, the better you will be at drawing them. I suggest going back and reviewing the information about hands in the graphite section of the book.

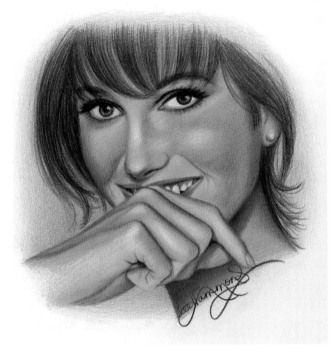

Hands Help Set the Mood
In this fashion pose, the hand plays an important part in setting the mood of the portrait.

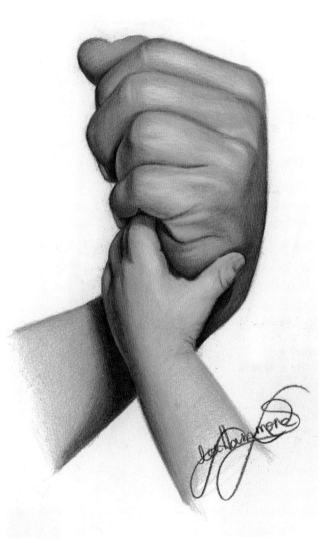

Adult Hands vs. Baby Hands
Baby hands look quite different from adult hands. Baby hands are plump and rounded, whereas adult hands are more boxy and angular.

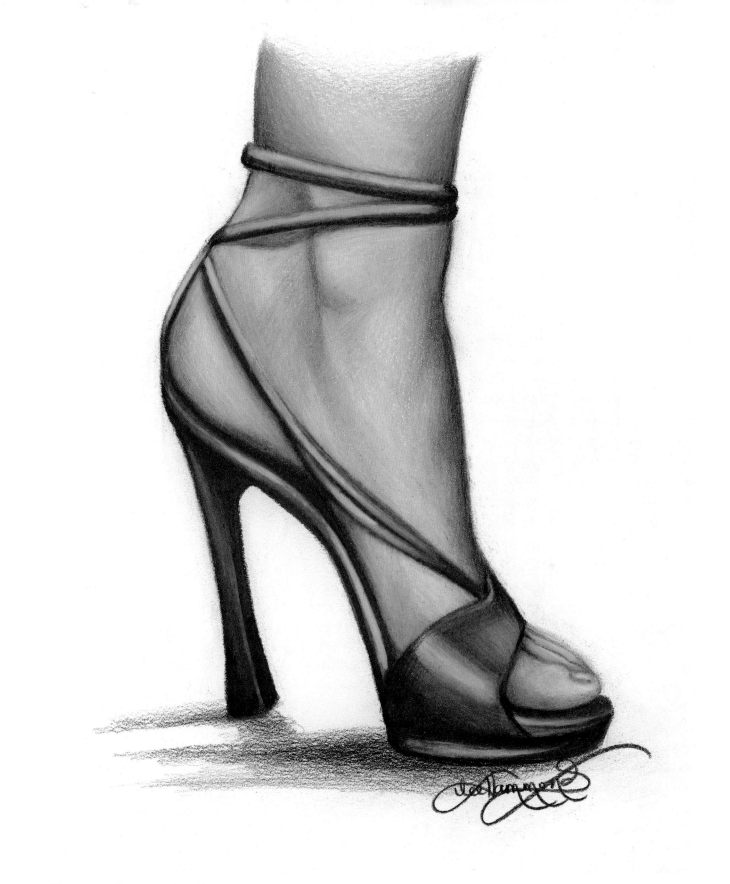

Curves and Contours of the Foot

The gentle curves and contours of the foot and leg give this drawing an artistic feeling.

I suggest using fashion magazines as reference for drawing hands and feet. You will learn a lot about anatomy this way.

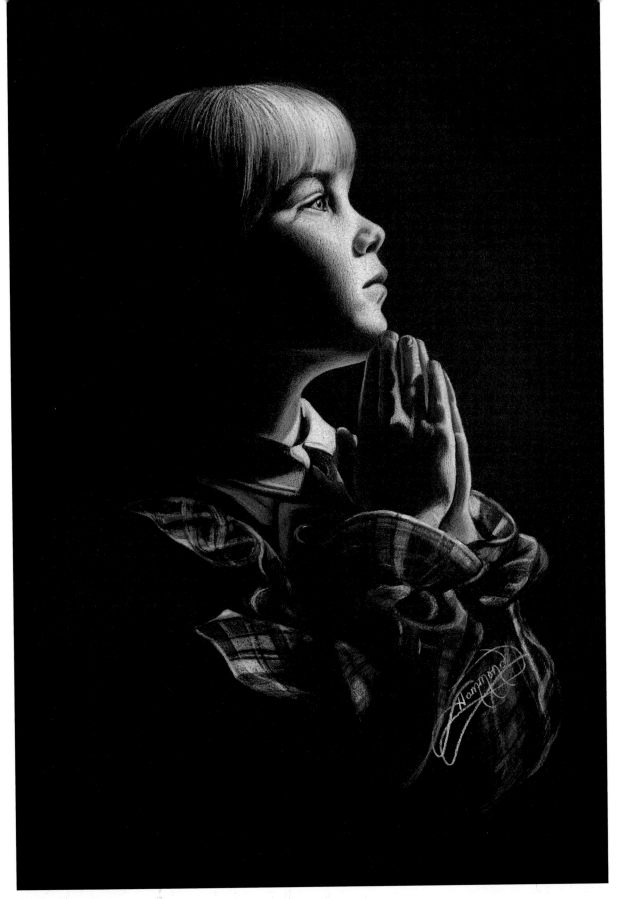

Lighting and Mood
This is another great example of the importance of hands in creating a theme or a mood. This was drawn on black Artagain paper, so burnishing was required. The dramatic lighting gives this piece a lot of appeal.

Draw Baby Hands

There are a few basic rules to keep in mind when drawing hands.

- Hands are not as round as you might think. They are angular, so watch for those straight lines!
- Do not overemphasize fingernails. They rarely have a dark line drawn around them. Study your reference closely to see where it is light and where it is dark.
- Hands are made up of many overlapping shapes. Each finger has a distinct edge, so look for which edges are light and which edges are darker.

 Follow the steps to draw a baby's hands.

MATERIALS

Paper
Strathmore toned gray paper

Colored Pencils
Indigo Blue, Non-Photo Blue, Peach, Terra Cotta, Tuscan Red

Other
kneaded eraser
mechanical graphite pencil
ruler

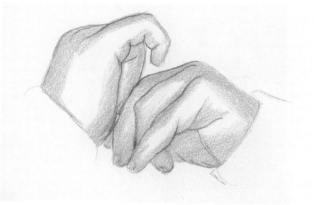

1 Create a Line Drawing
Use the grid method and a mechanical pencil to create a line drawing of a baby's hands. This is an unusual pose, so it will require some studying to capture the shapes accurately. Take your time.

2 Add Color
When you are sure of your accuracy, remove the grid lines with a kneaded eraser. Apply the skin tone with Peach. Allow the highlight areas to remain white. Create the edges of the fingers with Tuscan Red.

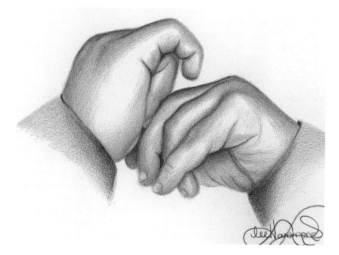

3 Deepen the Colors and Add the Shirt Sleeves
Deepen the skin tones with more Peach. Add more Tuscan Red to the edges of the fingers to darken them. Soften the edges with Terra Cotta as they fade to light. Create the shirt sleeves with Non-Photo Blue and Indigo Blue.

Draw Baby Feet

This drawing is actually from the same reference I used in the graphite chapter. I redid it here to show how different the same subject can look when an alternate technique is used.

Follow the steps to draw a baby's feet.

MATERIALS

Paper
Strathmore toned gray paper

Colored Pencils
Blue Lake, Indigo Blue

Other
kneaded eraser
mechanical graphite pencil
ruler

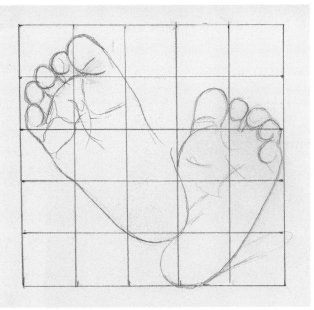

1 Create a Line Drawing
Use the grid method and a mechanical pencil to create a line drawing of a baby's feet.

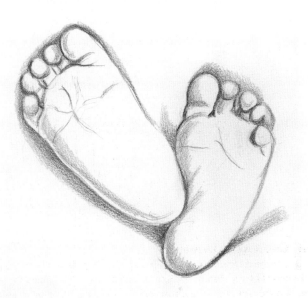

2 Build up the Shadows and Edges
When you are sure of your accuracy, remove the grid lines with a kneaded eraser. With Indigo Blue and a very sharp pencil point, build up the edges and shadows of the feet.

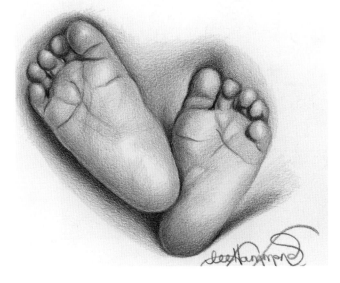
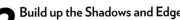

3 Deepen the Edges and Shadows, Add Creases
Add Blue Lake with a sharp point to create the halftones. Deepen the edges and the shadows with Indigo Blue. Add the tiny creases of the feet with Indigo Blue, using a light touch and a very sharp point. Do not use harsh or thick lines; they need to look delicate.

CHAPTER TWELVE
FABRIC & CLOTHING

I cannot express how important it is to learn to draw believable clothing. I have seen many of my students fall short in this department. While everything else looks great, the clothing lacks the realism seen in the other parts of the drawing. No matter how well you learn to draw a portrait or figure, it will be diminished if the clothing is not drawn as skillfully. Remember, a drawing is only as good as its weakest area.

This chapter will give you all the necessary information for learning the art of drawing fabric and clothing. I highly recommend doing the practice work here, for it is a crucial aspect of good portrait work. For more in-depth instruction on drawing clothing and fabric, consult my book, *Drawing Realistic Clothing and People*.

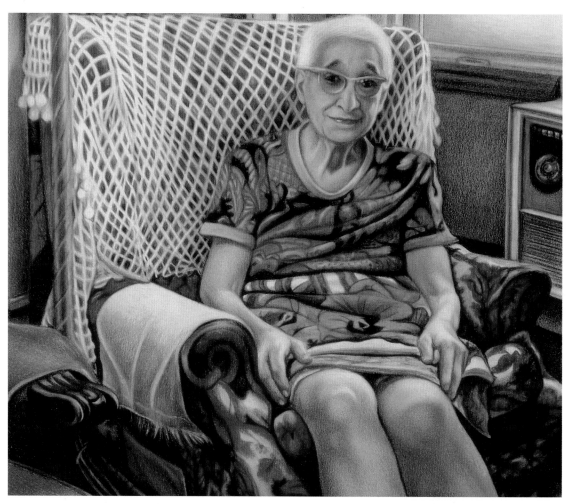

Grandma's Apartment
Colored pencil on regular surface bristol
16" × 20" (41cm × 51cm)

Textures

We covered the basic folds earlier in the graphite section. Before you attempt to draw clothing in color, put in the time practicing in graphite first to be sure you understand how to fully capture all of the curves and contours that fabric has.

Texture also plays an important part in any drawing involving clothing or fabric. Each area of the drawing below was done a bit differently to represent all of the various textures found in clothing.

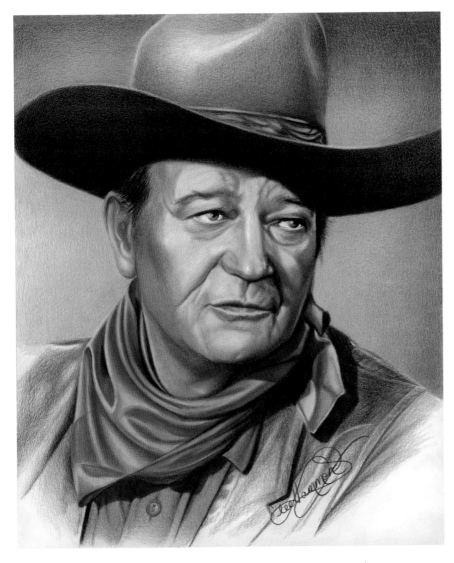

Pencil Lines Dictate Texture
Each fabric surface in this drawing was handled a different way. How you apply the pencil dictates the look you are trying to capture.

Lightly Layered Cowboy Hat
The light layering process created the soft look of felt in the cowboy hat.

Burnished Bandana
Burnishing was used to create the interlocking folds and shiny appearance of the bandana.

Roughly Layered Vest
This vest is layered like the hat but not with as sharp of a point on the pencil. The rougher approach gives it the look of suede.

209

Draw a Towel with Column Folds

This exercise will give you practice drawing a towel with column folds in colored pencil. Pay particular attention to the cone-like tubes of the falling fabric. Follow the steps to draw a towel with column folds.

MATERIALS

Paper
regular surface bristol

Colored Pencils
Apple Green, Grass Green, Indigo Blue, Sunburst Yellow

Other
kneaded eraser
mechanical graphite pencil

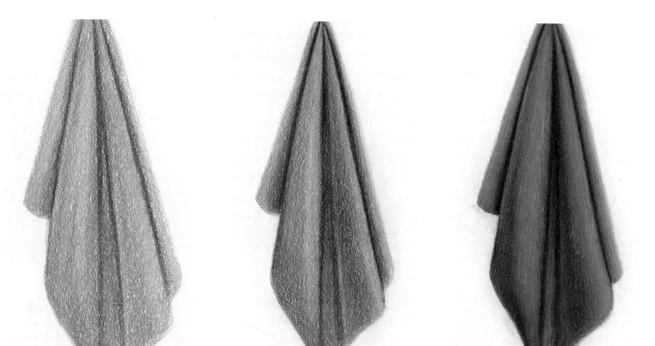

1 Draw the Shape and Begin Adding Color and Shadows
Lightly draw the shape of the towel with a mechanical pencil. Fill in the entire towel with Sunburst Yellow. Add the creases of the towel with Indigo Blue. Add Apple Green to the recessed area in the center. Use Grass Green down the lower left edge and to create the shadow areas of the towel.

2 Deepen the Shadow Areas
With Indigo Blue, deepen all of the shadow areas to create the cone shapes of the fabric. Refer to the five elements of shading and the cone shape discussed in previous chapters.

3 Continue Building Shadows and Deepening Colors
Deepen the overall color of the towel with Apple Green and Grass Green. Add more Indigo Blue to the shadow areas to build up the form. Do not burnish or you'll lose the texture required to make this look like terry cloth.

Draw Draped Fabric

Drawing fabric takes a lot of practice. It is so important to learn how to make the gentle curves of fabric look believable with gradual transitions of color. This segment drawing is a good practice piece for drawing draped fabric. This fabric is shiny, not textured, so the burnishing technique must be used.

Follow the steps to draw draped fabric.

MATERIALS

Paper
regular surface bristol

Colored Pencils
Black, Cool Grey 50%, Lavender, Non-Photo Blue, Pink, White

Other
kneaded eraser
mechanical graphite pencil
ruler

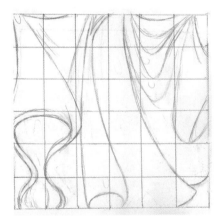

1 Create a Line Drawing
Use the grid method and a mechanical pencil to create a line drawing of the tubular shapes of draped fabric.

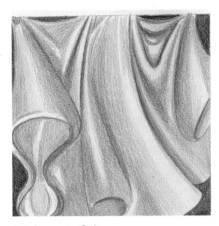

2 Layer in Color
When you are sure of your accuracy, remove the grid lines with a kneaded eraser. Begin laying in color. Start with Pink, followed by Lavender. Add a layer of Non-Photo Blue next. Use Cool Grey 50% in the creases and shadow areas. Add Black into the background areas.

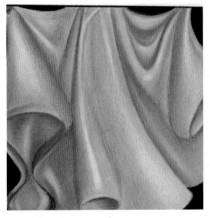

3 Burnish and Finish the Background
To make this fabric appear shiny, burnish everything except the background with White. This will blend all the colors together and transition them into one another for a smooth look. Reapply any color that may need to get brighter. Just remember that any time you add a color, burnish it back down with White. Don't forget to burnish the White highlight areas as well. Add a final solid application of Black into the background.

GALLERY

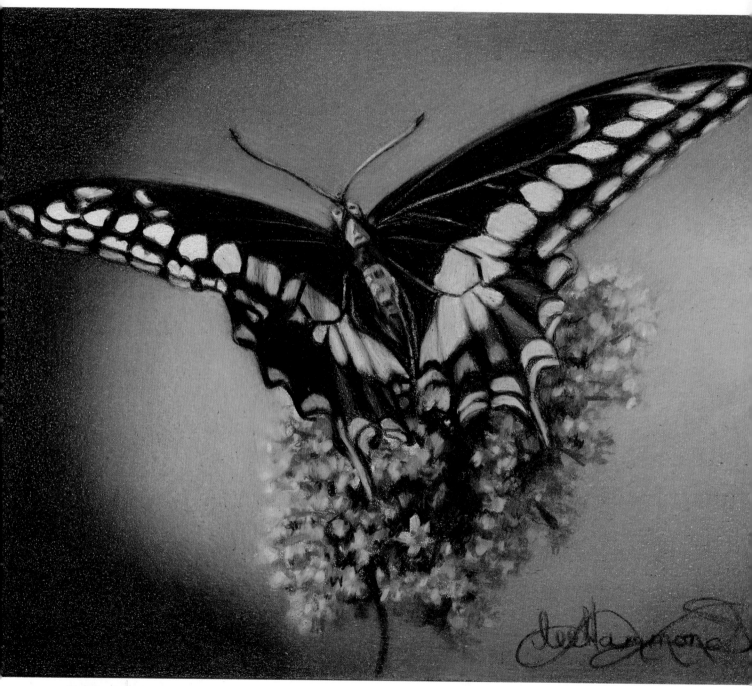

Black Swallowtail on Lilacs
Colored pencil on smooth bristol
8½" × 10" (22cm × 25cm)

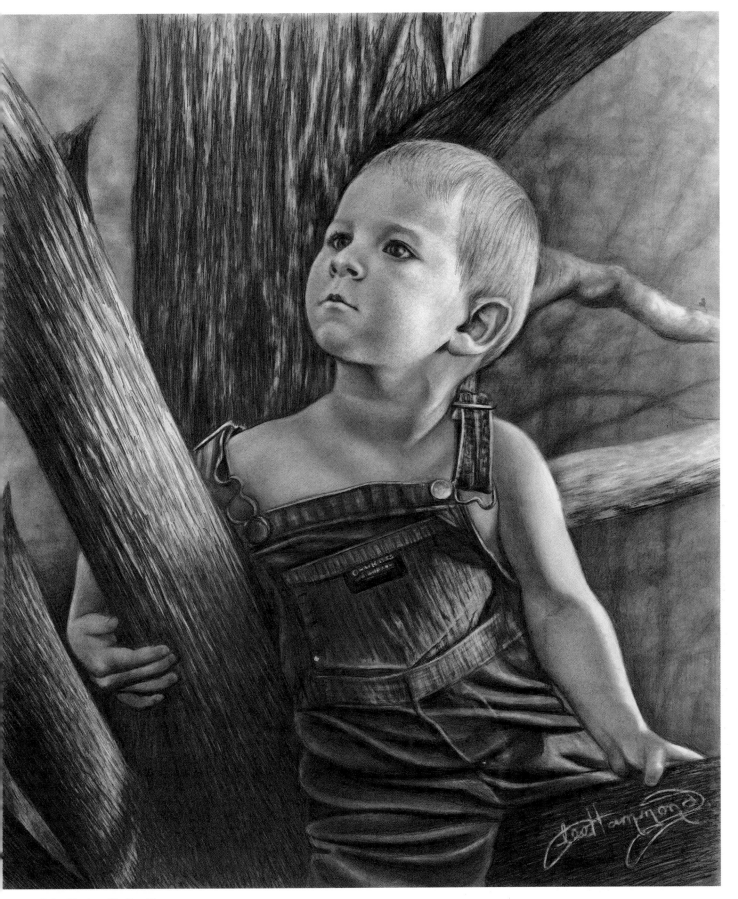

Colin Climbing His First Tree
Graphite pencil on smooth bristol
17 " × 14 " (43cm × 36cm)

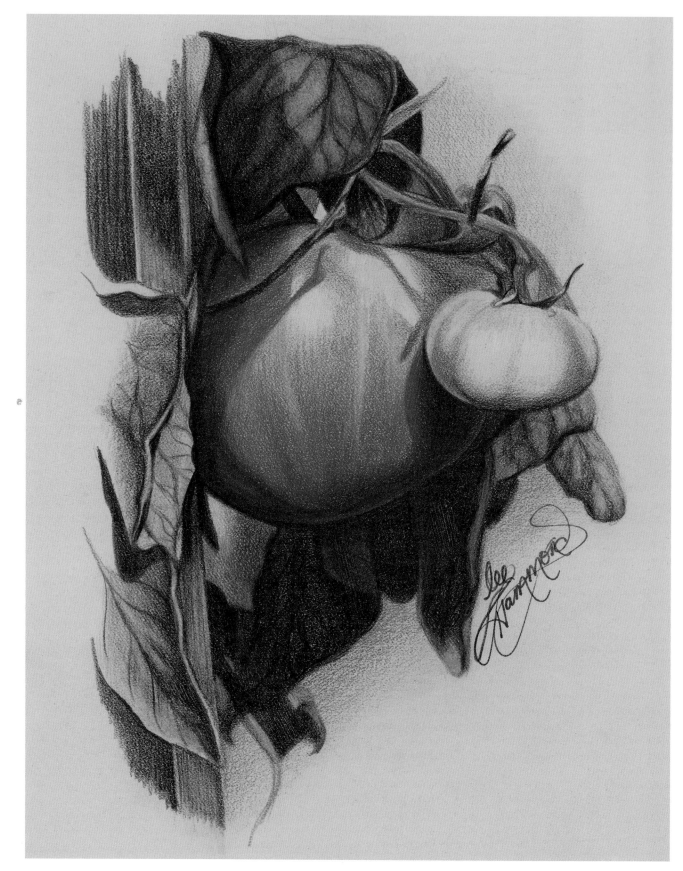

Tomato Garden
Colored pencil on pale green mat board
10" × 8" (25cm × 20cm)

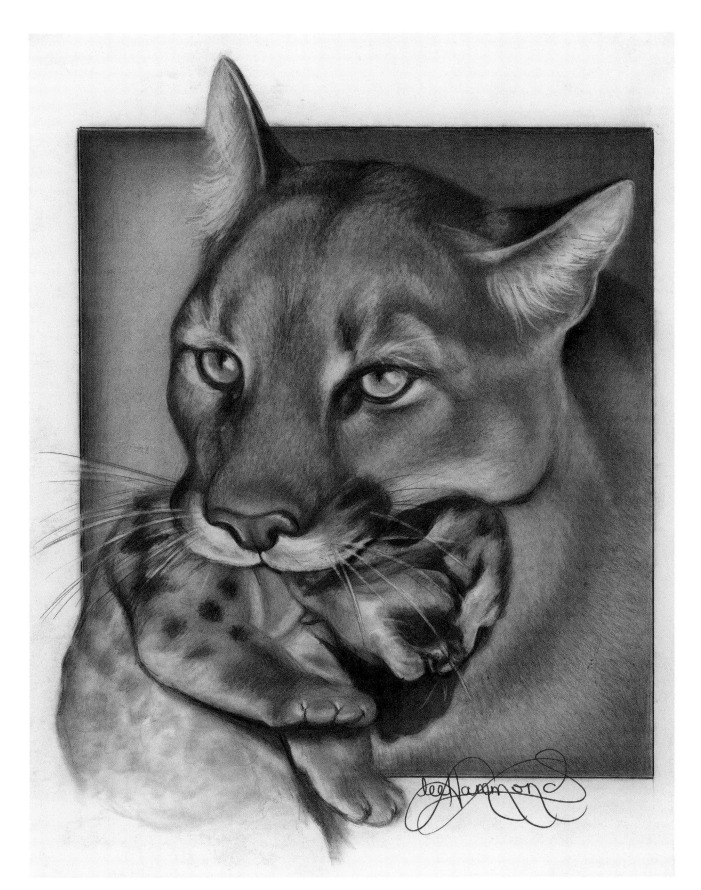

Mama Panther with Her Kitten
Graphite pencil on smooth bristol
14" × 11" (36cm × 28cm)

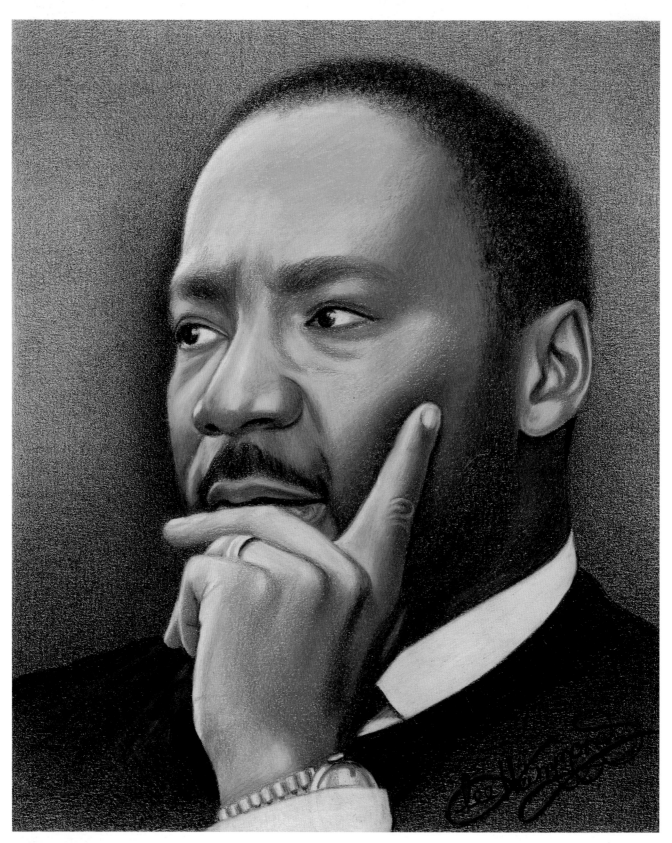

Dr. Martin Luther King, Jr.
Colored pencil on apricot mat board
14" × 11" (36cm × 28cm)

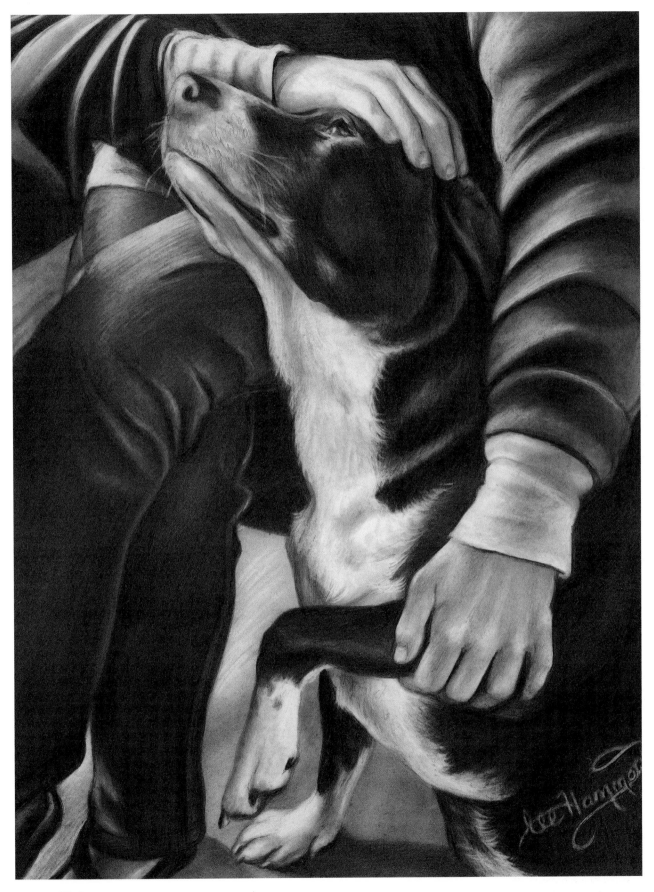

Jackie and Barbara
Graphite pencil on smooth bristol
14" × 11" (36cm × 28cm)

Conclusion

I want to thank all of you who have followed my career over the years. Many of you have more than one of my books, and some even claim to have a "Hammond Library." I am always thrilled when I am contacted by someone who tells me that with the help of my books, they have achieved something they never thought possible. Knowing that I'm able to reach such a wide audience is truly an amazing feeling.

Teaching is my calling. As long as I can breathe, I will continue sharing my art methods with the world. The good thing is I never stop learning and discovering new ways of creating art. I hope you will continue to watch me grow and seek me out as I share new and interesting methods.

This book was quite an undertaking. It was my goal to take old methods and give you new projects to explore. The techniques are timeless. They aren't trends or fads, and for that reason they will not change. If you continue to experiment with new subject matter while continuing to apply all of this information, you will never tire of that magnificent feeling of seeing your art improve with each piece.

Good luck to all of you on your artistic journey—thank you for allowing me to be a part of it!

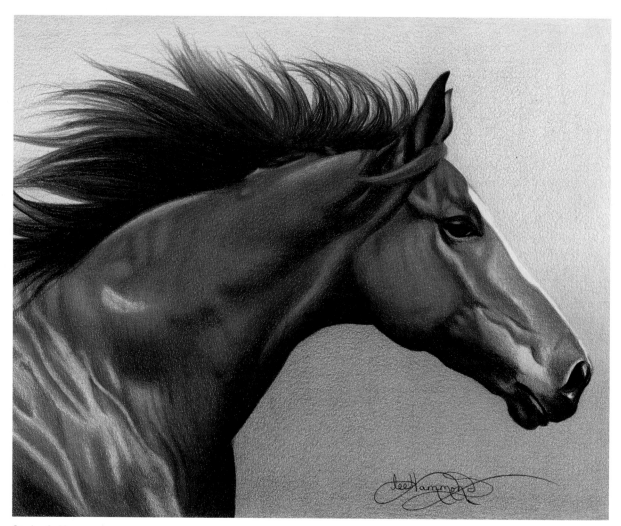

Study of a Horse
Colored pencil on Stonehenge paper
11" × 14" (28cm × 36cm)

Index

Other fine North Light Books are available from your favorite bookstore, art supply store or online supplier. Visit our website at fwmedia.com.

21 20 19 18 17 5 4 3 2 1

fw

DISTRIBUTED IN CANADA BY FRASER DIRECT
100 Armstrong Avenue
Georgetown, ON, Canada L7G 5S4
Tel: (905) 877-4411

DISTRIBUTED IN THE U.K. AND EUROPE
BY F&W MEDIA INTERNATIONAL LTD
Pynes Hill Court, Pynes Hill, Rydon Lane
Exeter, EX2 5AZ, United Kingdom
Email: enquiries@fwmedia.com

ISBN 13: 978-1-4403-4309-4

Edited by Christina Richards
Designed by Geoff Raker
Production Design by Jamie DeAnne
Production coordinated by Jennifer Bass

METRIC CONVERSION CHART

To convert	to	multiply by
Inches	Centimeters	2.54
Centimeters	Inches	0.4
Feet	Centimeters	30.5
Centimeters	Feet	0.03
Yards	Meters	0.9
Meters	Yards	1.1

Lee Hammond and her therapy dog, Jackie

About the Author

Lee Hammond has been an author for North Light Books for almost twenty-five years. She is formerly from the Kansas City area and now resides in Naples, Florida.

Lee's passion is teaching. She has owned and operated private studios her entire career, teaching fine art to thousands of aspiring artists. She is the Artist in Residence for the Rookery Bay Research Reserve in Naples, where she teaches a variety of mediums and subject matter. In addition, Lee teaches at the Naples Zoo and is an official artist for the Friends of the Florida Panther organization.

She is also a forensic illustrator and police sketch artist, providing aid to various law enforcement agencies by drawing composites of suspects, as well as reconstruction drawings for identifying John and Jane Doe cases. She is an expert age-progression artist. Her drawings have been integral in solving many cases.

Another career highlight was working as an illustrator for NASCAR, creating drawings and paintings of the racecar drivers. Those prints were sold all over the country and on QVC. She is currently in the process of developing a new product line to be sold on her website.

For more information about Lee's classes, product line, future book releases and public appearances, you can follow her on Facebook or visit her website at leehammond.net.

Lee Hammond with Jamie Markle

Acknowledgments

Writing a book is a difficult challenge. It takes much more than one person with a creative idea to turn that book idea into a reality. For almost twenty-five years, North Light Books has been my rock.

When I was first staring out as an artist and art instructor, I had a dream of having a book published about my art. Thanks to North Light Books, my dream was fulfilled. Then they helped me to turn that single dream into a solid career. It's often said, "It takes a village," and it's true. Without the editorial staff there guiding me along the way, none of this could have been possible.

As we go into almost a quarter century of publishing together, my admiration and appreciation for North Light Books never waivers. It has been a wonderfully fulfilling life, and I look forward to many more years of working with these fine people. Thank you to my editor, Christina Richards, for helping me once again create a best-seller!

I want to especially thank Jamie Markle for being such a constant supporter and cheerleader in all that I do. He has been there for most of my career. I couldn't ask for a better support system or a better friend.

Bill and Dorothy Hagen, my angels of inspiration

Dedication

In 1993, I lost my father, William Hagen. At that time I was publishing my very first book, *Drawing Portraits from Photographs*. He did not live to see the book in print. I dedicated that book to him and made a promise to him in my heart that it would become a best-seller. And it did.

This book is dedicated to my mom, Dorothy Hagen, who passed away while I was in the process of writing it. I had the great honor of having her at my side at many of my book signings. It is my goal to make this book a best-seller as well as a tribute to her. Mom was a constant inspiration to me with her easy approach to life. She was the one person who was always there for me. Thanks for being my mom. This one is for you.

Ideas. Instruction. Inspiration.

Receive FREE downloadable bonus materials when you sign up for
our free newsletter at artistsnetwork.com/Newsletter_Thanks.

Find the latest issues of *Artists Magazine* on newsstands, or visit artistsnetwork.com.

These and other fine North Light products are available at your favorite art & craft retailer, bookstore or online supplier. Visit our websites at artistsnetwork.com and artistsnetwork.tv.

Follow North Light Books for the latest news, free wallpapers, free demos and chances to win FREE BOOKS!

Visit artistsnetwork.com and get Jen's North Light Picks!

Get free step-by-step demonstrations along with reviews of the latest books, videos and downloads from Jennifer Lepore, Senior Editor and Online Education Manager at North Light Books.

Get involved

Learn from the experts. Join the conversation on wetcanvas